Sex Appeal

The Art of Allure in Graphic and Advertising Design

Edited by **Steven Heller**

D1602056

05 04 03 02 01 00 5 4 3 2 1

Published by Allworth Press
An imprint of Allworth Communications
10 East 23rd Street, New York, NY 10010

Cover design by James Victore, New York, NY

Page composition/typography by Sharp Des!gns, Lansing, MI

ISBN: 1-58115-048-2

Library of Congress Cataloging-in-Publication Data:
Heller, Steven
Sex appeal : the art of allure in graphic and advertising design / Steven Heller.
p.cm.
Includes bibliographical references and index.
ISBN 1-58115-041-5 (pbk.)
1.Sex in advertising. I. Title.
HF5827.85 .H45 2000
659.1'01'9--dc21 00-022194

Printed in Canada

Acknowledgements

This book would have been impossible without the efforts of my friends and colleagues at Allworth Press; thanks to Nicole Potter, editor, Jamie Kijowski, associate editor, Bob Porter, associate publisher, and of course, Tad Crawford, publisher, who has been a wellspring of support and encouragement.

Mary Domowicz, who compiled and edited the Timeline was an invaluable collaborator. And much gratitude goes to James Victore, designer and Mary Belibasakis, at James Victore Inc. for a terrific package.

The book would be impossible if not for the cooperation of all the contributors. Thank you so much for sharing your passions, obsessions, and widsom.

Finally, thanks to my family for putting up with my own obsessions. I'm sure it has not been easy.
—Steven Heller

Ever
wondered
why women
drink wine and men
drink beer? Think a
minute: fourteen-year-
old bikini girls sell beer;
healthy graying men in
expensive chinos sell wine.
Lately, a naked woman,
crouching face down on a
sheet of gray seamless, has
been trying to sell the
Palm Pilot . . . to whom?
Who cares. Go for it.
— Nancy E.
Bernard

Contents

Introd

uction

Sex Sells by Steven Heller

SEX. The word is so graphic. One syllable, two soft, seductive letters ending in a hard, throbbing X. What could be a better locution for evoking pleasure and passion, sin and taboo. There are few more evocative sounds than S-E-X. It excites, seduces, commands, admonishes. No other word communicates so profoundly. Indeed, no other human act drives behavior so totally. SEX is the fact of life. It is omnipotent. No wonder SEX sells.

But if ours was not an X-rated culture, SEX could not titillate the body politic in the way that it does. When it comes to SEX, American society is historically repressed and unrepentantly repressive. Never mind showing the sexual act in public; mere nudity is legislated to such a degree that in mainstream media exposed flesh attracts more attention than a presidential address. Men (and some women, too) routinely pay just to watch others disrobe. Voyeurism is a national pastime, and cultural progress is often measured by the number of private parts that appear on TV, film, and the stage. Even nudity in art was once a moral deviation, and illegal, too. Forget original sin. Just fantasizing about SEX is considered naughty. (Remember the outraged response to President Jimmy Carter's candid comment in *Playboy* magazine that he had lust in his heart for women other than his wife?)

This is why SEX is also so enticing. Because it is deemed taboo, it is a prime instrument for attracting public attention. SEX stimulates the libido, but in consumer culture it also stimulates sales. And since in the sales game ends justify means, "community standards" concerning SEX are routinely pushed to the limits.

In the United States women are commodified sexual objects, and there is no mystery why. Prior to gaining the right to vote, women were second-class citizens whose bodies were the property of men. Once the vote was won and ensured by a constitutional amendment, women posed a social and political threat to male superiority that was spuriously checked through sexual objectification. The male-devised image of women was purposely simplistic: Portrayed as either homemakers or whores, men found both these

stereotypes appealing for different reasons. The whore was free from moral constraint and thus sanctioned the exercise of lustful passion. Nonetheless, wrote illustrator James Montgomery Flagg in 1932, "Every man likes to think his Prize Package is a virgin in cellophane—direct from makers to consumer, untouched by human hand." Realizing this dichotomy, the advertising industry craftily combined these two roles into one seductive archetype that was flexible enough to shift with the ebb and flow of societal tolerance. In other words, the ideal woman was sensual, yet free of shame. Women's bodies were, therefore, gradually exposed until such time that an advertiser received complaints. The boundaries were continually pushed, and for each step "backward" the public was conditioned to go two eventual steps "forward." Not coincidentally, since men ran the advertising agencies, there was never a doubt that sex appeal was women's work.

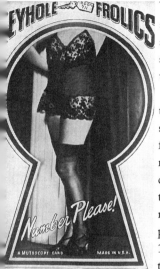

SEX was not as prevalent in mass media during the early twentieth century as it is today. In an era of ambivalence and denial, hypocritical moral standards were ordained by church and state and enforced by censors in film, advertising, and publishing. Collectively, their muddled morality reigned, so advertisers appealed to what they knew were repressed sexual drives by becoming masters of innuendo and double entendre, which laid the groundwork for future methods of sex appeal. SEX became something mysterious, and the mere hint of a woman's bosom, derriere, or thigh was a potent trigger. Recall the film seductress Mae West, who, in the 1920s and 1930s, exposed little flesh but revealed everything else through her tight-fitting, curvaceous fashions and her body and verbal language. Where flesh was prohibited, other forms of robust sexual exhibitionism were encouraged.

In proper society, showing unbridled passion was arguably more forbidden than exposing naked flesh. Passion bred lust and lust was a mortal sin. The sexual paradigm of the 1930s, 1940s, and 1950s was the solitary, sultry woman who through sensual pose and guise invited men to gaze but not to touch. In print, the many versions of this basic theme culminated in the pinup, which served as a generic advertising enticement. Used to promote thousands of small businesses, pinups hung like religious icons on walls or in lockers. The pinup was the quintessential fantasy girl, the harlot mistress for whom men would do almost anything to momentarily possess and caress her, including buying the product or service that she represented. Whether painted or photographed, the pinup girl was perfectly proportioned and precisely calibrated to ensure arousal. To this day commercial sex appeal is still rooted in the pinup paradigm. Whether in advertising campaigns, on CD covers, or on television game shows, few attractions grab the (male) public's attention more effectively than a temptress.

In the 1930s, public mores and tenets of acceptability changed. Victorian clothing that concealed women's ankles and necks was tossed aside for fashions that revealed more of the female's natural form. Silk-stockinged legs (slightly above the knee) and modest cleavage with a hint of nipple were tolerated. Advertisers took as much advantage of these developments as propriety allowed, and the modern objectified woman became more sensual. The venue for the most racy mainstream sex appeal was not common

advertising, however, but the genre of low- and middlebrow fiction periodicals known as pulps that began in the teens and became really hot during the late 1930s. They influenced a subsequent genre of pulp paperback covers that were prodigious in the early 1940s. The artwork used on these covers showed scantily dressed women, sleek and slim, often with torn clothing exposing sheer undergarments. For detective stories or sci-fi tales, these women were usually shown menaced by unsavory men or inconceivable aliens, adding the virtue of vulnerability to the prurience of their virtual nakedness.

"Pulp women" had plentiful breasts and capacious hips, like Rosalind Russell, Ruth Roman, and other well-endowed movie starlets of the day. In fact, pulp covers were akin to movie posters, which typically froze salacious moments from the romances, westerns, and noir thrillers they promoted. Similarly, the pulp cover artist, who was skilled at rendering lascivious nuance, often found obscure passages that lent themselves to graphic sex-ploitation. SEX was not the only component of the visual language of the pulp genre, but it was the dominant one. And, because the genre was so prodigious, it laid the groundwork for the dominance of sex appeal in mainstream advertising in the years that followed.

The visual lexicon of commercial sex appeal is simplistic yet replete with nuance. Women are clothed, partially clothed, or butt naked; they look innocent, erotic, or dissolute; they are sophisticates, bombshells, or seductresses. Some of the sexiest images are those in which women representing a certain high or middle class and caste are transformed into vamps, and conversely, in which abject vamps and tramps are made to look like housewives. "Whatever turns you on," as the old saying goes. Before the widespread use of photography in advertising (which exploded in the 1950s), painters produced the majority of pinup, pulp, and mainstream fantasies. But as the stakes increased and mores shifted, sex appeal demanded more verisimilitude. Real models, especially in unreal situations, ultimately dominated. Moreover, quirks and fetishes were added. Today bondage, homoeroticism, lesbianism, transvestism, and Lolitaism are part of the so-called porno-chic that is endemic to fashion and cosmetic advertising.

Yet before indicting sex appeal as soft-core pornography, a distinction must be drawn between what is used to sell and what is designed to pander. Although the distinction can be perilously slim, pornography (which according to the Supreme Court is a subjective designation based on community consensus) is that which has no redeeming social value. Commercial sex appeal, on the other hand, has value if for no other reason than it stimulates the economy, and the economy is the life force of the republic. By this logic, sex appeal is not pornographic until or unless the public stomps its common foot and finds it intolerable. By extension, overt sexual display is as necessary to a healthy economy as intermittent hikes in the prime interest rate.

For those who might argue that this is a resolutely sexist justification, sex appeal was never solely designed to titillate men. Women were also targeted for arousal as consumers. Somewhere within the paradigm of objectification, women were exposed to their own secret fantasies as well. Much

mainstream advertising for products and services that employed (and exploited) sensual females were aimed at women consumers. Sure, men savor bra ads in the Sunday *New York Times Magazine*, but the buyers of intimate apparel are women. Fashion and cosmetic ads routinely propagate the ideal woman and promote the ingredients for making her more attractive to both men and herself. Sex appeal is as much about creating a standard for American women as it is about stimulating American men. Of course, today men are also props. Sweaty muscular bodies covered only by tight-fitting workout clothes have been proven to excite women as the pinup does heterosexual men. And now that homosexuality and lesbianism are more tolerated in mainstream media, sex appeal is aimed at even wider, more diverse audiences.

SEX is a fact of life, and sex appeal is a matter of fact. It pervades every facet of mass communications, from art to commerce, and it is such a common component in advertising and graphic design that its existence goes without saying. However, its very recurrence is the reason for continual reinvention. What was once shocking—and shock is a key to grabbing consumer attention—quickly becomes ordinary. Nudity never ceases to interest, but in an advertising environment where skin is no longer hidden, flesh alone is not a priori a turn-on. Allure is no longer determined by the degree of exposure, but by how hot or cold the body appears.

Sex Appeal: The Art of Allure in Graphic and Advertising Design is the first book to examine the roles of SEX—the overt and covert—in visual communications. It is not a SEX/design manual, but a critical and phenomenological analysis of how the commonplace and taboo intertwine and how sexuality is unleashed in commercial markets. The anthology of essays begins with Ralph Caplan's reprise of SEX as a marketing tool in the 1960s, at the onset of the sexual revolution, and continues with sections that serve as rubrics for the key positions of SEX in commercial art. In "Animal Magnetism," the primal and biological allure of SEX is examined through objective science and personal psychology. In "Sex as Metaphor," the many symbolic reasons for SEX's gravitational pull come to light. "Chic Sex" observes and critiques the transformation of SEX from a taboo into style and fashion. In "Sex, Power, Feminism," the energy that SEX both exudes and spends as a determinant of socio-cultural relations is argued. "Sexual Progress" recalls the history of SEX in design. And in "Talking Sex," three participants in the sexual revolution explain their motives.

The public's fascination with SEX and the graphic and advertising designer's acceptance of it as a potent tool have fed each other for the run of the twentieth century. But the public has always been divided on the lengths to which sexuality can and should be used to sell, if at all. Polarization between right and left, conservatives and liberals, religious and nonreligious is not new to American culture, but the dissenters seem to be more vociferous than ever before, which begs the question: How have designers contributed to the schism? Since sex appeal continues to motivate, stimulate, and exacerbate this ongoing debate, designers must take more than a modicum of responsibility for the how and why SEX sells.

Fore

play

Period Piece by Ralph Caplan

When Steve Heller asked me to contribute to a new book he was doing, I complained that he had done too many already. "What's left in graphic design for you to do a book about?" I asked.

"Sex," he said.

I recounted a scene from John P. Marquand's play, *The Late George Apley*, in which the stuffy turn-of-the-century Bostonian protagonist notices a volume of Freud in a house he is visiting. He picks the book up and examines it.

"What is this about?" he asks his host.

"Sex."

"The entire book?"

"Well, it is a bit padded," the host admits.

"Is your book on sex going to be padded?" I asked Heller.

He shrugged. "All my others are."

In the face of such stunning candor, I could hardly refuse him. Still, as the author of a novel that was dismissively described by a reviewer as "a book in which no one gets seriously laid," I was not sure I had much to contribute. I needed to be coaxed. "No padding without prodding," I said. Heller prodded. "You must have something in your files," he said.

It was a reasonable supposition. The use of sex in advertising has been an interest of mine ever since puberty, which in my case coincided with the publication of John Steinbeck's *The Grapes of Wrath*. One of the book's most evocative passages describes the hamburger stands and coffee shops lining Route 66: "The walls decorated with posters, bathing girls, blondes with big breasts and slender hips and waxen faces, in white bathing suits and holding a bottle of Coca Cola—see what you get with a Coca Cola." To my literal adolescent mind, Steinbeck's interpretation seemed absurdly far-fetched. But it started a lifetime of brooding on the matter. As Steve suggested, I looked through decades of files until I came across a piece I had written about cheesecake in industrial publicity. The article appeared

in 1962 in *i-D* magazine. I also found in a later issue a sharp rebuttal: A spokesman for the Industrial Publicity Association wrote a letter to the editor declaring, "Fifteen prints from the girlie picture collection in Caplan's editorial attic do not make a standard for modern industrial publicity."

He was right about that, but I was not raising questions about standards. I was asking an older question: What's a girl like you doing in a place like this? For, as the name of the offended organization emphasizes, this was industrial publicity. I took the shock of venue as a sign that we were looking for sex in all the wrong places—the lush pages of glossy magazines, where epicene models strut and spread their stuff on behalf of clothing and fragrances and beach resorts and, now as ever, Coca Cola. The sex images I had uncovered, however, were directed to a different shopper—purchasing agent or plant manager—to be captured in a different environment: trade magazines and trade shows dedicated to promoting not artifacts of pleasure but the most quotidian industrial goods. The ads and PR blurbs presented in the article were designed to be sexy precisely because the stuff they were selling was not. True, the Mercedes on page 8 qualifies as an object of desire. But the kinky exuberance with which the car is roped (the only restraint of any kind shown here) by the cowgirl dominatrix is at bottom more reflective of D&B than S&M. Reading the article now, I am chastened to find that the sexism it derides is matched at every point by my own sexism. The piece is patronizing in usage, leering in tone, and focused on the comedic ineptness of the promotional materials, rather than on their exploitative purposes.

I have not changed anything in it, but I have added a few footnotes to help bridge the generational abyss. These are instruments of clarification, not excuse. The piece is dated. Given its age and mine, it has a right to be.

A Personal Look into the Texture of the Design—and Designed—World

by Ralph Caplan

In March, I reported the Northrup Corporation's ingenious introduction of a soprano voice into the design of an aircraft emergency sound warning system. The operating principle behind this widely publicized safety measure is as new to electronics engineering as it is old to situation comedy: the incongruity of woman in a man's world.[1] Yet, however dramatic the juxtaposition of the sexes may seem to a pilot, it should not startle any designer who has seen how his[2] products are presented in, or at least to, the business press. Today, even the soberest heavy industrial equipment is launched with a brand of still photography not seen elsewhere since Ann Corio[3] turned legit.

As a result, there is probably more décolletage in *Progressive Plumbing* or *Stamping and Forging Age* than there is in *Playboy*. And with good reason. For one thing, the former really are "men's magazines." For another, the girls in *Playboy* are offered as designs in their own right, while the playgirls of modern industrial publicity are always ancillary to nuts, bolts, printed circuitry, or laminated wallboard. Their use is based on the gloomy premise that industrial news is so dull—even to the companies who claim they are making it!—that prospective readers and buyers must be given visual toys to play with. The toys shown here have been stored in my editorial attic for some time now, and I am ready to share them with all the neighborhood.

Sex and Subtlety

Figure 1 has a natural prettiness and restraint rare in business literature. She is a sort of June Allyson[4] of industrial pinup girls—wholesome and modest, her scrubbed American face infused with a radiance clearly attributable to the slim volume in her trembling hands. Here her resemblance to the girl next door (at least the one next door to me) ends; for what she is pretending to read happens to be not *Indian Love Lyrics*, but even headier stuff—the Equipment Manual of the Precision Equipment Company.

1

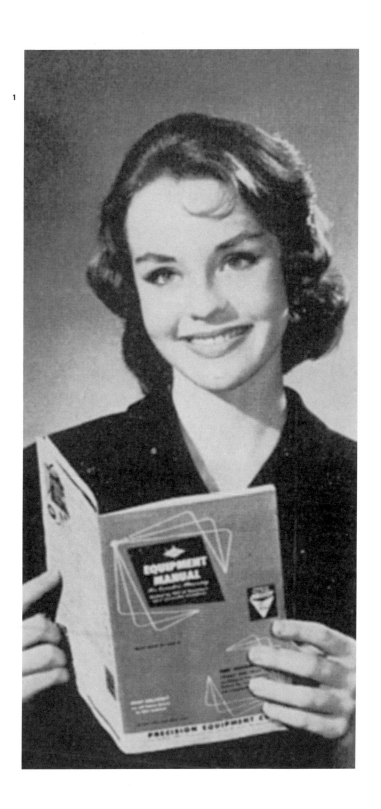

2

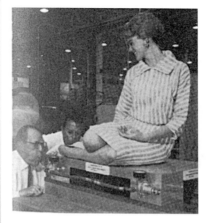

3

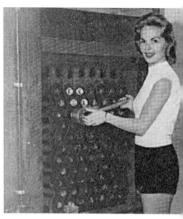

4

Sex in this kind of press agentry is frequently defended with the explanation that the woman in the picture makes a point effectively. Sometimes this is slightly true. Every product photographer with a gift for cliché knows that when shooting a product whose smallness is a selling point the rules of the trade require that he place a paper clip or a cigarette package or a thumbnail beside it for scale. He also knows that if lightness or simplicity of operation is the point, it can be made with a little cheesecake, which is easier to come by than a little imagination.

Figure 2 is a routine example of this technique, although in this case the photographer has been frustrated by a copywriter who doesn't trust either the viewer's eyes to see, or his mind to understand: "An engine block as light as a blonde," the caption proclaims. Figure 3 tosses gallantry aside: The leggy model is ostensibly there to show how much weight can be moved by General Dynamics's friction-free air bearing and a couple of puffing and panting lab technicians. Figure 4 is my favorite of the even-a-girl-can-do-it school, perhaps because this one can do it without even looking. The photo shows how easily bolts can be loosened with a product called Swench Wrench. The Swench Wench in the picture is identified as a secretary in the Marquette Division of Curtiss-Wright, but it is not clear whether these are her secretarial clothes or just the company's idea of appropriate dress for women loosening bolts. The company does boast that "The portable wrench—it needs no auxiliary equipment—has made friends in such places as shipyards, railroad shops, garages and other commercial plants . . ." I am not impressed. Wearing that outfit, the secretary alone could make friends in the same places. And she needs no auxiliary equipment—not even the wrench, which I find redundant.

In some instances, the relevance of woman to product is so feebly established that one wonders why anyone bothered. Figures 5, 6, and 7 have no excuse whatever except the availability of a model who can evidently be moved to flights of fantasy by the contemplation of any product that pays

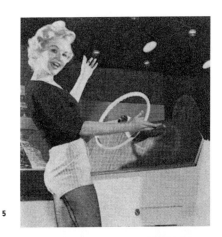

5

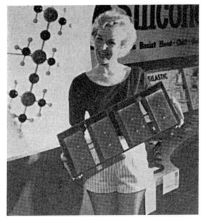

6

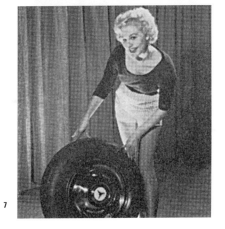

7

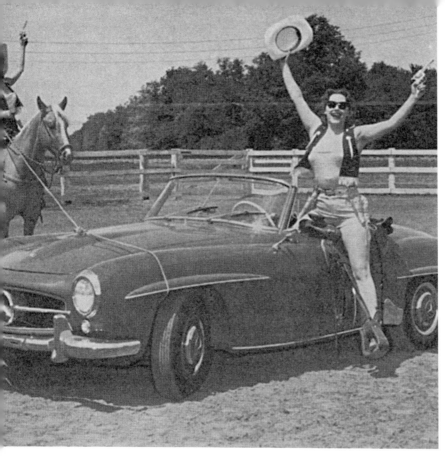

8

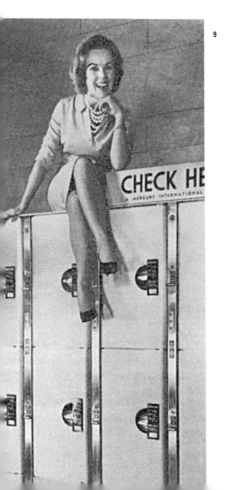

9

CHECK HE
A MERCURY INTERNATIONAL

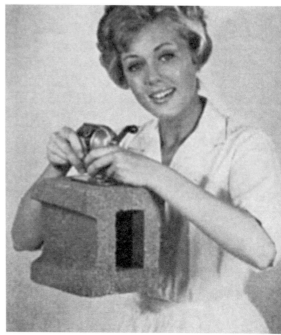

10

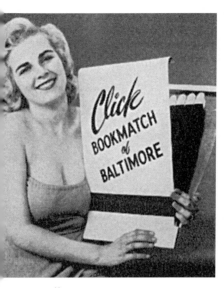

11

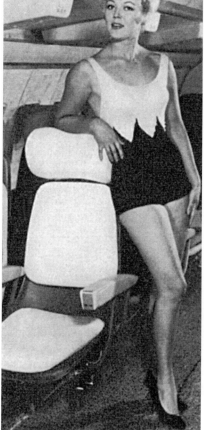

12

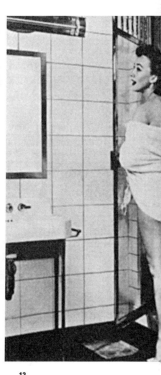

13

a living wage. Figure 8 also has nothing to do with anything; the whole weight of the nonsense is carried by the term "Road-E-O," which may be industry's lamest pun since the "You Auto Buy Now"[5] campaign of 1958. Figure 9 proves that coin lockers are strong enough to sit on, an important feature, I guess, now that the luggage inside is no longer strong enough to stand on.

Figure 10 shows how dangerous this otherwise innocuous bumbling around can be. Here, a company actually has something that it wants to say, but the photographic gimmickry has made it almost impossible to guess what. The message, cleared up in text, is that the pencil sharpener can be attached to a variety of surfaces without drilling holes. But what the picture seems to show is that cinder blocks come equipped with pencil sharpeners, and that girls can lift them without strain.

Whatever the rationalizations for the preponderance of near nudes who promote our most commonplace products, the theory honestly behind them is that sex sells. This can hardly be challenged. Certainly the cleavage in Figure 11 inspires me to look with favor on the Click Bookmatch Company and, what is more, on the city of Baltimore. And if, as the caption relates, the new Mason airplane seat "scientifically hugs human form," I for one am delighted that in Figure 12 it has a human form worth scientifically hugging.

Yet there is always the risk that what sex really sells is sex. The creators of Figure 13 may believe that when the viewer gets tired of the lady who has lured him to the page, his attention will turn to the product. But by that time, will he care about the product? Would you? (Ironically, the

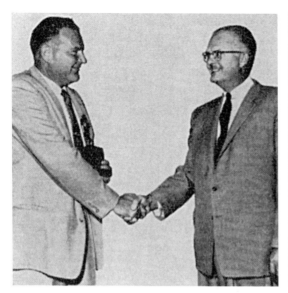
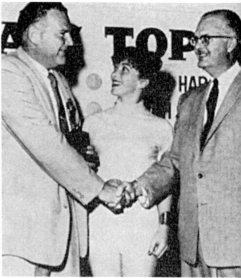

product is not the shower unit or the lavatory or the towel, but the radiant heater on the wall above the mirror.)

We must not take this matter lightly, no matter how droll its manifestations. The dilemma faced by the manufacturers of product publicity is grave indeed: If the product is shown as an adjunct to sexual fantasy, prigs and other people of taste will find it vulgar, stupid, ludicrous. But if it is shown straight, it may never get published at all. (That is, not unless the product has intrinsic merit, and while that is desirable as coincidence, it is hardly substantial enough to sustain public relations activity.)

There is a way out. Figures 14 and 15 and Figures 16 and 17 have been hanging around the *i-D* office for years, occasionally pressed into service as sources of local amusement, and as props for extracurricular chores. The former managing editor once used them in a speech on public relations, and I have used them in every speech I could work them into, regardless of subject. For they are magnificent examples of almost anything.

Figure 14 shows what I take to be a salesman at the climax of a national convention, honored with everything a grown man could ever want, a trophy, a handshake from the national director of something or other, and an approving smile from, I suppose, Miss Retail Hard Goods of 1958.

Figure 15 is the same shot, edited for use in magazines that think they have what Rocky Graziano used to call "diggity." The pictures are sent out as a pair, and each editor can choose the one that meets his needs.

Figures 16 and 17 also operate as a pair. They were sent out with the same press release (long since lost—we keep only the valuable part), and, again, each editor can pick the one most likely to appeal to his readers. Figure 16 was prepared with an epicene audience in mind. Figure 17 is apparently for church journals. Or, as an astute business consultant I know puts it: Figure 16 appeals to readers for whom Chicago is the convention town where you tip cab drivers to take you to Calumet City. Figure 17 is

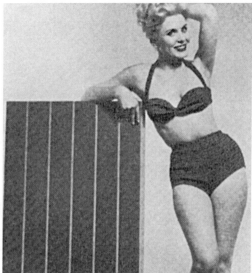

16-17

for readers who are long past caring where cab drivers take them.

Ralph Caplan writes and lectures on design and other adult subjects, and is the author of By Design: Why There Are No Locks on the Bathroom Doors of the Hotel Louis XIV and Other Object Lessons.

Notes

1. I had indeed written the previous month about the use of a woman's voice for a warning system, where psychologists thought its unexpectedness would command attention. This was before women routinely reported on sports, rocket science, the Dow Jones, and computer technology. To be sure, women were already being used as television weather announcers; but no one pretended that they were meteorologists, or understood the cold fronts they threatened us with. The weatherwoman of the fifties was the precursor of the game-show alphabet turner of the eighties, decorative and diversionary.

2. The use of "he" and "his" as the generic pronouns in a magazine about industrial design reflected standard editorial style and the paucity and invisibility of women in the field.

3. Ann Corio was a stripper billed as "the world's most beautiful showgirl." She died in March 1999 at age 87.

4. June Allyson was a movie star. At present, she does television commercials for a brand of adult diapers.

5. The "You Auto Buy Now" campaign was publicly endorsed by President Eisenhower as a national effort to jump-start the economy by getting consumers to perform their patriotic duty by consuming whatever the market offered up.

Section

Animal M

One:

agnetism

Monkey Business in the
Erogenous Zone by Nancy E. Bernard

"The enlightened analysis of one age is often regarded as the self-serving manipulations of ideology by another." Don't you wish you'd said that? Regina Barreca wrote it in her introduction to *Desire and Imagination*, a collection of classic essays on sexuality, many from the 1800s. 'Round about a hundred pages into the book, I took her point. Consider 1990s' received wisdom on human sexuality: Sex is a gift of the creator, not to be misused for purposes of domination, manipulation, material gain, advertising, or design. We have been given our gifts to elevate the taste and perceptivity of the unwashed masses—not to poison them by tickling their more ignoble instincts.

Yeah, right. Ever tried to convince anyone of anything by appealing to his or her higher sensibilities? Using crystalline logic? Pointing out the virtues of selfless commitment? Did it work? I didn't think so. People are motivated by basic emotion—and sex is definitely basic. Advertising designers largely get this. Graphic designers largely don't. Sex works because it's a powerful motivator. In 1954, Abraham Maslow (pronounced "Mazlov") published his theory of the "hierarchy of need." His main point was that our needs are organized by priority. First come the biological needs: survival, food, water, sex, and safety (yes, sex comes before safety in some cases). Next are the psychological needs: affiliation (love, acceptance, belonging) and esteem (achievement, competence, recognition, and approval). At the top of Maslow's hierarchy are self-actualization needs: to create, think, invent, and perform.

Maslow theorized that the lower needs must be met before the higher needs can be addressed. So, if a big rock is bouncing down the hillside at you, you'll toss that buttered potato aside and hoist your lover in front of your face as a shield. Neuroscience has found physical evidence for Maslow's hierarchy in the hypothalamus—a cluster of nerves front and center in all mammalian brains that organizes impulses from the sensing organs, such as hunger, thirst, and libido, and feeds them to the endocrine

system, which regulates simple behaviors. Turns out the hypothalamus, as it happens, prioritizes its messages much as Maslow proposed.

This means that it's not your fault you used your lover to fend off the rock: Your hypothalamus made you do it. Knowing this, the next time you want an audience to give generously to your client's foundation, and you suspect they'll be reading the fund-raiser before their nightly cuddle, toss them a sexual bone. (If you suspect they'll be reading before dinner, toss them a potato.)

In order to find sexual motivators that work for just about everybody, we have to turn to evolutionary psychology—hereafter referred to as EvoPsych. If you were wondering when the monkey was going to show up, here it is: Most of these ideas are based on primate and anthropological studies cribbed from books by Natalie Angiers (biology reporter for the *New York Times* and author of *Woman*), Deborah Blum (science reporter and author of *Sex on the Brain*), Edward T. Hall (*Beyond Culture*, among many others), and Desmond Morris (*The Human Zoo*, ditto).

The first thing EvoPsych teaches us is that primates really like sex. A lot. Much more than other species. Did you know that human males have the largest penises in the primate order? Or that primate females are the only females who are physically—if not emotionally—able to mate any time? Or that primates have more uses for sex than any other mammal? It's all true, and for good reason. We need sex. Without sex, we'd be an unhealthy species of clones. ~~Without sex, therefore, there would be no art, no commerce, and definitely, no graphic design.~~

Of the millions of species on the planet today, hardly any are into self-replication. Early single-celled creatures tried asexual reproduction—earth was a lonely place at the time—but pretty soon mutations arose: The cells needed more genes to choose from. The cleverer ones figured out how to swap their DNA, and sex was born. The purpose of sexual reproduction, then, is genetic diversity. And it's been very successful. At this point, "even broccoli recognizes its own pollen, and won't fertilize with it," as Deborah Blum points out in *Sex on the Brain*.

This has led to some interesting behaviors. Concerned about their future offspring, individuals became picky about whom they'd swap genes with. The instinct for parenting was high on the list of desirable qualities, because committed parents give their spawn the time to grow big brains, which the little ones can use to figure out how to survive when their ecosystem changes—which is pretty much guaranteed to happen. Meanwhile, most parents aren't going to stay together unless you make it worth their while. So sex became very, very pleasurable. Thus, successful reproduction in big-brain species is founded on recreational sex. The rest of the argument goes like this: Mom and Dad stay together, become the family, which becomes the clan, becomes the tribe, becomes the nation, and some of us get to specialize in fancy areas of work. (The old phrase "cradle of civilization" rings with new meaning.)

Because sex is pleasurable, it's also valuable—which makes it a natural medium of communication and exchange. If you're worried about this, let

Desmond Morris, an English zoologist who studies the human species, reassure you: "Man's opportunism knows no bounds, and it is inconceivable that an activity so basic and so deeply rewarding should have escaped diversification." In *The Human Zoo*, Morris describes ten kinds of sex. Most of them—procreation, pair formation, tranquilizing, etc.—are beyond our purview, because though design can inspire the act, it can't provide completion. The sexual functions we *can* examine are exploratory sex, occupational sex, and status sex.

Exploratory sex arises from our natural curiosity, which has super-evolved into a definite need for novelty. Morris says that exploratory sex can actually help to preserve pair-bonds—unless the exploration takes place outside the pair. This is where designers come in. We can provide virtual novelty, satisfy that need, and keep those pairs intact. Since the idea is to satisfy the need to explore and discover, suggestion—sexy shapes in sexy positions—can work better than overt depiction.

Occupational sex "functions as a therapeutic remedy for the negative condition produced by a sterile and monotonous environment," says Morris. So, use sexual imagery any time you suspect your audience may be bored: Photograph Acme Widgets in low light, with colored filters, amid rumpled sheets. Or arrange them in interesting poses. Or paint their apertures red. This may sound silly, but it has been done.

Status sex is the communicator's gold mine. In status sex, the goal is dominance, and the symbolism used, even by females, is masculine. Some monkey males display brightly-colored genitals to signal status and aggression; in other species, females have evolved brightly-colored pseudo-penises for similar use. Both females and inferior males will present their bums when attacked by a dominant male, indicating submission to avoid taking a beating. Morris says: "The actions performed are still sexual actions, but they are no longer sexually motivated." The point is that penis display, and its variants—towers, sports cars, leatherwear, and in-your-face-ing—effectively communicate threat and superiority.

The use of sexual stimuli is especially appropriate in design because sexual excitement, like any strong emotion, burns associated events into the memory. (This is the principle behind smacking schoolboys' hands with a ruler.) The hormone associated with male orgasm, vasopressin, has in fact been proven to enhance memory (as well as to create that cozy, cuddly feeling). Think of the implications for branding and identity . . .

So, what stimuli should you use? Curves are good—for both sexes. Think of all the rounded body parts of the human: We have bigger, higher, rounder buttocks than any other mammal; our calves, biceps, pecs, and deltoids are fuller, rounder, and more clearly defined than any other mammal's. We've chosen, through aesthetic mate selection, to be round. We like round. We like complex, intersecting curves. Use 'em.

Both sexes (contrary to popular wisdom), also like dependable partners. International surveys on mate preference show that the top four attractants—for both men and women—are love, dependability, emotional stability, and a pleasant personality, in that order. With women, fifth place

goes to fiscal solidarity; with men, to looks. Though the media have been telling us that all men want is a young mother and all women want is a fat wallet, sane and steady is actually sexier.

The last item that seems to work across culture and gender is rhythm. Specifically, a rhythm of forty beats a minute. This is the rate at which milk ducts pulse in the nursing breast, babies suckle, and orgasm throbs. It's also the rhythm we use to pat our dogs. I have no idea how print designers will use this—can visual rhythm be organized by time? But interactive people will have no problem: They can cycle sound and animation at forty beats per minute to give users that happy, peaceful glow.

Now let's break it down and look at gender differences. There is one clear biological predictor (estrogen) for one real gender difference (sensitivity). Estrogen, it turns out, intensifies sensory perception. When estrogen peaks, women are much more sensitive than when estrogen dips. So, since we women have so much more estrogen than you men, it's true: You don't have to scream at us to get our attention. On the other hand, we do have to scream at you. Another design-relevant Mars-Venus trope is that men are better than women at reading maps. Depends on what you mean by better. Men read maps using distance and direction, while women connect the landmarks like a string of pearls. True? False? Biologically based? Culturally based? Who cares. Both sexes will be reading any maps you design, so use the compass rose, indicate streets with lines that show connections and directionality, and include major landmarks. Better yet, do user studies. You already know that people think differently; finding out exactly how differently they think is fascinating.

Hoggamous, higgamous,
Man is polygamous.
Higgamous, hoggamous,
Woman monogamous.

According to EvoPsych, this pleasant ditty by William James is absolutely true. The proof is found in chimpanzee behavior—since chimps share roughly 98 percent of our genes, it is assumed they are very similar to us. Chimpanzee males collect lots of mates, use physical intimidation to command their mates' movements, obedience, and fidelity, and will sometimes kill offspring they suspect aren't their own. On the face of it, it seems James has us pegged: Males are naturally polygamous, females monogamous, However, female chimpanzees manage to slip away and get pregnant by outsiders about half the time. This suggests that their need for sexual variety is very, very strong. So, go ahead and appeal to men with promises of new and varied sexual partners—but appeal to women as well.

How about gender attitudes toward explicit sexual material? To find out, the Kinsey Institute showed pictures of nudes, from Botticelli to *Playboy*, to both sexes. Fifty-four percent of men reported becoming aroused, compared to only 12 percent of women. Fine. Angiers, our biology reporter, writes, "Ellen Laan, of the University of Amsterdam, has shown that women's genitals congest robustly when they watch pornography that the women later describe as stupid, trite, and distinctly unerotic."

It seems that raw porno makes most of us—including 46 percent of men—uneasy, though it does work to arouse us.

Design should therefore avoid deploying raw porn. This is fine, because we have the potential to create gentle, cultured porno. Angiers suggests, "In love we seek not just passion, but a balm for passion . . . We want, in love, our mothers, our idealized mothers, our soulful other halves, our children, our haven . . . the extremities of passionate romantic love must be resolved, and dissolved, with true love . . ." Maybe raw, high-attitude, aggressive communications only do half the job—even tough guys need a tender finale.

Here's some monkey science to back up the idea. Barbara Smuts, primatologist and evolutionary biologist, has observed three mate selection strategies in male olive baboons. In the first, males fight off other males to ensure that all their mate's offspring will be their own—a process called mate-guarding. In the second, males spread their seed widely by cultivating their seduction skills and staying alert for signs of female receptivity. The third strategy is to gain steady access to the means of reproduction by bonding with female and young. All three strategies work well in terms of fertilization, but mate-guarding gets tiresome, and, with mate-guarders around, the seduction strategy tends to end in death. Meanwhile, with males competing to bring their sperm to market, females tend to get harassed unless they have a steady guy. All of this suggests that marriage might have grown out of a need for protection on *both* sides. Marriage rituals could be the institutionalization of the need to say, publicly, "touch me and you deal with her." As Angiers says, "If marriage is a social compact, a mutual bid between man and woman to contrive reasonably stable micro-habitat in a community of shrewd and well-armed cohorts, then we can understand why, despite rhetoric to the contrary, men are as eager to marry as women are . . ." And so marriage becomes a safe haven for both sexes. Safe = species survival = sexy.

The protection scenario could explain why some women are attracted to bad boys: If the woman could fix the bad boy up, and reserve his combative expertise to herself, she'd have a helluva protector. However impractical the notion, this is fertile ground for design: In order to say "protect yourself" to females, you could pair the headline "Be Your Own Bad Boy" with an image of a strong woman, whether in leather or business wear. The protection pact also explains the success of communications that either tweak male fears of inadequacy (life insurance: "What will happen to them if something happens to you?"), or exploit male fantasies of heroism (life insurance: "Protect their future with your love").

Another cliché of nineties sexual lore is that women are conditioned by evolution to seek good providers. Trouble is, the bulk of the food in hunter-gatherer tribes is produced by gathering—by women. And when the hunters do return with the goat, they usually distribute the meat to the whole tribe, not just their own families. Further, while the hunters are off hunting, women have only each other to rely on. Therefore, women may have needed the cooperation of other women more than they needed

meat from men. This suggests another device for irresistible female "porno"—promise women that other women will be there for them, in practical solidarity. Hallmark knows this: They figured out years ago that women send greeting cards to women and built their Shoebox product line around messages like "who needs men, we've got chocolate" and "husbands may come and go, but sisters are forever."

Primate evidence aside, gender differences remain problematic. Many studies in infants and toddlers have concluded that boys act remarkably like boys and girls act remarkably like girls because they're biologically programmed to do so. Trouble is, if you show someone a picture of a crying baby and say it's a boy, the viewer will say, "He's angry." Say it's a girl, and the answer is, "She's scared or miserable." Or, if you dress a bunch of toddlers in unisex outfits and have adults watch them toddle, the adults can't guess their gender based on, say, combative behavior (let's face it: we're all self-centered and aggressive until someone else socializes us). The upshot is that the cultures we create also create us.

The granddaddy of cultural studies, Edward T. Hall, defined culture as a set of rules and assumptions about manners, trustworthiness, and the nature of the cosmos. He also demonstrates that culture is "that part of man's behavior which he takes for granted." What this means is that we assume we do things a certain way because that's what people do, or because we simply choose to act that way. But this isn't entirely true. Where animals engage in species-specific mating rituals, humans engage in culture-specific mating rituals. North American culture holds that men and women can control their sexuality, so North Americans don't assign duennas to young women or cloister their wives. They think that Latins, who believe men are unable to resist their urges and women are unable to resist men, are sloppy, and that their rules about keeping the sexes apart are absurd.

Gender roles vary by culture as well. Hall tells us that in Persian (Iranian) culture, ". . . men are expected to show their emotions . . . if they don't, Iranians suspect they are lacking a vital human trait, and are not dependable. Iranian men read poetry; they are sensitive, have well-developed intuition, and in many cases are not expected to be too logical. They are often seen embracing and holding hands. Women, on the other hand, are considered to be coldly practical. They exhibit many of the characteristics we associate with men in the United States."

Great. If our own culture is invisible to us, and the culture of others is opaque, how can we manipulate our audiences? Literature, movies, and songs can help. To understand "what woman wants," consider the ideal males created by female authors. Sure, they're steady, loving, and financially secure. But more than that—see Austen, Wolfe, Atwood—they value the heroine's mind and character. They share in her intellectual, creative, and spiritual life without fear of competition. You want to create irresistible appeals to women? Give your communications the voice of this collaborating, inspiring male partner. Tell us our brains are sexy, and that you want to play with them. This approach was popular in the thirties—

remember the *Thin Man* movies, with the terrific wordplay between Nora and Nick? It was a very successful series.

Hall says, "The artist does not lead cultures and create patterns: He holds up a mirror for society to see things it might not otherwise see." Clearly, human sexual behavior is driven by genetic and cultural codes that operate on us invisibly—beyond the level of consciousness. Biology drives our drives, the cultural environment conditions our actions—and design can condition the environment. Don't fight it. As the research presented in this article proves, sex can be very persuasive. Use it in good health.

Nancy E. Bernard is managing editor for California-based Critique *magazine, having found her life's work after many years as a freelance illustrator in New England.*

Legs, Logos, and Ethology: Just How Graphic Is Graphic Design? by Roy R. Behrens

In the late 1980s, when New York designer Tibor Kalman was writing an advice column called "Dear Tibor" for the *AIGA Journal of Graphic Design*, I was teaching in Cincinnati. I didn't know Tibor but I loved his column, and to feed his sense of humor, I sent him anonymous querulous notes from fictitious admirers like Much Kneaded, Bo Doni, and Gregory Torso. In one of those, I asked if he knew that George Petty, a World War II-era calendar illustrator, would sometimes lengthen models' legs by about 25 percent when he made nude pinup illustrations. "Dear Tibor," my man Torso asked, "So what is this supposed to do? And does it really work?" "How do I know?" the columnist replied, "Some guys get off on girls with long legs. Do Barbie dolls turn you on?"

Petty's long-legged pinup girls flourished during the 1930s and 1940s, while the Barbie doll was premiered by the Mattel Company in 1959. By coincidence, during that same thirty-year span, more or less, related work was going on in a new branch of biology called *ethology*, which studied instinctive responses among animals and humans. The chief proponents of ethology were Konrad Lorenz and Niko Tinbergen, two European zoologists whose research won the Nobel Prize in Medicine and Physiology in 1973.

One of the subjects investigated by ethologists was "cuteness," as seen in the facial proportions of dolls, puppies, stuffed animals, and cartoon characters. Presented with human infants, baby animals, or images that possess some or all of seven features (among them a disproportionately large head, a protruding forehead, big eyes located below the middle of the head, and chubby cheeks), we instinctively respond to the presence of a helpless child. Whether real babies, Beanie Babies, Pekingese lap dogs, a litter of kittens, Bambi, or dime store paintings of tearful waifs, it is believed that such images automatically trigger "parenting behavior," which prompts us to pick up the child, puppy, or kitten, to cuddle it, to stroke it, to coo, and to talk in a silly, high-pitched voice.

Not surprisingly, the same scientists also studied mating behavior, including the preference for "supernormal stimuli," or the tendency to be more responsive toward distorted, overstated shapes than standard, supposedly accurate forms. A certain bird species, for example, was shown to prefer dummy eggs that were four times the size of its own, and a supernormal clutch of five eggs, rather than the customary three. To follow, it was reasoned, human beings (heterosexual males, for example) may also instinctively tend to prefer forms of uncommon size or amount, the typically cited examples of course being silicone breast implants and, more recently, the push-up bra.

Such instincts have evolved, ethologists said, because they contribute to the propagation of a species. In the case of humans, they prompt us to engage in sexual intercourse and, having reproduced, to instinctively cuddle and care for our young.

Recalling George Petty's pinup illustrations, it is evident that not only did he lengthen the legs of his models, but in some cases also enlarged the breasts, reduced the waist, and, as a consequence, emphasized the hips. From the viewpoint of an ethologist, when a heterosexual male gets "turned on" by a Petty calendar girl painting, he is presumably being aroused by dramatized (or supernormal) versions of the same form attributes that characterize a young, sexually mature female.

So what does this have to do with design and sex appeal? The obvious connection is that pinup illustration (whether cheesecake or beefcake; straight or gay) and erotic advertising are part of the province of graphic design, a substantial and increasing part. Like it or not, nearly all the sexually provocative or "graphic" images in our society are produced by people who are employed as illustrators, photographers, advertising artists, or designers: The catalogs and TV commercials for Victoria's Secret. The well-known ads for Calvin Klein. The *Sports Illustrated* swimsuit issue. Other sexually-oriented magazines, books, Web sites, and films. And deceptive, more sinister characters like Joe Camel, whose gonad-equipped proboscis is a dead ringer for a flaccid penis, in what ethologists call "body self-mimicry."

Another connection is more subtle. For many years, I have sensed that sexual enticement is closely analogous to corporate advertising, or, to put it differently, that legs and trademarks are alike in the sense that they serve as a logolike ad—whether corporeal or corporate—for a "body" of opportunities. I recall one of the first times I thought about this. It happened thirty years ago as I was reading Adolf Portmann's book on *Animal Forms and Patterns: A Study of the Appearance of Animals* (New York: Schocken Books, 1967), the subject of which, as the translator states, is "animal Gestalt." On page 154 of that book is a marvelous pen-and-ink drawing by Sabine Bauer of the throat patterns of eight varieties of baby birds. They look like hard-edge paintings by Ellsworth Kelly, George Ortman, or other post-painterly abstractionists, and, were it not for the context, I might never have guessed that they were bird throats. In addition, they are reminiscent of the best trademarks from the same time peri-

od: William Golden's CBS eye, Paul Rand's ABC logo, or John Massey's symbol for Atlantic Richfield. Like classic trademarks, these throat patterns are breathtaking in their simplicity and elegance (they are all brightly colored, and those of some birds that nest in the dark even have luminous nodules, like eerie airport landing lights). They also function like trademarks: When the parent bird returns to the nest from food gathering, the babies beg with open mouths—in Portmann's words, "the beaks of the whole brood gape open towards the feeding parent bird, as opening flowers toward the light." According to ethologists, these abstract, brilliant open throats automatically stimulate feeding behavior in the parents.

Don't misunderstand. I'm not suggesting that a corporate logo can trigger specific behavioral acts in humans like feeding, parenting, or sexual intercourse. But I do believe that we respond unconsciously—all the time—to abstract visual attributes (shapes, sizes, values, colors, textures, and so on), and that a well-designed corporate logo is a compressed essence, an iconic abbreviation that makes us feel instinctively (regardless of whether it's truthful or not) that the firm it symbolizes is "trustworthy," "stable," "enterprising," "receptive," "forward-looking," and so on.

We respond with the same immediacy to sexual imagery, and on the same level. For example, while scanning the newspaper this morning ("Yehudi Menuhin Dead at Age 82"; "Bomb Explodes Outside Abortion Clinic"; "President Thanks Impeachment Defenders"), I was stopped and aroused by a wonderful ad for a spring sale of Hanes hosiery. It consists simply of a cropped photograph of a woman's feet, legs, and thighs. Dressed in hosiery and elegant high-heeled shoes (with stiletto heels and ankle straps), she is seated on the edge of a chair with her long legs extended and her dress swept back to bare her thighs. When I happened upon this image unexpectedly, it was like a vicarious visual affair. I took a deep breath, and returned to it several times to recapture the sexual stir that I felt in seeing it for the first time.

Like many people, perhaps most, I have somewhere a little stash of "naughty pictures." Nearly all of them are mildly but richly erotic. They include a few pinup illustrations; anthologies of erotic art and photography; and an assortment of single, simple images clipped from magazines that rejoice in this or that detail of a woman's softness: long legs, the elegant curve of the small of the back, a woman's hands, the intelligence of her eyes, her smile, the resplendent fullness of her breasts, her hair as it falls on the back of her neck, her stomach, hips, thighs—and, as e. e. cummings said, "her et cetera."

I have always thought art was connected to sex. On the same shelves as my stash, I have hundreds of beautiful volumes about graphic design, modern painting, and the appearance of animals, including butterflies. Among those titles is *The Living Stream* (New York: Harper and Row, 1965), a book about ethology by a British zoologist and artist, Sir Alister Hardy. On page 151, he makes an amazing digressive remark that, to my mind, allows me to traverse the boundaries between legs, logos, and ethology: "I think it likely that there are no finer galleries of abstract art than

the cabinet drawers of the tropical butterfly collector. Each 'work' is a symbol, if I must not say of emotion, then of vivid life. . . . It is often, I believe, the fascination of this abstract color and design, as much as an interest in biology or a love of nature, that allures the ardent lepidopterist . . . he has his favorite genera and dotes upon his different species of *Vanessa* and *Parnassius*, as the modernist does upon his examples of Matisse or Ben Nicholson." As a schoolboy, I delivered the morning newspaper on my bicycle, and I recall that I often went out of my way to peek at a calendar in the lighted window of a local business. It was a pinup calendar, probably by George Petty, with a picture that changed at the end of each month. My dreamlike memory of that calendar was anticipated by Hardy, who concludes: "The one-time schoolboy collector will in later life be transfixed with emotion for a moment at the sight of a Camberwell Beauty or a swallowtail—I speak from experience."

Roy R. Behrens, professor of art (graphic design and design history) at the University of Northern Iowa, is a contributing editor of Print *magazine and editor of* Ballast Quarterly Review.

Growing Up with *Playboy* by Martin C. Pedersen

1964: Sex Ed 101

I first become aware of *Playboy* at the age of ten. I discover it while rifling through my dad's nightstand, where he has the current issue stashed under a pile of Ian Fleming paperbacks. Two weeks later it gets spirited out of the house and devoured by four prepubescent boys camping out in a pup tent in the backyard. It's hard to describe the mixture of excitement and heart-racing shame we experience sneaking furtive peeks at the Naked Women of 1964. The Swingin' Sixties haven't quite kicked in yet, so the women still have that bouffant sheen about them. Part airline stewardess, part astronaut's wife.

Now I don't remember whether I think what we're looking at, with our shaky flashlights, in any way reflects some future reality. But I do remember looking at the party photos, the huge cartoon tits that predated silicone and breast-enhancement by a quarter century, the Playmate of the Year candidates, the "interactive" centerfold, which takes too long to unfold and rarely delivers full-bore nudity, and trying in some way to learn, to commit body parts to memory. So here, so this, so *these*, are what women's bodies are all about? Amazing, bewildering, scary.

1969: Sex Ed 102

The Sexual Revolution is in full swing—somewhere else. At fifteen, I am the über-Virgin. *Playboy* has nevertheless evolved from a piece of contraband smuggled out of the house in a sleeping bag into a racy magazine full of illicit promise that my old man actually allows me to "borrow" on the sly. Instead of the centerfold, though, I much prefer the annual "Sex in the Cinema" series. Here, in all their grainy glory, are the definitive movie stills of my horny adolescence: Ursula Andress, Brigitte Bardot, Jane Fonda in *Barbarella*, and, my personal favorite, Joey Heatherton. These brief flashes of movie nudity, preserved on paper forever, merit second, third, and fourth viewings.

I find I'm as hungry for the information in the magazine as I am for the fleshy pictorials. The *Playboy Advisor*, I soon realize, is infinitely more important to my future well-being than any Playmate of the Month. Still you have to wonder: How does a teenager who's never been out on a date properly process information on the correct way to administer oral sex? It's a bit like reading the training manual for a jet before learning to parallel park.

1974: Cartoon Madness

I am a student and the only magazines I can afford to buy are *Rolling Stone* and *The National Lampoon*. I remain an avid *Playboy* reader, but choose to peruse it standing at a local newsstand. Even in a college town, you can't spend hours reading a magazine you have no intention of buying, and then forty-five minutes into it unfold Miss April. This is not only insulting to management, but sends the wrong message to women, who in witnessing it might think you're engaged in a crash course in female anatomy. So I peek at the centerfold as if looking for a key under the doormat, and devour the articles. Dan Greenburg becomes my patron saint of sexual misadventure. I am continually astounded by the Interview. Famous Men lose their virginity in the most amazing ways! On the steps of a church! In a hammock! On a trampoline! Airborne, in a Cessna two-seater!

As a budding sophisticate, I begin to recognize the cartoons for what they are, a kind of men's club initiation. A literary smoker. One cartoon shows a pair of Wall Street types, attaché cases in hand, observing a pack of naked young people streaking past. "Holy shit, Bob," the caption reads, "And I thought Hancock from Accounting was a redhead!" This is not a brilliant joke, but I laugh at it anyway—out loud, in public. I feel as if I've been clued in to a profound truth: Lust in nearly all forms can actually be *funny*. What a relief.

Sometime in the Early 1980s: Girls of the Ivy League!

I can now afford to buy *Playboy*, but I don't. I don't know anyone anymore who does. Since I live in New York City, I can't read the magazine on the newsstand either, because the nasty Pakistani in my neighborhood has a huge "THIS IS NOT LIBRARY!" sign posted near the racier titles like *Argosy* and *Jugs*. So I . . . skim *Playboy*. Although it no longer serves as a quasi instruction manual, and the past decade and a half has squeezed the naughtiness out of it, I find *Playboy's* cultural presence, in the land of Jerry Falwell and Ed Meese, reassuring.

When *Girls of the Ivy League* appears, provoking howls of protest from knee-jerk feminists, I break down and buy the issue, as a gesture of solidarity. What I find particularly arousing about the photos (if I can confess to being aroused by a bespeckled coed wearing a crimson sweater, her left nipple discreetly exposed, reading *Moby Dick)* is their voyeuristic, anti–art directed ordinariness. These women definitely inhabit "The Realm of the Possible." In fact they look uncannily like women I might date (or try to

date). The photos also provide a partial answer to one of man's most primal questions, one we all immediately ask upon meeting any attractive woman: I wonder what she looks like with her clothes off?

1988: First-Time Subscriber

I receive a subscription card from *Playboy*. A mere twelve bucks a year. I take them up on their generous, circulation-boosting offer and become a first-time subscriber. At thirty-four, I find that the magazine poses a lot more questions than it answers. What's the etiquette with today's woman? Do you leave *Playboy*s out on the coffee table in anticipation of her first overnight stay? Or hide them away in a dresser, under the pile of fraying underwear?

Since when, I wonder, did posing nude for *Playboy* become a career move? An actual strategy designed to ward off has-been status? And why did that still from *Goodbye Columbus*, back in 1969, showing Ali McGraw's incredible butt, excite me so much more than the splashy, multipage treatment now given former seventies sexpot Farrah Fawcett? And the final, most perplexing question of all: Are women's breasts getting bigger? A *lot* bigger? If so, why have I not experienced, up close and personal, this startling trend?

1994: Breast Inflation

Yes, it's true. The *Playboy* Breast (that proud American icon) has indeed grown larger. They are huge, gravity-defying. I look at the mammoth breasts sported by Miss June, Miss July, Miss August, and think: These are not naturally occurring phenomena. In my mind, "Tiffany"—born in 1976 (yikes!), whose career goal is to "own and operate a chain of preschools," and whose turn-offs include "rude people" and "hairy backs"—is like the NFL lineman who weighs 320 pounds but doesn't have an ounce of fat on him. As beautiful and eye-catching as Tiffany is, I think, this just cannot be done without help from the medical community. So I begin to question *every* larger-than-life boob I see in *Playboy*. I look for girl-next-door solace where I always have, but they've covered every athletic conference in the country at least twice, so "Girls of the Big Sky Conference" feels a bit tired. And I can rent most of the movies in "Sex in the Cinema" and replay the nude scenes, frame by frame (or just rent a porno video).

I am forty years old—roughly the same age as my father when I first discovered his copy of *Playboy*. The last time I saw a woman's breast, other than my wife's, was two years ago at a beach. This is traditionally where *Playboy* should reenter the picture, to step into the Walter Mitty–like void of early middle age, but I pass on the Pamela Anderson Lee pictorial and flip through my wife's Victoria's Secret catalog instead.

1999: Heff and Me at the Millennium

I am now the father of not one, but two very young children. As far removed from lusty bachelorhood as that ten-year-old in the pup tent.

When I pick up a copy of the magazine now, at the age of forty-five, I notice something curious. *Playboy* is almost hip again. How the hell did *that* happen? Hugh Hefner, as a symbol of retro-hedonism, is ascendant. Young men have embraced him as the embodiment of fifties-style, martini-shaker cool. A kind of Rat Packer Emeritus. Now exactly the same age as my dad, a swinging and vital (and tucked) seventy-three, Heff is out of his legendary pajamas and seen in public with what his press agent calls "constant companions, Brande, Sandy and Mandy." Three blond, beautiful, buxom babes with rhyming names, and a combined age of under seventy. How cool is that? If you're twenty-five years old, it's practically off the charts.

The *Playboy* Mansion is again the scene of allegedly wild parties. Meanwhile, in what could be a watershed moment for the future of the twenty-first-century American Breast, Pamela Anderson Lee reportedly undergoes *breast reduction* surgery. (An event that future historians will surely mark as the unofficial end of the 1990s.) One night watching the evening news, I see a promo for *Entertainment Tonight*. A raucous Hollywood event is in progress. "Coming up on ET," says the hyperventilating announcer, "Hugh Hefner . . . Wild parties! Three women! *Viagra!*" I laugh, continue feeding my six-month-old son, Alex, and think: Go, Heff, go!

Martin C. Pedersen is a writer and executive editor at Metropolis *magazine. His short stories and essays have appeared in* New York *magazine, the* Nation, New York Newsday, Intro *magazine, and other publications.*

Section
Sex as M

Two:

etaphor

Perfection by Natalia Ilyin

I used to work with a commercial printer who routinely pulled a press sheet, threw it up on the light table, and said one of two things. Either he bent low over the linen tester and muttered, "Sexy . . .sexy" over and over again until I thought I would die of the banality, or, if things were not going well, he raged, "What an abortion!" to anyone within earshot.

Since I was his assistant, I was generally the one who got to hear what an abortion the whole thing was turning out to be. He had the Playmate of the Year calendar stuck to the control panel of his Heidelberg. Needless to say, I hated the guy.

Now, as I think about sex and eroticism in graphic design, this printer's twin comments come back to me. Not because he was intentionally saying something about sex or eroticism—far from it—but because his choice of words was a reflection of something more in graphic design, something all over the profession from top to bottom, from the get-go, from the Bauhaus on.

Sex and design, "sexy design," sex as portrayed by designers, and, I'm sure, a certain amount of what passes for sex between designers, all have one thing in common: a search for perfection. A search for the perfect typestyle, the perfect substrate, the perfect balance of elements, the perfect "imperfection" of a texture or a ragged edge. We are forever searching for the perfect photograph of the perfect woman or the perfect man, the perfect shrub or the perfect hand, the perfect SUV atop the perfect pinnacle. We long for perfect cherry cabinets above our perfect soapstone sink. We want perfect children, perfect gardens, perfect résumés, perfect friends. We must have a dog that is the perfect dog. We believe that all our many photogenic lovers should be perfect in thought and deed. Anything else is aborted.

The portrayal of sex itself in design and advertising and television is about perfection: It is the pursuit of the perfect. Sex in graphic design is male sex: the sex of car fenders, tall buildings, the grid: It is the sex of modernism, the sex of order, hierarchy, and control. Photoshop is the tool

of our search for the perfect, the tool of our mythically male side, the side of the mind that wants to stretch the Cosmo girl so that she is just a little bit more, well, perfect. A little bit more Mondrian, a little less Kandinsky.

Our search for the perfect is fired and fueled by our participation in an economy built on dissatisfaction. We designers participate in this wheel of dissatisfaction, making fresh new brochures and logos and Web sites and visible everythings that excite the eye with the promise of the new—with the promise of a final gluttonous fulfillment—if we just buy enough new things, pretty things, perfect things.

The word "consumer" means "eater." Dante, in his vision of Hell, describes the Inferno as a place where hunger, in all its forms, overcame all other human needs or tendencies, and was never satiated, never gratified. Our search for the perfect, and graphic design's juggernautlike need for the new and the perfect, push the American consciousness further into Dante's Inferno. We create need where there is no need, and we helped create the current malaise, a dissatisfaction with the imperfect, with the average, the normal, and the sane.

Luckily, Dante wasn't all hunger, and at the end of his trilogy, he describes his vision of Heaven as a place where hunger and desire are in permanent harmony with each other; he sees the resolution of hunger and desire as twin spheres that spin around each other for all eternity.

What is desire if it is not coupled with sex? If it is not a search for perfection? Well. Hunger is the need to eat something, to take it into your body, to destroy it, and to eventually get rid of it. But desire is the need to be a part of something else. It is the longing for dissolution in the other. It is the need that sends us outward, searching to be a part of a community, a business, a family.

Sex is about finding a suitable fellow procreator, and as such, the sexual drive is the drive toward genetic perfection. But eroticism is the drive toward creating desire. There is a big difference between sex and eroticism. It is the difference between the mythically male desire to individuate and the mythically female desire to include.

Graphic design was dreamed up by individuators. Commercialism and consumerism rest on the individual's desire to get ahead of the pack, get the best-looking mate on the block, have the 330-count pima cotton sheets. We all want to be better, strive alone, shoot the largest lion. And yet, there's that other side of us, the mythically female side, that is not represented by perfection, that does not measure up, get the best grades, wear a bikini on the front of the *Sports Illustrated* Swimsuit Issue, or think hierarchically. This side is not represented in the graphic design of our—or any—era. It is not the side chosen for the photo shoot. It is not the side that fits into the box, into the grid, of Modernism.

In the early seventies, as a freshman in high school, I took sex ed. We all did. It was the equivalent of driver's ed. The administration figured that you were bound to be out on the road anyway, so you might as well know how to use a stick shift. Mr. Schultz, the football coach, told us the

logistics. He drew energetic circles and arrows on the blackboard as if calling a play. I'm sure the circles and arrows spared me confusion in later life. But what I remember particularly about sex ed—why I remember sex ed at all, actually, and why I am mentioning it to you—is that it was the first time I saw this split in action, this split between the mythically male and the mythically female, the sexual and the erotic, in our culture. I learned about it from sitting between Pam and another girl whose name I don't remember. The girl who was so hard to look at, yet was so beautiful.

Sex ed codified sex for me. Before that time, I heard the distant thrumming of a Porsche engine coming down Lucas Valley Road in the silent summer night, and heard that engine as erotic, erotic like the purr of a cat, the crash of the tide. Before the circles and arrows and charts and graphs, I smelled the night smells of sun-baked California hillgrass and bay laurel and live oak and eucalyptus, and thought the trees' swaying and the night stars were sexual, were erotic. There was no split for me. I grew up with that night wind and those purring engines and those silent nights, and I knew I was no less a part of the pulse of the world than they were, that sex and eroticism were inextricably linked.

But after sitting between Pam and that other girl, I started to see things differently. I remember Pam's name because Pam became Miss California a few years later. This came as a shock to those of us who had known her in sex ed. She was quiet, nice, bland. Not a fireball of charisma. But suddenly Pam's face was everywhere. And it turned out her facial features were not actually bland, but regular, photogenic, perfect. Pam was sexy; she taught herself how to fit in with that mythically male search for perfection. She started with good cheekbones, and ended with a red corvette, a rhinestone crown, three sequined beauty-pageant evening dresses, and a nice scholarship to the college of her choice. Pam taught herself how to be a commodity: how to satisfy our culture's hunger for the perfect. We all—men and women—teach ourselves how to do that.

But that other girl in sex ed—I don't remember her name because she could never have been Miss California—could never have been considered perfect. The first time I saw her, I turned away. Hers was a serene, oval face, a lovely face, something out of a Georges de la Tour. But a fine white scar started high on her left temple, ran lightly across her eyelid, over the bridge of her nose, down her right cheek to her jawline. She had been in a car wreck. That scar spoke of experience. It ruined the perfect oval; it looked like a crack in an egg. It gave that girl a great beauty, a beauty beyond her years. And strangely, it was erotic.

There in sex ed, sitting between Pam and that other girl, I thought for the first time that the beauty of a woman might lie in her imperfection. That personhood lies in experience, not perfection. That girl's face symbolized the ruin of virginity, the punctured egg, the corruption that is the hallmark of female sexual maturity. And, in a larger sense, her face was a symbol for the soul broken open by the pain of being human, of being imperfect. She was the embodiment of imperfection, of the brokenness that ensures continuance. She was like the book Jan Van Toorn designed so long

ago that required that you destroy the cover in order to get to the contents.

They come together, perfection and imperfection. The celebrated "perfect woman" of the Swimsuit Issue satisfies one side of our minds; that California night wind and the beauty of imperfection satisfies the other. One is sexual, the other erotic. Graphic design celebrates one, but leaves the other unchronicled.

Natalia Ilyin is the author of Blonde Like Me, *recently published by Simon and Schuster.*

The Inevitable Sexuality of Competence by Deb Margolin

I lied my way into the type business. I was twenty-six, lubricating constantly, completely tangled up in the theater, acting, writing, learning a life. I was broke. There was an ad:

Proofreaders. Typesetters. Experienced Only. Top shop, good money.

Well, you put "shop" and "money" in the same paragraph, and you were destined to see my pert, destitute young butt come up for an application. I'm a natural for proofreading: a Virgo, a reader, a writer, a perfectionist, a person who memorizes poems in order to eat them. But I had to lie: This was a whole trade. They gave me a test. There was an odd kind of ruler that said "PICAS" on it, and I thought that was a kind of coffee or tea. They gave me some odd paper and called it film, and told me to read it for spelling and "specs." Someone came in and asked me if I had checked the density, and I said, "Oh yes, I certainly have, and it's fine! The density is lovely, it's perfectly lovely!"

The type business was where I learned about sex, about the inevitable sexuality of competence. I was, in a certain sense, a virgin until I set type. Type is all about shapes and spaces, about tending to the shape and grace of people's words and numbers; it's a meditation on the synonymous nature of shape and meaning—like sex. Letters are like dancers, like actors. They work in ensemble to create meaning, standing in different forms, different orders, moving against infinite chaotic tropes, millions of years of groaning and hieroglyphs, toward orderly, sinuous language. Type. The sexiness, the devastating beauty, of letters. People would order their type the way they'd order an escort. Think of it: paying for words, the way you want them; what's said is what you want said, exactly the way you want it, the way you want to see it. Order flimsy or lacy or slouchy; demand whisper-light or dominating bold. Describe the curves you want to see, the shapes you want suggested. Choose the words. If they don't move you, change them on a dime. You pay for them, you get what you want. "TNT" meant Tight/Not Touching; "T/T" meant Tight and

Touching; "Stet" next to type meant Leave Me Alone.

In the obsessive-compulsive laboratory of the type shop, I wasn't the only person bothered by the way two numeral *1*s sit so far apart, or the final *V* and *A* in the word "VULVA" have that devastating, endless, oblique vaginal corridor separating them. Kerning, it's called. Certain pairs of letters need to be mated better, closed up; they seem too far away from each other; their isolation makes a word seem wrong, neglected.

I could barely zip a zipper and yet I became the systems manager for this major computer and typesetting system dedicated to the printed word. I was the queen of this kabalistic kingdom, where symbols were everything. I learned what density was: the crispness, the thickness of the type, the color of the print, its level of darkness, its integrity. I went from night proofreader to day proofreader to typesetter to night typesetter to night foreman to systems manager in the obnoxious, dizzying sweep of a single year's time. Although I had no mechanical ability, I was so in love with the printed word that I forced the system to work, faith-healed it when it failed me, changed its hard-disk drive with my bare hands in the middle of the night like a thoracic surgeon massaging a heart on Christmas Eve. My competence itself was a powerful pheromone, and I always got what I wanted at the type shop. And sometimes, what I wanted was lucky enough to get me.

It was a beautiful community. Everyone just ended up there. No one studied to be a typesetter or a proofreader. It was an accident, a shipwreck, a catastrophic professional Gilligan's Island, a lucrative coincidence. You had to be smart to do it, and it paid top dollar. Good artisans made $25 an hour in a $4-minimum-wage world. As a result, the shop attracted all kinds of drunk dreamers, transient studs on motorcycles, revenants, actors, loose women, fast risers: Jim Morrison's ex-wife; Duayne, the cocaine-addicted mathematics genius; Roxanne, the one with the habit who French-kissed all the women just to say hello; Jay, who answered our ad for a typesetter and came to his interview naked from the waist up (hired instantly and thereafter became an only occasional pants-wearer); Henry, a foul-mouthed jazz pianist with a heart transplant; Famm, the deaf gay poet who read lips and kept hoping for a menage à trois with me and the elevator repair man; the owner's son, hanging around, mumbling, and groping you when you walked past; and Gwendolyn, a typesetter who threw up all the time for no reason and got pregnant by the man responsible for the computer system that synchronizes traffic lights on all the New York City avenues.

Once you were in the type business it was hard to get out. It had a gravity; it held you. Anything could happen and you would not be fazed. You could walk into the darkroom and interrupt someone cutting cocaine or giving head on the Typositor plate, then answer the phone with complete equanimity and aplomb. I could do anything with type, anything. A client asked me to set an advertisement in a certain typeface going from the smallest possible point size up in 1/4-step increments, line by line, to create two different shapes: Galveston, Texas, and a naked woman. I

worked odd hours, any hours, all night, all day and night. A lonely, crazy man couldn't remember the name of a typeface, called me at two in the morning, and made me figure out which one he meant by describing the lowercase *r*, the peculiar shape and bevel of the curved piece that hung off the vertical line "like the paw of a begging dog; like a penis right after orgasm." (It was Perpetua. Natch.)

Lucien. Lucien was a typesetter on my shift. He was about my age, he had a son about my age, and he was constantly high. I don't know what drugs he worked with, but he was smooth as butter and he smiled all the time, a profound, genuine smile. I was the foreman on the shift. It was graveyard, twelve to eight; it was all-night radio and cigarettes, a combination of high pressure and darkness and silence.

Lucien. He was always a tiny bit late. Late people are always late by the same amount; with L it was about six minutes. He would slide in, mumble something smiling, then start setting up for the evening. It was a big process. L was a speed typist with excellent accuracy who could only work when he had eight things going on at once. He had a miniature television and a walkman. He would turn on the TV, hook up his headphones, and pop in an Aretha Franklin tape. He'd call a woman on the phone and crank up his monitor, moving one earphone away from his ear to accommodate the telephone receiver. He'd start setting type. Aretha, *Gunsmoke*, a woman's voice, the type specs, the text, the movement of his fingers on the keyboard, his eyes on the line, and me. I always had his eye. I was always one of his pieces of eight.

He mumbled, I remember that. He was inaudible, and he spoke in a slangy, sexy, encoded way, but you always knew what he meant. I went home one morning and was awakened by his voice, murmuring into my machine: "Hi, beautiful . . . number three burnt down . . . smokin' . . . I repeat: number three burnt down . . . smokin' . . ." I knew that meant terminal three had had a short in a wire and wasn't functioning, but it said something else to me as well. It said: God baby, Oh god every day you walk in here, I think: If I don't have this woman soon then heaven won't be good enough for me when I die . . .

See, we worked with our hands, that was the problem. Our competence abided in our hands. Hands are prehensile genitalia. Hands are sex objects made visible, be-ringed, quotidian, functional, external, wildly suggestive. This was a man with flying fingers. This was a man who could do eight things at once. Ninety words a minute. Music and talk and text and type. This was a man who could do me.

We worked together one Sunday. On weekends, the dingy type shop was like a hotel. Sunlight came in the windows differently. The phone was silent, like we were in an ICU. The mood was odd, italicized, in the absence of the jangles and serifs of weekly commerce. I couldn't hear a word he said all morning. Church day, double overtime. There was a huge project due, and it was just him and me. We worked silently, and I remember feeling terror, and that full feeling, dangerous, like having had too much to drink. Hours passed, two or three. I took a canful of film into the darkroom. The darkroom was gorgeous, curtained in black. There was

a certain kind of light in there, red light, like in the windows of whores in Amsterdam, a kind that wouldn't expose film, a kind that exposed other things; a dark, dreamlike, arousing light, half water, half sloe. The galley processor was a huge machine, almost like a booth, a confessional; film placed like a sin on the dark side, washed through a judgment of lye into legibility, emerging lucid, readable, fluent on the other side, in the light. I turned on the monster, placed the film on the shelf, pulled it out a little way, lifted the lid of the developer, pulled the film a bit further—all things I knew how to do in the dark, had known, would always know. The developer caught the film and pulled it on its own, and it flowed like silk, hissing under the tips of my fingers. I shut the lid, turned, moved the black curtain, and he was there, waiting.

Deb Margolin is a playwright and performance artist who is currently on the faculty of Yale University's Theatre Studies Program. A book of her plays and monologues, entitled Of All the Nerve: Deb Margolin SLO, *was published in 1999 by Continuum Press in New York.*

Drugstore Travelogue

by Tobias Frere-Jones

A comedienne, whose name escapes me, once remarked that a male gyne-cologist is like an auto mechanic who's never owned a car. Some things in the world are entirely foreign to me, like right turns on red and alternate side of the street parking. Bereft of a driver's license, I find traffic laws mysterious and strange. Similarly, the ins and outs of cosmetics are unknown to me. Years back, though, I was asked to develop logotypes for a line of faux fingernails, a perfume, and an entire line of hair care prod-ucts. That I was more likely to get a parking ticket than to actually *use* any of these products didn't seem to bother the client. Naturally, the briefs involved making the logo look "feminine" in some fashion. Problem is, I don't know feminine from fuel injection. Still, I had a paying client on the line and a job to deliver. How, with just a handful of letterforms in black and white, does one produce a feminine air?

An abstract problem to be sure, which calls for similarly abstract head-scratching. Type designers rarely see their work as a collection of drawings that happen to land next to each other. Instead, any typeface begins as an attitude, a sensibility, or an abstract aesthetic. Those little marks on the page are that attitude made flesh. The real design is not in the curve of an *S* or the flip of a question mark, but in the idea that generates them. Any specific effect, then, starts there.

Staring at a blank screen long after I should have gone home, I ran through the structural possibilities for one of these logos. From the outset, the client had forbidden scripts as obvious and hackneyed. Grudgingly, I had to agree. But what else is there to use? What other dials can I turn? Weight . . . Heavy? No, fat is generally a bad idea. It should be light (dressmakers' creative sizing scales come to mind). Width . . . Condensed could have some connotation of slender . . . That could be a good thing. But squeezing the widths would probably make the curves all boxy and square . . . Not sure about that. A generous width would let the curves fill out. Serifs? No idea. Contrast . . . This seems clear enough. The

undulation of curves and variance of weights between thicks and thins can carry the implication of delicacy or voluptuousness, whereas the low contrast of a typewriter would not.

Some days later, I had a sans serif on screen, its weight gently bending this way and that over a luxuriant frame. But was this insulting? It seemed right enough to me, but I'm not part of the audience. With no manual to consult and certainly no experience to manifest, I could only study things that I had never thought to notice. I had to play anthropologist, observing with prescribed distance the language directed at the opposite sex. But would I just repeat other logo designers' stereotypes? Clichés or not, they exert some influence. They create a code. This typographic code may be commonly recognized, but it is never defined in isolation. Here was the heart of the task: to find the threshold at which a neutral form begins to resonate at a feminine frequency.

I could keep dabbling in such disembodied ideas, or I could test them in the field to know their accuracy. Wearing my best poker face, I went down to the local drugstore, where all of this would ultimately appear. Shuffling past the salves and panaceas, I went looking for any significant typographic trend. I needed to know the conventions here before deciding whether to follow them. Notes I took on a return visit to the makeup aisle chart the use of different typographic structures in the display racks:

Almay	High-contrast sans: 100% High-contrast serif: 0%	Low-contrast sans: 0% Low-contrast serif: 0%
L'Oreal	High-contrast sans: 95% High-contrast serif: 0%	Low-contrast sans: 5% Low-contrast serif: 0%
Revlon	High-contrast sans: 35% High-contrast serif: 10%	Low-contrast sans: 45% Low-contrast serif: 10%
Cover Girl	High-contrast sans: 95% High-contrast serif: 0%	Low-contrast sans: 5% Low-contrast serif: 0%
Maybelline	High-contrast sans: 15% High-contrast serif: 0%	Low-contrast sans: 80% Low-contrast serif: 5%

A pattern emerges here. First, a high-contrast sans appears a popular choice. Surprisingly, Optima is chosen without exception. Second, price point and contrast seem to run parallel, from Almay down to Maybelline. Third, there's a reason that the Revlon display gave me a headache.

Even before visiting the drugstore, I was following the prevailing patterns. Had I unknowingly absorbed their conventions, or had I just arrived at the same conclusion independently? Whatever the case, the logo I had drawn was a high-contrast sans that easily could have been Optima. Why

is it so common? What nerve does this typeface strike? A full two-thirds of the makeup racks are outfitted in it, regardless of manufacturer. Why would cosmetics companies, who depend so much on distinguishing themselves from the competition, all rely on the same design? What kind of identity is that? Did this start with a bunch of designers parroting the same logo? What informed them? I can chart the where and how of type selection, but not the why. What is so feminine about Optima?

Here, it seems, is the real question: Is a typeface used because it has some intrinsic "feel", or does that "feel" come from where it's been seen before? Looking at type and gender does use drive association, or is it the other way around? In true chicken-and-egg form, I suspect both and neither. How did any of this start in the first place? Hermann Zapf was hardly thinking of mascaras and nail polishes. For better or worse, his design calls up just the right image.

It seems strange to design by statistics, or by reverse-engineering the focus groups and demographic charts of big ad agencies. Nonetheless, any designer in this arena must acknowledge their predominance. It may be cynical, or just realpolitik, to say that market research should accompany a designer's training and ability. It may just be common sense to pace the aisles of the local drugstore, jotting down notes and getting sideways glances from store security.

Tobias Frere-Jones was born in 1970 in New York. He graduated from Rhode Island School of Design in 1992 and began full-time work for Font Bureau as a senior designer. In 1999 he began work with Jonathan Hoefler in New York. He teaches a type-design course with Matthew Carter at Yale School of Design.

(i) The Erotics of Type by Max Bruinsma

From the simple figure "69" to elaborate tongue-in-cheek exercises like Michael Worthington's Dominatrix typeface, typographers and type designers as well as readers (and censors) have used letters and ciphers to suggest "prurient" content. Throughout the history of typography, the "abstract" medium of type has been employed to evoke eroticism, not by merely using the obvious words, but by using the letterforms: copulating letters, erotic ligatures, and the dot.

A simple way to describe how type can be erotic, or, if you want, pornographic, was demonstrated to me by typographer Chris Vermaas: "This," he said, typing some characters at my keyboard, "is the most concise manner to depict the female sex—only three strokes!" I had to admit that his typographic drawing was quite accurate, and wondered how one could be so explicit with such limited means. Was it my own dirty mind, or perhaps a congenial aspect of all pornographic imagination that it needs only the slightest outline to conjure up the most detailed picture?

In more puritanical times (and still today in some demure cultures), this same mechanism of imaginative crystallization has been used the other way around, to censor from the written, public, imagination what cannot be kept from the mind's p....e eye. The most sophisticated use of this typographic device, these priggish but all too telling dots, is hidden in a nineteenth-century German novel in which an officer—no gentleman, alas—admits his burning desire to a lady who cannot bear to hear this and thus faints, upon which he " . " This single dot, separated from the rest of the story by two spaces, tells of the unmentionable. For those who haven't read the signs, it becomes clear in the subsequent chapters of the book that the lady was "taken advantage of" during this unfathomable moment, and, tragically, has become pregnant because of it.

Goethe, in his epos about Doctor Faustus's longing for forbidden knowledge, uses similar means to both escape the censor and tickle the imagination and poetic proficiency of his readership when he changes

words for dashes. In these sentences, for instance, the devil shares some of his most impudent musings with an old woman:

Einst hatt" ich einen wüsten Traum;
Da sah ich einen gespaltnen Baum,
Der hatt" ein——— –;
So—es war, gefiel mir's doch.

V

The rhyme—and of course the context—suggests that the missing last word in the third sentence is *Loch,* "hole," and a contemporary of Goethe would probably not have had too much trouble in finding the rest. Such accentuations give another meaning to the word "typographic." Indeed, ever since the invention of print, typography has been perversely used as a means to graphically depict what could not be written.

It is not only by the most abstract of signs, dots, and dashes that writers, typographers, and censors have tickled their own and their readers' imaginations. In the history of type, it seems, there remains an incessant longing for the pictorial. Far from forgetting that letters once were pictograms, typographers have always sought to compensate the letter's growing level of abstraction with ever more vivid pictorial renderings of the alphabet, foremost of which is the anthropomorphic alphabet.

From Peter Flötner's alphabet of the 1530s to Anthon Beeke's photographic version of the 1970s, engravers and typographers have seen human bodies in letterforms. Flötner's all-caps "human alphabet" has been widely copied, more or less explicitly. A German advocate of the Italian Renaissance, Flötner seems to have had no trouble with depicting classically nude figures in sometimes rather confrontational poses, as in the *V,* or *M,* both of which depict a man lying on his back with his bottom toward the reader, his legs spread wide in the manner consistent with the letters. Only in some later versions does the man wear briefs. Apart from the mere fact that the engraver uses nude human figures, the erotic content of these anthropomorphic alphabets is initially marginal: Flötner's *A* is made of two women kissing and holding each other's arms, while the closest intergender contact is his letter *H,* in which a man and a woman hold hands. In both cases the arms constitute the horizontal bar of the letter. An Italian version of the human *A* a century later (and not necessarily connected to Flötner), from Giovanni Batista Bracelli's *Alfabeto figurato* of 1632, shows the letter as a man mounted by a woman—perhaps a typographic play on a Latin lover's deepest fear, to be taken for a ride . . .

One of the most elaborate "human alphabets," in terms of its formal quality, is Anthon Beeke's, published by de Jong & Co. printers in their experimental Kwadraat series in 1970. His capitals, built entirely out of carefully choreographed ensembles of nude girls (no less than twelve for the *M* and the *W*), are a tongue-in-cheek reaction to Wim Crouwel's experimental "new alphabet," published in the same series in 1967. Piquant as it may be, Beeke's alphabet is also a meticulous reconstruction of the formal outlines of classic Roman capitals, including thicks and

thins and serifs. Although, as a programmatic counterpoint to the conceived mechanical coolness of Crouwel's protodigital exercise, Beeke certainly wanted to celebrate the sensual aspect of classical letters with their subtle curves and roundings and their perfect proportions, his nude alphabet is not explicitly erotic.

But since the association between letters and the human figure, or a combination of figures, has been made, it doesn't come as a surprise that these configurations have also been used to depict the most obscene poses, especially in our sexually revolutionized times. Joseph Apoux, a French genre painter of the 1880s, is an early and, in terms of drawing technique, quite sophisticated example. His alphabet of decorated capitals is as cheerfully prurient as it is blasphemic: The *C* is formed by a nun administering a blow job to a hooded old monk who is toting a whip. Letters like these were of course "anathema," banned by the church, and lived "under the counters" of shadowy places, known only to the connoisseurs.

It took the 1960s and the sexual revolution to bring such pictorial plays with letters and words out into the open. A 1965 Parisian announcement

ABCDEFGHIJKLM

for a salacious revue demonstrated a defiance of any censorship, clerical or other, by using the word "anatheme" as the show's title and rendering it as an acrobatic mound of caricaturesque figures in lewd poses. By the early 1970s, such typo-graphic exercises were abundantly adorning the pages of the growing erotic press and the classified ad sections of liberal magazines. The virtual acrobatics needed to bend human figures into the shapes of such letterforms was matched by the 1970s' intense interest in erotic positions. These, in turn, became schematized almost to the point of typographic abstraction in a then popular sticker that incited people to "make love, not war."

The rigid structure of the letterform apparently offers an intriguing mold for the most impossible postures. Here, single letterforms are used as pretext for a highly improbable—and impractical—form of imaginative erotic gymnastics that in the world of literature probably finds its match only in the works of the Marquis de Sade. Fritz Janschka, an Austrian artist affiliated with the Vienna School of Fantastic Realism, devised some extremely fanciful conglomerations of figures engaged in all kinds of sexual intercourse, while at the same time managing to carefully follow the outlines of the classic Roman capital, serifs and all. His initials, executed in the best etching and aquatint technique, were made to accompany quotations from James Joyce's *Ulysses*, subtly associating on Joyce's hero Bloom's ambulant musings in "the most trivial of pornographic manners," as Joseph Kiermeier-Debre and Fritz Franz Vogel remark in their splendid book on *die Bildwelt der Buchstaben* (the world of images in letters), to which I owe many of the examples mentioned here. Another example of a

truly pornographic use of letterforms can be found in a rare dedicational drawing by Salvador Dalí, in which he "writes" the names of his friends Paul Eduard and Eduard's wife (and Dalí's lover), Gala, in an all-revealing script of obscene poses.

But type's erotic caprices are not exhausted with human figures as letters. Nor do they have to be as subtly typographic as the one Chris Vermaas demonstrated to me. Roland Topor, for instance, finds an even more epigrammatic, though less detailed, way to depict the female sex, by using an inverted *A* at the designated spot in his 1975 drawing of a woman reading a "love letter." Her face is an *A* too, and the letter reads "ah!" The simple, though somewhat contorted, drawing suggests that mind and underbelly mirror each other, at least when the right words are used. Such play with the different meanings of the word "letter" is extended in typographies of other words that enhance certain aspects of their meaning. What to think, for instance, of the logo for an Italian gay magazine of the 1970s, *Homo*, in which the title is typographed as a well-hung *H?* In this way, the typographer can limit the field of association of cer-

tain words instead of broadening it with typographic means. Thus, a word like "obsession" becomes rather focused when Robert Brownjohn writes it on a woman's bare chest, using her nipples for the *o*s. And Max Kisman's interpretation of the opening in a violin's body leaves little room for contemplating the auditory associations of the sign. Rather, it is an allusion to the *violon d'Ingres* and to Man Ray's interpretation of that term: a photo of a nude woman, kneeling, with the two mirroring *f*s painted on the small of her back. And, of course, it's the first letter of that four-letter word.

With all these more or less pictorial interpretations of type associated with eroticism, a question remains: Can type be inherently erotic? In a most general sense, typographers often admit to being in one way or another aroused by the beauty of details and proportions of perfectly decent letters: the slim waist of a Garamond *a*, the voluptuous curves of a Baskerville *g*, or the buxom firmness of a Gill Sans *a*. Slovak typographer Peter Bilak is somewhat more explicit when he states that his The Case Mix has a peculiar erotic feel in its merging letters, with their fluent forms—a liquid quality that can indeed be interpreted in sensual ways.

More openly erotic is Michael Worthington's typeface Dominatrix, a font that is obviously inspired by the BDSM-scene's predilection for Blackletter type. Here, it is not so much the explicit eroticism of the typeface itself, but the suggestive context to which Worthington makes a cheerfully kinky reference in the presentation sheet for his font. For decades, those who seek the bizarre *in eroticis* have appropriated Blackletter and associated typefaces. Although the association of the letter family's character with power, dominance, and aggression is, for obvious

reasons, historically rather problematic, it is used to great effect in any design that aims at suggesting an eerie flavor of dangerous sex. The inspiration for Worthington's Dominatrix comes from such bizarre titles as *Demona*, a 1970s Milanese horror-sex magazine, and affiliated publications, one of which used a kind of Blackletter in combination with a half-naked girl in a noose, and the rather discomforting catchline: "If you don't buy this magazine, we'll hang this girl."

With this kind of politically quite incorrect visual and verbal language, we're back at the provocative side of eroticism, that *épater le bourgeois* aspect that seemed to have vanished from civil discourse ever since the mid-1970s. Provocative is Barry Deck's Canicopulous, a quite disrespectful version of Gill Sans, made after Deck read that Gill fooled around with dogs. The font consists of, in Erik van Blokland's words, "letters that try to stick things into each other." Another typographic provocation—in this case a social critique as well—is Worthington's Viagra font, which can't be set in any size smaller than seventy-two points. In these and similar cases, the erotic content of the typeface is highly contingent on the associations triggered by the fonts' names—as with most erotic content, the substance of the message is realized primarily in the mind of the beholder. When sharpened by context, or sheer lust, innocent little details can become highly titillating. Ligatures, for instance. A normal f-l or f-f ligature, in a classic Roman typeface, already has a definite sensual quality in its subtle merging of lines. It becomes almost obscene—as with any exaggeration—in Emigre's all-ligature font Mrs Eaves Just Ligatures, especially with the italics. The *t* and *y* are still dancing, holding hands and drifting along with the music; the *g* and *y* are definitively on the verge of serious intercourse; and with *i* and *t* "it" happens

With the advent of movement in computer-based typography, these kind of playfully erotic associations—whether intended or not—can be made more explicit. In Luc(as) de Groot's 1994 series of typo-erotic animations called MoveMeMM, plain sans-serif capitals morph into highly pornographic images. The simplest is the *Q*, in which the tiny protuberance starts to move in a rather indecent manner. The *W* is mainly cute, demonstrating that the letter is actually made up, not of two *V*s, but of two *W*s in love. The *A* morphs into an extremely sexualized summary of female details; the *P* jerks off; and the *L* grows into a full-blown phallus.

Such bizarreries, as de Groot seems to acknowledge in his rendering of the *L*, the first letter of his own name, are the typographic variant of the famous portrait of Freud, entitled *What's on a Man's Mind*, in which the face of the arch-psychoanalyst is rendered as a woman's body. This painting, in combination with its title, suggests that it's not the thing itself that is erotic; we can project eroticism onto practically anything.

Nonetheless, type is a special case. It's the stuff texts are made of, the most direct—and sometimes only—way of communicating our deepest fancies, beyond the spoken, or whispered, word. Conversely, as in our adult life we are apt to read erotic allusions into the most improbable visual stimuli, we see letters in anything that remotely suggests them in a

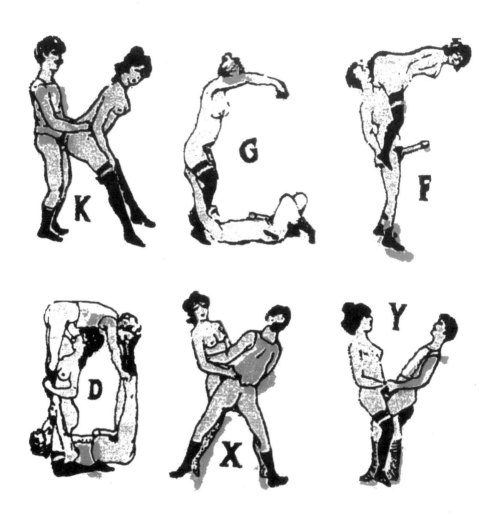

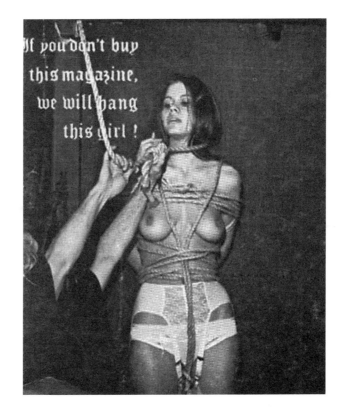

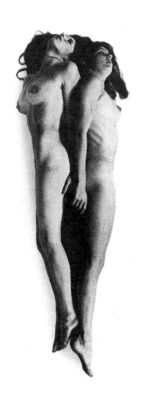
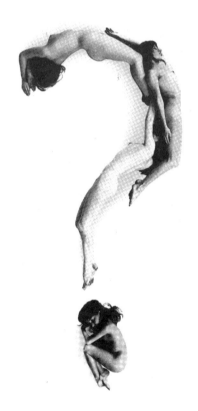

contour or a shadow. Paul Elliman's Fuse alphabet of 1992 is a good example of this, of what I termed "imaginative crystallization." His *S* is based on the flitting appearance of the letterform in the locks of the performer, and although one could hold that the girl is simply shaking her head, the resulting expression is almost archetypically erotic. And maybe one would be overinterpreting Elliman's *M* and *Y* as erotic images by themselves, but what if one writes *MY* in this alphabet? Eroticism, after all, is in the eye and mind of the beholder. Why, for a narcissist the letter *I* would be arousing, regardless of the typeface in which it is written.

Max Bruinsma is a former editor of Eye, *the international review of graphic design. His critical writing is published in major Dutch and international art and design magazines. Max Bruinsma teaches at the Sandberg Institute in Amsterdam, where he lives.*

List of Illustrations, in order of appearance
1. For an illustration of Chris Vermaas's "most concise manner to depict the female sex," see the title of this article.
2. Peter Flötner. Anthropomorphic alphabet (Germany, ca. 1540). In "Human Alphabets" in *Amor Librorum: A Tribute to Abraham Horodish*, by Helmut Lehman-Haupt (Amsterdam, 1958). See *Kiermeier-Debre, Vogel, Das AlphabetóDie Bildwelt der Buchstaben* (Ravensburger Buchverlag, Germany, 1995).
3. Demona, anon., (Milan, 1973).
4. Giovanni Batista Bracelli. Alfabeto figurato, Italy, 1632. In *Bizarrerie*, by G. B. Bracelli (Paris, 1963 and 1975).
5. Anthon Beeke. Nude alphabet, Kwadraad (The Netherlands: Steendrukkerij De Jong & Co., Hilversum, 1970).
6. Max Kisman. mailto:maxk@sirius.com.
7. Plexus, anon. (France, 1969).
8. Homo, anon. (Milan, 1972).
9. Peter Verheul: "Typorno," 1990s.
10. "If you don't buy this magazine . . . ," anon., 1970s.

Sex and Typography Revisited (Letters of Discredit) by Michael Worthington

I can clearly remember my first time. I was looking at back issues of *Typographica* in the Saint Martin's School of Art library, London, when I came across the work of Robert Brownjohn and was drawn toward an article entitled "Sex and Typography." I experienced something of a design epiphany, an adrenaline rush, as I excitedly flipped through *Typographica's* pages like a dirty old man poring over a porno magazine. I was thrilled to find someone making connections between my two favorite things: sex and typography (not necessarily in that order). But to my dismay, the essay almost entirely avoided the intriguing subject of its own title. There was no in-depth analysis. Instead, Brownjohn focused on showing his work, especially his title sequence for *From Russia with Love.* I made a note in my sketchbook at the time, "rewrite Brownjohn's Sex and Type essay." Over the next two years, my student work became littered with references to sex and typography. I described myself as a "typo-maniac," a "typo-fetishist," a "typo-phile," and when I later attended graduate school, sex emerged again as a major theme in my typographic work. All the time, Brownjohn's essay lingered in the back of my head: Just the title, the ill-fitting coitus of those two words, was enough to set my mind whirring through a typographic Kama Sutra of design possibilities.

Though I never rewrote Brownjohn's essay, I began to build a collection of typographic ephemera concerning sex that fed my obsession with the intersection of the seemingly disparate areas of sex and typography. I kept scrapbooks full of newspaper sex ads, collected condom packages from around the world, photographed the handlettered and neon vernacular of sex-shop windows and strip joints. I began to collect the raw material for a study of the relationship between sex and typography that Brownjohn (also a collector of street ephemera) would surely have admired. My obsession with erotic typography seemed to eclipse everything else in my life. I became some kind of voracious typographic nymphomaniac, my pockets always stuffed with "calling cards" for sex workers left in London's phone

56

booths. More than once I had to fight with the lackeys that stuck the cards up, since they caught me stealing them before any erstwhile customer could call the numbers.

I began to convince myself that perhaps the relationship between sex and typography wasn't that strange after all. I made connections comparing typographic and sexual typologies, noting similar phrases such as body, bed, x, head, foot, swash, tail, and stroke. I collected soft-porn magazines from the fifties, fetish mags from the nineties, anything in which type and sex might intersect. In an attempt at organizational clarity I drew a Venn diagram to mark out clear territories, the circle on the left labeled "the typography of sex," the one on the right labeled "sexual typography," the intersection untitled. By examining the three portions of this diagram I wanted to see if type could be sexy, if sex had a typographic vernacular, and to find out what happened when the two of them got together.

Sexual Typography

There seems to be many different models for how the form of type might be considered sensual. The most obvious is perhaps typography that has an overt erotic quality to the shape of the letters, such as the heightened-for-pleasure form of Modular Ribbed or the vibrator aesthetic of VAG rounded and Frankfurter. This formal seduction can be traced back further, to the loose and "feminine" forms of free-spirited art nouveau (seen on the next page, revisited in the flowing curves of a 1970s' Letraset promotional poster), or the entwined forms of Arnold Böcklin, where typography becomes sexy through the quality of the line rather than through a direct pictorial reference to sex. In general, typography's secondary signifier, or its formal attributes, work in such a crude manner that in order to communicate successfully to an audience it often has to be clichéd, shouting rather than whispering, crude rather than subtle. How subliminal can that message become and yet still communicate? We all seem to attribute qualities of femininity and sensuality to a curvaceous script face, (though I wonder if these forms are sensual because they traditionally have implied the hand of a woman, or because they imply the shape of a woman) but is it just me who finds Cooper Black naughty and fleshy? I hope not. Stanley Hlasta, in his *Printing Types and How to Use Them*, uses adjectives such as "masculine," "handsome," "dashing," "feminine," "beautiful," " graceful," "romantic," and "charming," to describe the fonts he shows. If type can have these attributes why not take a step further into the realm of "passive," "dominant," "arousing" . . . ?

Perhaps the reader needs to have sex on the brain to make these subtle connections. Brownjohn knew this. In his essay he states, "For some reason (probably clear to a psychiatrist) four design projects in which I have recently been involved have all had a strong emphasis on sex. . . ." I remember some scientific research concerning how many times a day we think of sex: 206 times. I'm sure I think of typography even more than sex. There has to be an intersection. For example, to me there has always

seemed something perverse about the form of Keedy Sans, whether it's the penile quality of the curved head of the letterforms, or the shaft of the *i* approaching the little dot hovering above it.

There seems to be many ways in which type designs can associate themselves with sex: Some work by association to a vernacular within a given culture (Blackletter = S + M, domination), some solicit the human form (belles lettres), while others operate on a more conceptual level. Barry Deck's naughty puppy, Canicopulous, is an example of the latter. An homage to Eric Gill's Gill Sans, the font's letterforms have horny extensions that reach out to touch each other (a reference to Gill's prolific sex life), and that look like wagging tails as well, a reference to Fiona McCarthy's biography of Gill that implies he had sex with a dog (see interview with Deck in *Emigre* no. 15). Sometimes, as with the fonts Canicopulous, Cyberotica, Modular Ribbed, my own Dominatrix, or John Barnbrook's Mellor, the name of the typeface can clue one in to the designer's intention. Barnbrook's font, which he describes as "Gill with curvy sperm tails," was designed to advertise the female condom in the UK and was named after David Mellor, "the Tory MP that had to resign over his affair with an actress and generally not being able to keep his willy in his trousers." Alternatively, the name can seem sexy (Jonathon Hoeffler's Fetish or Geoff Kaplan's Suckerbut) and though the font designer has no conscious intention of focusing on the sexual, the sex peeps through subconsciously in the form, or perhaps like an innocent double entendre, it is only apparent to those with sex on the brain.

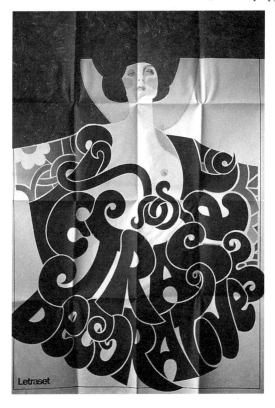

Letraset

Keedy Sans

Phallic Forms

abcdefghijklm
nopqrstuvwxyz
ABCDEFGHIJKLM
NOPQRSTUVWXYZ
1234567890

Frankfurter

Rubber Forms

abcdefghijklm
nopqrstuvwxyz
ABCDEFGHIJKLM
NOPQRSTUVWXYZ
1234567890

Dominatrix Black

Dominating Forms

abcdefghijklm
nopqrstuvwxyz
ABCDEFGHIJKLM
NOPQRSTUVWXYZ
1234567890

Canicapullo Script

Touching Forms

abcdefghijklm
nopqrstuvwxyz
ABCDEFGHIJKLM
NOPQRSTUVWXYZ
1234567890

Arnold Boecklin

EMBRYCING FORMS

abcdefghijklm
nopqrstuvwxyz
ABCDEFGHIJKLM
NOPQRSTUVWXYZ
1234567890

The Typography of Sex

The other side of the Venn diagram is "the typography of sex." This usual-
ly takes the form of an established vernacular for sex ads and strip clubs in
which the content (both words and pictures) gives a context for the typo-
graphic form, and so eroticizes the typographic form and seduces us into
thinking that the type is sexy too. To prove this, some of my students and
I took a collection of newspaper "phone sex/escort" advertisements—
which collectively looked remarkably like a photosetter's type sample book
from the late seventies—and performed a semiotic striptease, taking away
each of the design elements. The first layer to be discarded was the
images, the immediate visual denotation of sex. We quickly discovered
that even with the imagery missing the ads retained their meaning, the
words still pointed the reader in the direction of sex. So we changed
words, from the explicit to the banal. But this created another meaning, by
way of a humorous or sarcastic juxtaposition, so we introduced nonsensical
words. By doing this all the signifiers were removed except the typograph-
ic form, which was left standing there naked. For the most part the results
were sexless. Without context or content to offer clues to the reader, these
typographic forms said nothing about sex. They were too subtle for that,
they were nebulous and undefined, waiting for a word or an image to con-
textualize them and give them meaning. When a script font says "little
devil," you associate the sexy words with the form and that becomes sexy
too, but when it says "learn macramé," then it's just about macramé. We
concluded that generally the typographic form is not intrinsically sexual,
but is sexual in relation to the context, and the information supplied by
the content.

A Great Year... 69 Any Way You Look At It

BIZARRE Nº 24

The editors of *Avant-Garde* do hereby issue an appeal to readers of this magazine to submit to them, for publication, manuscripts describing their most memorable sexual adventures. The object is to create a series of narratives entitled "The Lust Battalion: Sexual Adventures of the Avant-Garde."

The second installment of this Space-Age Decameron appears on page 60 of this issue.

The manuscript you send may be as long or as short as you like, and there are no rules governing prose form. You may wish to pour the new wine of your experience into the shapely old bottle of the true-life erotic form, as exemplified by Frank Harris; or you may, like Henry Miller, adopt a style that is intensely personal. If you like, you may simply describe your experience in the form of a letter. The important thing is that the experience described *must be true.* It may be licit or illicit, normal or "perverse," ecstatic or embarrassing—*just so long as it really happened.* (Names may be changed—to protect the guilty.)

Send all manuscripts to: "The Lust Battalion," Avant-Garde, 110 W. 40th St., New York, N.Y. 10018. A stamped, self-addressed envelope must accompany your manuscript if you wish to have it returned. Avant-Garde assumes no responsibility for lost manuscripts, so please keep a carbon copy. Manuscripts accepted for publication will be paid for at Avant-Garde's standard rates.

AND FANTASY

The Intersection of Sexual Typography and the Typography of Sex

In certain instances the typography of sex and sexual typography come together: when letterforms that shine like PVC, drip with lubrication, or promise to pierce for pleasure are used in the context of sexually related material. The most apparent examples come from the prostitute cards deposited in London's phone booths. They operate on a crude level, in a world where the signifiers of the type scream for attention. Other examples can be found too: Brownjohn's "Obsession and Fantasy" poster, John Willie's covers for *Bizarre*, Barnbrook's False Idol font (based on bad rubdown type in porn magazines), some of Herb Lubalin's work for *Eros* and *Avant-Garde* . . . but they seem far and few between.

Perhaps the connections are best kept quiet. Implied sexuality is more acceptable in most instances than explicit sexuality, and if we really are thinking about sex over two hundred times a day, and we all know sex sells, it is clearly a major component of visual communication in our economic structure. Though it has to be implied, or eroticized, or "done with taste," when sex is portrayed too literally it becomes cheapened and enters the realm of pornography. Similarly with typography, most designers won't use a loud, crude, bawdy font; they want something sensual and smart that implies raw sex and vivaciousness rather than depicting it.

Sex and typography rarely intersect on a sophisticated level. For the most part they are two pieces from different jigsaw puzzles that interlock perfectly but don't always make a consistent picture. Their mixed marriage is acceptable in the circles of pornographic or sexually implicit content, but if they appear to a wider public, it is with an implied or suggested eroticism, more about the sensual than the sexual, more connotation than denotation. To me there is beauty in the moment when sex and typography do meld together, because it is a truly odd juxtaposition that seems like it should make sense, but rarely does, a moment of tumultuous simultaneous orgasm: a braille edition of *Playboy* in a Gemstone Bay pawnshop; a Texas girl with "fuck you" tattooed on her back, the letters formed from severed penises; type bursting like bubbles on Jane Fonda's nipples in the titles to *Barbarella* . . . Perhaps I'm just trying to address the disappointment I felt with Brownjohn's essay. While sex seeped into his design both consciously and subconsciously, he never explored it thoroughly in his writing, yet the mere title of his essay always cracks me a smile, and points me in the direction of the intersection of sex and typography.

Michael Worthington is the codirector of the Graphic Design Program at California Institute of the Arts. His typography has been published in design books and magazines, nationally and internationally, and his design writing has been published by Eye, *the* AIGA Journal, *and in* The Education of a Graphic Designer. *Additional research for this piece was carried out by MFA graphic design students John Kieselhorst and Sophie Dobrigkeit.*

"I'm Wet and Ready Now!": A Brief Look into the World of Adult Typography By Cyrus Highsmith

Adult Typography refers to the distinct typographic style that penetrates nearly all printed advertising for phone sex, escort services, and strip clubs. It is distinguished mainly by the limited range of typefaces that are employed by the typographer. In general, most of the fonts can fit into one of three hot categories—Squeezed Sans, Dominatrix Style, and Sleazy Scripts.

In the adult sections of printed media, the columns are tight and narrow while the "900" numbers are long and hard. There is a need for super compressed typefaces that allow you to squeeze in as much as possible. Consequently, the Squeezed Sans category is the foundation of Adult Typography. The fonts in this group are usually of the geometric variety, like Futura or Kabel, and have been seductively squashed by means of horizontal scaling. But that's not all. These fonts often also receive the pleasure of the outline shadow treatment. The most ubiquitous font in the Squeezed Sans category is Lithos by Carol Twombly. Many Adult Typographers like distorting this typeface so much that it is done even when there is room to spare. Squeezed Sans has become a stylistic convention as well as a functional one.

Dominatrix Style is a disciplined kind of typeface found mostly in advertisements for S&M and similar services. These fonts are usually bold and a bit on the deviant side. As opposed to the plainer fonts in the Squeezed Sans category, Dominatrix Style faces are decorative, sometimes to the point of being exotic. Some of them, like Honda and Totally Glyphic, have a sort of Fraktur flavor. Others, like Ironwood, go for the dungeons and dragons look. And don't forget the cool authoritarian feel of the slab serif Aachen. This category is not restricted to just S&M material though. The skilled Adult Typographer will use a Dominatrix Style font to add a touch of taboo to more conventional content.

Finally, the sexiest category—Sleazy Scripts. A Sleazy Script has a very special spot on the Adult Typographer's palette. Unlike the first two

Antique Olive

Mistral

Choc

BANCO

categories, these fonts are reserved almost exclusively for ads aimed at straight men. Sleazy Scripts can be almost any pseudocalligraphic typeface in which the letters more or less connect with each other. Usually, they are light and have a slant. They can be formal, like Shelley Script, which can bring a whiff of elegance to even the smuttiest copy. They can be informal, like Kaufmann, for a cheap but sexy spin. It is hard to imagine pornography without Sleazy Scripts.

This genre would not look the same without the renowned French type designer Roger Excoffon (1910–83). No other type designer has so much work that ranks so highly in not just one but all three categories of Adult Typography. Antique Olive, Excoffon's sans serif masterpiece, has a comfortable spot in with the Squeezed Sans group. Mistral and Choc are by far some of the sexiest and most popular Sleazy Scripts. His brilliant font Banco makes other Dominatrix Style typefaces kneel down in submission. Would Excoffon have been proud of this accomplishment? No one knows. How a typeface is used is beyond the control of the type designer. But perhaps he would have had a sense of humor about it.

Cyrus Highsmith lives and works at the Font Bureau in Boston.

Plastic Phallic Fantastic!

by Johanna Drucker

In Mel Ramos's 1964 painting *Miss Cornflakes*, a robust beauty emerges from an ear of corn, her broad, smooth body coyly turned three-quarters to display appealingly ample buttocks and one perfect, full-bodied breast. She embodies a pre-workout standard of American feminine beauty, fully ripe and at her peak. Generationally she is posed between sweater-girls, wartime pinups, and the pop, high-fashion models of the sixties. As a type, she is pure playmate, peeking pertly out of the oversized corn with an engaging smile, all party-girl sweetness and appeal. She is no one's mother, nor is she a wholesome, mousy, girl next door, a smoldering femme fatale, or an elegantly aloof, cool beauty. She is singularly of her era—synthetically produced and readily enjoyable, projecting an attitude of leisure time diversion, carefree sexual-revolution availability, and low-risk fun. She has a bouncy flexibility to her entire being, a resilience characteristic of the then newly exploding plastics industry.

Not an advertisement for Kellogg's, but a pop art painting at the height of the movement's visible success, Ramos's image plays first and foremost with consumability as a feature of sex appeal. Words suitable for describing breakfast cereal, such as "yummy!" and "delicious!" come easily to mind looking at *Miss Cornflakes*. This reinforces a nice overlap of woman and food, flesh and sweet corn, in a metaphoric image of nutrition as pleasure, oral gratification, and sensual indulgence. Ramos's position within the world of pop also factors into the character of this image. The Californian artist pushed pop further toward the vulgar low end of popular culture than most of his counterparts. For instance, in contrast to Ramos's imagery, Roy Lichtenstein's paintings of women as appropriated comic-book figures look positively classical. His tasteful, high-art depictions of stereotyped beauties with sweeping hair, full lips, and clear complexions are a far cry from Ramos's flagrantly tacky paintings with their unabashed appeal to an appetite for calendar art. In another contrast, James Rosenquist's fragmented images, whether of Marilyn Monroe or appropriated and

generic photographs of model-perfect hands, nails, and lips, read as the product of an intellectualized imagination struggling with the signs of mass culture. Even Tom Wesselman's obsessive renderings of the female body, carved with a fetishist's perversity into isolated zones of erotically erect nipples, inflamed and open lips, pubic mounds, and tan lines, in-your-face as they may be, don't cater to the lowest common denominator, as does Ramos's beauty. Miss Cornflakes represents appeal as a working-class image with her procreative body type (the airbrushed version of a mud-flap girl). And she flaunts her low-art sources: the imagery of the illustrations of Varga and other finely skilled but art-world-disdained artists of the pinup genre. Ramos's achievement was to push pop into extending the limits of its exploration of popular culture past the safer-seeming imagery of benday dot–produced clichés and billboard or adver-tising imagery, and into the slightly sleazy realm catering to even less edu-cated or sophisticated tastes.

Whatever her origins and suggested class associations, Miss Cornflakes is completely appealing. Everything about this image and the drawn depiction of the young woman contributes to its sexiness. There are all the overt aspects of the way she's made attractive and erotic. Her dark hair is tied up in a little ribbon and then hangs with pert flirtatiousness down her back so that it swings in a teasing ponytail echo of her curves. Her bangs are swept to one side in the vinyl imitation of a Veronica Lake curtain of sexy hair. The dark color accentuates the hint of her ethnicity while at the same time suggesting a dyed, tinted tone—clearly synthetic and racy. Her cosmetic perfection is part of her daring, free-spirited character. Her light lipstick echoes the light color of her hair ribbon, and all the details around the face—perky nose, short upper lip, thick (false?) eyelashes, and pointed line of mascara accentuating her eyes—enhance the sense of a dark and saucy beauty. Her back is arched to push her butt up and out and there is no swimsuit or panty line on her smooth tan—indicating that this is a woman who sunbathes with the goal of looking good in the nude. Un-inhibited and unrestrained, she is clearly comfortable in her undressed state. Her skin is taut, tanned, and healthy, though without any overdisci-plined athleticism. This is a party-girl body, not a hard-work or heavy-workout one. And in a final, seductive gesture, the corn silk swishes out behind her like a horse's tail, its curves drawing the eye right onto the rise and dip of the buttocks. And she plays with the last bit of sheath from the corn, fondling it deftly to keep the bit of vegetable matter erect.

In regular, old-fashioned, psychoanalytically influenced critical parlance, she is, of course, both the phallus and standing in as its surrogate while displaying her manipulative dexterity. The remnant of the cornstalk she plays with between her thumb and forefinger and the broken-off stalk sticking out at the base of the ear combine to suggest that she is strad-dling a splinter of the sheath, even rubbing her full belly against the erect corn. She's all curves and female beauty in its most fulsome mode, but she is also the slim flesh projectile revealed as the dry foreskin of the leaves

falls away from her—a rising phallic body as erect and stiff as the nipple on her upturned breast. Everything about her is sexual and sexy and inscribed in one code after another of phallic and erotic visual language—a semiotician's dream of multivalent articulation at every level of representation. But there's something else here that accounts for the appeal, after all: her playmate-type invitation, the feeling that she is available for the taking with little or no psychic or social tax.

More importantly, she conveys a sense that she is as synthetically processed as the food product she is associated with here. She isn't serving as an ad for Kellogg's. Instead, the brand name suggests an endorsement of her. If she is celebrated as Miss Cornflakes, it's not just for her beauty, but for the way her mode of production parallels that of the always repeatable, standardized quality of the Kellogg's product. Her body, like her smile and attitude, have been processed to perfection, the raw material of her self transformed into the consumable product of her image. Just as her ethnicity—the suggestion of an Annette Funicello–like Italianicity lurking in the palette of her hair and flesh tones—has been tamed cosmetically, so the physical appeal of her energy has been repackaged in a soft, pliant, plasticity. She seems endlessly available for use, perfected for consumption. Not disposable, but reusable. With a rinse and a wash and a little blow-drying, she's refreshed and ready. She's product perfect and perfected through processing: an ideal fantasy image of a 1960s' attitude of unlimited consumability. Depicted nude—that is, apparently without any accessories or products enhancing her natural appeal beyond makeup and the low-budget hair ribbon—she appears to have absorbed her consumable sex appeal into her very essence, and so becomes the produced product in yet another level of synthesis.

Needless to say, she is without a single grain of feminist consciousness, hardly something one can celebrate without hesitation and qualification with current historical perspective. One wants at least to imagine her capacity to assert her own sexual needs and appetites in whatever social, intimate bargains she enters into, but it's not necessarily easy to believe she has the ego or self-possession—or even the self-knowledge—to do so. Still, her utter lack of inhibition about her own sex appeal spells relief in contrast to the moral policing of later generations, with their agendas of personal correctness in every sphere of real and imaginative existence. If she's unconscious, she's also unjudgmental, unlikely to inflict guilt or criticism or angst within the dynamic of the fun-filled encounter she seems to promise. She's all beach blanket bingo fun and games, blatantly conforming to an unrepentant and unreformed sexist sensibility.

At the same time, she is an embodiment of a new product sensibility: the erotics of pure plastic. Her sex appeal affirms the erotic and economic viability of a whole range of synthetic products and their characteristics (vinyl, latex, and acrylics, all firm but pliant and resilient, moldable, formable, and able to facilitate mass production of a broad spectrum of items for domestic, industrial, business, and entertainment markets). Thus

the aesthetics of her sexiness are consistent with the synthetic sensibility that characterized the "contemporary" tone of 1960s' style. This is antinatural nature, a perfectibility available through the miracle of plastics, and her sex appeal is precisely aligned to reinforce the virtues of a newly burgeoning industry of synthetic products and processes through the image of an easy erotics of consumption.

Johanna Drucker holds the Robertson Chair in Media Studies at the University of Virginia. She has lectured and published widely on the topics of contemporary art, history of typography, artists books, and digital media. She has been printing experimental work since the early 1970s, and her books are represented in special collections in museums and libraries worldwide.

The Hard Sell by Michael Dooley

The penis is in.

Aesthetically, the penis has always been in, from primitive fertility symbols through Michelangelo sculptures to Robert Mapplethorpe photos. Societally, however, this private part has only recently become a widespread topic of general discourse in the United States. During the 1980s, it was implicit in discussions of the AIDS epidemic; in the early 1990s, it received explicit exposure with the media's in-depth coverage of such relative insignificancies as Long Dong Silver, John Wayne Bobbitt, and Pee-Wee Herman. As the decade wore on, it reached presidential proportions: Bob Dole decided we needed to know how Viagra restored his wounded psyche even as his former adversary, cigar-wielding Bill Clinton, seemed intent on demonstrating his own prowess on a citizen-by-citizen basis. And the public grew to accept it.

By 1999, male genitalia had even worked their way into graphic design competitions. Phalluses both subliminal and blatant showed up in calls for submissions and other promotions, and much of the work came under fire. Some critics found these displays to be in questionable taste; others took them as a sign that males in the profession were becoming too cocky, figuratively speaking.

Let's begin our survey of the material in the traditionally buttoned-up South, where two different announcements got into the act, with varying degrees of cleverness. An invitation to an Addy awards ceremony in Norfolk, Virginia, by Virginia Beach agency McMahon Creative, paired a Viagra bottle and an Addy trophy with the headline, "Now available with prescription. Or without." Copywriter Paula McMahon said the agency wanted to do an "edgy" ad; instead, it came off as obvious and pedestrian (not to mention gender-exclusionary, if we're being literal-minded). Next, a North Carolina call-for-submissions poster for the Piedmont Triad Advertising Federation's Addy competition, showed a row of men standing at urinals, with one sneaking a sidelong glance at his neighbor,

accompanied by the tag line, "See how you measure up." The theme reflected the contest's rigid judging standards, and the Burris Agency in High Point was proud to have offended "the suits." "If it doesn't make someone nervous, you shouldn't do it, because it will just be part of the general clutter," reasoned copywriter LeAnn Wilson-McGuire. Modestly accomplished, the poster delivered the informational goods while ridiculing awards as a yardstick by which designers measure their self-worth. And, unlike the Virginia version, it skewered male vanity, letting women in on the daring, although dated, joke.

Moving up to the ostensible urban sophistication of New York, the city's Addy Club promotion emphasized designers' obsession with the work, not the prize. A call-for-entries poster depicted a deep blue Manhattan night, with a distant apartment's well-lit window revealing a nearly naked man and woman on the verge of a tender embrace. In the foreground, a guy with a scruffy beard gaped through a pair of binoculars—not at the pre-coital couple but at a three-story image of a yellow rubber duckie on the side of a building. (The duckie, with the Mercedes-Benz logo imprinted on its eyes, was the winning entry from the previous year's contest.) This image, by New York agency Hill Holliday, attempted to convey that advertising can be more compelling, more stimulating, than sex, and the Club was pleased with its "irreverence." However, although the photo was adroitly handled, it was about as funny and racy as a *Playboy* cartoon circa 1959—almost, but not quite.

Jumping over to stiff-upper-lipped Britain, the Designers and Art Directors Association in London hoped to reposition itself as a youthful, hip organization when it assigned Saatchi and Saatchi and Farrow Design to promote its worldwide competition. One ad showed a harsh Polaroid-style photo of a man's torso, his black nylon briefs bulging with the contour of D&AD's Yellow Pencil award. Another equally artless ad showed the Pencil standing amidst vibrators and dildos in a medicine cabinet.

And a graphic for the call-for-entries brochure imprinted the Pencil on individual Viagra tablets—as if one prize-as-potency-pill ploy wasn't already one too many. D&AD's chief executive, David Kester, claimed that those who took offense were simply missing the point, but there wasn't much of a point, other than the one on his Pencil. The concepts were so trite, and their presentations so leaden and reserved, that any irony in using this stubby writing utensil as an icon of sexual ecstasy was easily lost.

Back in New York, a promotion for the international competition held by the locally based Art Directors' Club caused an uproar. The ADC, also intent on shaking its over-the-hill image, had MTV's off-air creative group design its call-for-entries mailer. The teaser copy, "By yourself," unfolded to a Seussian "With the TV on. In a group. On the Web. In the dark. With a magazine." The full poster depicted a computer-generated illustration of a gigantic pulsating vibrator, dubbed the "creative stimulator," glowing in brilliant yellow with an acid-green handle, bulbous, rubberized protrusions on its pink neck, and missile-shaped extensions on its silver metallic head, ribbed for who knows whose pleasure. The payoff: "However you get off, get it in by January 15, 1999."

Its visual treatment wasn't particularly innovative, echoing the macho cybergraphic style demonstrated throughout the 1990s by Thirst, Me Company, and the late P. Scott Makela. And the sexual entendres were puerile. Yet the poster proved quite popular among its intended audience, as many displayed it in their studios like a high-tech tribal totem. It also unleashed a Pandora's box of vitriol. Several people wrote the ADC to denounce the stimulator as ugly, obnoxious, demented, and "obviously designed by a male with a very small penis." One former ADC president threatened, in a scathing letter to the board of directors, that he would "do everything to see that you will not get an opportunity to produce more crude junk." Even D&AD Pencil-pusher Kester considered it "disgusting and obscene."

But the ADC claimed to be unfazed, citing "scintillating" responses as proof of the psychedelic power tool's ability to excite. Indeed, the Vibrator from Another Planet succeeded by the sheer force of its out-of-control lunacy. Its execution was so patently absurd as to parody the notion of the creative process as a source of self-gratification, and its self-consciously sophomoric stance took a well-deserved poke at venerated views of high design and refined taste. While the producers of most of the other designs were relatively clumsy and restrained in their approach, this team was not only having comfortably uninhibited fun itself, it was also sharing the fun with its "partners," the audience that appreciated the poster's subtext. And this is what brings the material beyond sex, into something resembling love.

Max Bruinsma, editor of the British magazine *Eye*, critiqued D&AD's pencil and ADC's vibrator without drawing much distinction between them. He admonished designers to spend less time "getting off on their own work" and more time listening to the needs of their clients. But ironically, both pieces fulfilled their briefs; their clients credited them for

marked upswings in submissions. And their functional success should be expected: With jaded, cynical creatives as their target, sex-as-sales-strategy is an effective approach for appearing transgressive while assuring bang-for-buck results.

Bruinsma also blasted both campaigns as masturbatory and as products of male-centered egoism, "just too phallic to be trusted!" His broad-stroke condemnation and strict equation of aggression with masculinity misinterprets the ADC's stimulator: It's tongue-in-cheek, not hand-on-crotch. But countering his argument may be futile; considering his apparent scorn for graphic self-pleasure, it's unlikely he'd heed the humbling advice often meted out to those who can't take a joke.

While most of the work failed to satisfy aesthetically, the ADC's—and, to a lesser extent, the Piedmont Triad Advertising Federation's—calls for entries demonstrate that, properly handled, the male organ—and bad taste—has a place in graphic design. This isn't to say that the profession isn't capable of producing a much higher caliber of design. Perhaps a future wave of promotions using female iconography would generate even more controversy, but the images also might be smarter, subtler, and more sophisticated.

Meanwhile, it's helpful to keep in mind that promotions for pompous, self-congratulatory design awards shouldn't be taken so seriously. To misquote a celebrated Viennese psychoanalyst, sometimes a Pencil is just a Pencil.

The Dirty Bits: Tortured Torsos and Headless Women by Phil Patton

You might forget your first topless woman; you'll never forget your first headless and topless one. I was maybe twelve, and I saw her in the Indian reservation town of Cherokee, North Carolina, in a souvenir shop next to the Sequoyah Cafeteria. There, amid the rubber tomahawks and glass arrowheads bearing little gold "Made in Hong Kong" stickers, I saw a ceramic figure of a reclining woman—a "squaw," I suspect. Her breasts were removable salt and pepper shakers. This titillated, but what shocked was *she had no head*. The violence of the gesture lay in the implicit suggestion somehow conveyed that the decapitation had come at the last minute of design, for reasons of cost or manufacturing, because the mold wouldn't accommodate it. As a result, the figure, even with its legs, lost much of its legibility as a human body.

There are many such kitschy-sexy tropes of long standing—take the woman's legs made into a nutcracker. But contemporary ads use similar visual strategies. The degree of seriousness or facetiousness employed varies. And the goal varies, though not the formal qualities. For ads or magazine covers, we know, the easiest, cheapest, quickest appeal is sex appeal. And you only need a bit of it. If titillating abbreviation, the glimpse of décolletage or ankle has long been the seductress's technique, the marketer uses the same, but far more crudely. Dividing parts and focusing on them serves the salesman as much as the lover—or the pervert. Cartoon and devotion often use the same techniques: Compare R. Crumb's women with the Venus of Middendorf. Take Man Ray's giant lips, hung in the sky of a landscape. Sex sells, and strangely it sells best in part, by slicing and framing and pointing to "the naughty bits," to use the old Monty Python phrase.

For years, many of us have been confronted with another classic image that is ultimately mysterious: "Fashionable, Durable, Rust Free" are the slogans on the Snap Klip key holder display. I've seen the cardboard displays in convenience stores and gas stations for years. They hold dozens of plastic key holders, but what you notice the most is the image of the rear

end, female, tightly blue-jeaned. It's as familiar and as long standing a fixture of the checkout counter as the Ronson lighter flint car, or the air filter display that has borne an image of Marilyn Monroe since before anyone knew who she was.

The strange thing about the Snap Klip card is how focused it is on the part in question. The legs are cut midthigh by the bottom of the card. At the top, just above the waist, only a mannequinlike piece of body appears, ending in a wavy line such as that a technical artist uses for mechanical clarity to indicate a truncated part. A *V*-shaped pattern sewed on the rear pockets bears a disproportionate amount of detail considering the abstraction of the tortured torso above. Abstracted parts charged with some vague sexuality are common on low-end commercial point-of-purchase displays. But this one has always confused me: Do women buy the Snap Klips? Or do men attracted to women with rear ends like that buy Snap Klips? Like an unidentified corpse, the Snap Klip torso attracts largely by its mystery.

I thought of that Snap Klip ad when the business magazine *Fortune* appeared with a cover showing a jean-clad woman's rear end. The justification was a story inside on Levi Strauss. The cover brought unusually explicit criticism from the editor of rival *Forbes*, who called it misleading and suggested it was exploitative of the reader. Levi Strauss recently launched its own sexy-parts campaign to help reinvigorate its brand. Posters and print ads of close-up lips direct viewers to a Web site where the very Levi's name is cut away: *www.l____l.com.* Another equally wordless ad in the series features a road receding in the V of perspective topped with the V of a female crotch, soft top juxtaposed with hard bottom.

The juxtaposition of soft flesh and hardware seems to have become especially attractive to the computer industry of late. Palm Pilot's recent ads featuring a nude woman with the handheld computer placed in front of her attracted enough attention to be parodied on the Internet. Far more effective, not to say witty and almost tasteful, is a close-in photo of a woman in a two-piece bathing suit, seen only from the waist down to midthigh up, with the tiny Rex PDA slipped into the bikini bottom. "Hip new organizer," reads the ad. Hip or lip, sexually charged parts are themselves turned into creaky, crude appliances for conveying information and projecting appeal.

Phil Patton is the author of Dreamland: Travels Inside the Secret World of Roswell and Area 51. *He is a regular contributor to the* New York Times *home section and a contributing editor of* Esquire, i-D, *and* Wired *magazines. His previous books include* Made in USA: The Secret Histories of the Things that Made America *and* Open Road: A Celebration of the American Highway. *He was curatorial consultant for the Museum of Modern Art's recent show "Different Roads: Automobiles for the Next Century."*

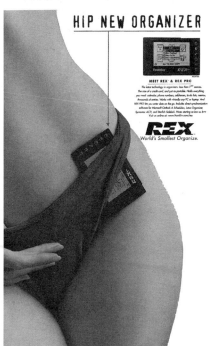

HIP NEW ORGANIZER

MEET REX & REX PRO

The latest technology in organizers. Less than 1/4 ounces. The size of a credit card, and just as portable. Holds everything you need: calendar, phone numbers, addresses, to-do lists, memos, thousands of entries. Works with virtually any PC or laptop. And REX PRO lets you enter data on the go. Includes direct synchronization software for Microsoft Outlook & Schedule+, Lotus Organizer, Symantec ACT!, and Starfish Sidekick. Prices starting as low as $99. Visit us online at: www.franklin.com/rex

REX

World's Smallest Organizer.

Phallocentric Sales Pitches and Crotch-Driven Slogans by Paul Lukas

Sex sells, or so goes the cliché, but who's buying? We're constantly being told that the consumer landscape is brimming with sexual imagery and sex-laden marketing campaigns, but this conventional wisdom depends on a rather one-sided view of sexiness. A quick survey of the cultural elements usually cited as the worst offenders—beer commercials, blue jeans ads, *Baywatch*—finds an ample supply of T&A but nary a naughty male body part in sight. Sure, the Freudians will tell you that everything from a Corvette to a cigar is a phallic symbol, but just try to find some genuine male anatomy out there—can't be done.

I'm a big T&A fan myself, but I'm also a believer in equal time, so I'm happy to report that phallocentric sales pitches do exist, and not just at Ye Olde Sex Shoppe—you just have to dig a bit deeper to find them. Consider, for example, Mr. Long (Shamadan Food Industries), a candy bar with a mildly suggestive name and an unmistakably crotch-driven slogan: "When you're this long, they call you Mister." Whoa, is that a totally rude marketing angle or are you just glad to see me? Mr. Long is in such a class by itself, in fact, that it should be a shoe-in to land a product-placement spot if they ever shoot a sequel to *Boogie Nights*.

Mr. Long hails from the Middle East, which brings up the obvious question of whether men in that part of the world are unusually obsessed with the size of their, uh, candy bars. They may have good reason to be— Mr. Long doesn't exactly live up to its name, measuring only six inches from stem to stern, and that includes the rather generously sized wrapper. Oops, cancel that product placement! Meanwhile, a Canadian version of Mr. Long speaks more softly (it's called Mr. Big, which sounds limp by comparison), but, at nine inches, carries a bigger stick, which raises some interesting questions about our neighbors to the north. As it happens, my Canadian pal Margie always responds to queries about her homeland by saying, "It's a Commonwealth thing, you wouldn't understand." Margie, I think I'm beginning to understand.

Of course, size isn't everything. As Maggi Cock Soup (Nestle U.S.A., Inc.) and Grace Cock-Flavored Soup Mix (Grace, Kennedy & Co., Ltd.) handily demonstrate, sometimes the smut is in the details. The manufacturers would no doubt have us believe that these items, despite their scandalous product names, are simply chicken broth mixes, but a variety of libidinous subtexts suggest otherwise. As one of the packages explains, cock soup is equally suitable "as a starting course for a main meal, as a snack on its own, [or] as a base for many homemade recipes," which is obviously code for, respectively, foreplay, a quickie, and a dizzying range of deviant bedroom activities. One of the mixes makes "3–4 servings," which just goes to show that some people like more cock than others, while the other packet simply "makes one pint," allowing the consumer to determine how many servings of cock this constitutes. The Grace packet goes so far as to describe cock soup as "a party time favorite with adults," and adds that it's ideal "as a 'pick-me-up' with toasted bammy," a reference whose precise meaning eludes me, but you have to admit it *sounds* dirty. As for the cinematic product placement, it's another no-brainer: the sequel to *The Cook, the Thief, His Wife, and Her Lover.*

But enough of these fringe products. Sometimes the most explicit example is the one we'd least expect, the one sitting right under our noses. Such is the case with Gerber Graduates Meat Sticks (Gerber Products Company), sort of a Vienna sausage for toddlers. At first glance, the illustration on the label appears to show a stick of the product firmly grasped in a child's clenched fist. After a closer look, however, one gets the distinct impression that the cherubic hand may actually be engaged in what might politely be described as an act of onanism.

Go ahead, call me depraved. That's basically what Gerber spokeswoman Melissa Dunn did when I called and asked if anyone at the company had noticed the illustration's arguably lewd content. "I don't know who's raising these concerns or issues," she said, "but from our perspective here it's absolutely absurd, and I think I'm going to leave it at that." Not leaving it at that, she added, "I mean, this is simply a package designed for a toddler's product, and that's it. And I will not even acknowledge any comments or concerns beyond that."

Fair enough, but I'm not the only one who finds the Gerber illustration a tad risqué. I've pointed out the label to a number of people, all of whom have had more or less the same reaction: "You're nuts, I don't see anyth . . . holy shit, *it's true!*" Could all of these people simply have their minds in the gutter? Maybe. But if Gerber is looking for a product placement in the next *Look Who's Talking* movie, I suggest they stick to strained peas

Paul Lukas is the author of Inconspicuous Consumption: An Obsessive Look at the Stuff We Take for Granted *(Crown) and publishes* Beer Frame: The Journal of Inconspicuous Consumption, *which examines consumer culture in excruciating detail.*

Girl Games by Katie Salen

Pornography sells image. Quality sells clothes.
 —Thieves
Now sponsoring girls.
 —Tastygrl@tasty.com

Irony and explicitness have always been the tools of choice in representations of commercialized sexuality, particularly within the hardcore world of skate and street-wear graphics. Beginning in the early eighties, skateboard companies such as World Industries, Fuct, and Toy Machine pioneered transgressive forms of representation by using controversial, often sexually explicit graphics on their boards and clothing. Celebrated pornographer Larry Flynt's purchase of the irreverent skate 'zine *Big Brother* in 1996 did little to affect the already familiar connection between skate graphics and radical sexual imagery. Artists such as Ed Templeton of Toy Machine and Erik Brunetti of Fuct had for years been producing boards that skate shops couldn't display, and recent ads by street-wear companies such as Black Flys and Fresh Jive have gone on to extend their graphic territory to include hardcore porn.

 Marrying underground subversion with mainstream exploitation, skateboard designers have created a standard for graphic deviance and transgressive forms of sexualized representation, an approach recently adopted, in intent if not in degree, by the neighboring subculture of snowboarding. Sharing in a desire to embody elements of subcultural cool while averting the encroachment of commercialism (MTV has bought into snowboarding in a big way), many snowboard graphics, such as a recent RadAir board depicting a woman in fishnet stockings and stiletto heels, use sexual imagery as a way to appeal to a male-oriented market. This crossover should come as no surprise: Sex does sell. And while it is doubtful that skate, snow, and street-wear representations of sex will change any time soon—their target market is reputably "alternative," after all, and draws upon the hormonally induced chaos that is puberty—a new market of

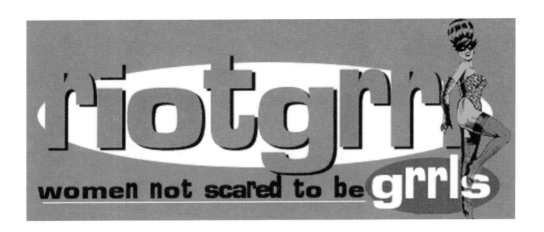

riotgrrl

women not scared to be grrls

female riders is quietly emerging to challenge the inevitability of these testosterone-driven forms of representation. The girls are shucking the curve.

Simultaneously resisting, challenging, and adapting images and ideologies established by their male counterparts through the recontextualization of language and gender stereotypes, women-oriented skate and snowboarding companies such as Rookie Skateboards, Goddess, Deep, and Betty Rides are carving out their own space of decidedly feminine representation within the sexualized edges of skate and snow culture. From the girlie girl imagery of Southern California companies such as Cold as Ice, to the adventure diva aesthetic of K2 or Burton, the scope of female representation has never been wider or so clearly articulated in women's own terms. As the first female-run companies producing boards and apparel for girls by girls, companies like Rookie or Goddess marry technical concerns with a desire for individual identity, offering alternative versions of femininity that must walk a fine line between representations of athleticism, sexual appeal, and hip credibility. As Kathleen Gasperini, editor of *W.I.G.* magazine[1] notes, "It's tough being a girl. We want to be sexy, stylish and still be taken seriously. As an athlete and as a woman." Working with a verbal and graphic language that has traditionally been used to portray women as weak, or merely decorative, these girl companies are turning conventions inside out to create a notion of femininity that is both strong and smart. Sarcasm, in the form of recontextualized female stereotypes,[2] pokes fun at the chauvinism inherent in a male defined industry while allowing a new, highly feminized language to emerge.

Not surprisingly, this language often flaunts an aggressive tongue-incheek femininity, with boards by Goddess, for example, in hues straight from Barbie's closet—hot pink, neon yellow, shiny silver, baby blue, and pretty pink. Names such as "Snow Angel," "Snow Bunny," and "Cookie" take girl style to the edge while remaining true to Goddess's mission to construct boards that perform. Apparel such as Betty Rides's "Diva" jacket

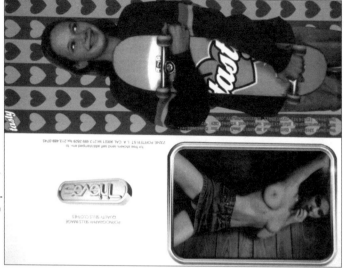

and Cold as Ice's "Dragon Lady," "Dream Girl," and "China Doll" parkas embrace gender and cultural stereotypes as alternate forms of empowerment. Roxy (from Quiksilver) has even introduced a mechanic-looking one-piece suit called "Rosie the Riveter." This reference to Rose Will Monroe, the model for the famous World War II poster, reminds us that long before Title IX[3] became law, women had claimed a space of their own in fields from which they are sometimes still excluded today.

While one design approach has centered on a girly attitude, graphics don't have to be pretty to appeal. The decks of Rookie Skateboards, a New York City company known for clothing designed in military camouflage and dirty hues, rather than glitter and neon, feature graphics of Mohammed Ali, city skyscrapers, and subway trains, imagery that acknowledges the reality of the urban context in which these women ride. Similarly, snowboarding companies such as K2 and Burton, who sell boards for both men and women, define girl style in multiple ways through graphics that range from soft and painterly to hard-edged and aggressive. K2's first "women's" board, the "Morgan LaFonte" pro model, is designed to appeal to both men and women with an androgenous graphic approach. Goddess's "He Loves Me," by contrast, is designed with a graphic language so gender-directed it will perhaps appeal only to women.

While skateboarding looks to popular culture and the street for graphic inspiration, women's snowboard apparel has found itself in the interesting position of pushing the leading edge of the fashion world while simultaneously reinventing the "look" of the female athlete. In heavy rotation on catwalks and in the pages of glamour magazines such as *Seventeen*, *Vogue*, and *Mademoiselle*, the creation and diffusion of new styles of technical snowboard clothing has offered fashion designers an interesting view of the collapse between sexual appeal and functional athleticism. A catalog caption by Southern California–based Cold as Ice sums up this connection best: "Made by girls who ride, for girls who ride, our gear was meant

to be out in front where everyone else can get a good, long look at it . . . all the way down the mountain."

This diffusion of visual style from the subculture of women's snowboarding to the fashion market is not only an interesting cultural process, but a commercial and economic one as well. Models of artisan capital, small-scale companies like Cold as Ice, Deep, and Bombshell are establishing new trends and generating new looks, which feed back into the appropriate industries.[4] Foregrounding athleticism, functionality, and attitude—whether hardcore or girly—these companies have been able to create a meaningful visual space for women on their own terms. As the designers have acknowledged, in one of the few sports where men and women can truly go head to head, riding with the guys no longer requires a girl to look like one.

Finally, subcultural style not only responds to but dramatizes a set of cultural conditions. For girls born after 1972, the year Congress passed Title IX, gender equity has hardly seemed an issue. As Gasperini points out, "This is a generation of women who have had their Title IX. They grew up not knowing that a glass ceiling existed." Women like Elksa Sandor Bici of Rookie and Janet Freeman of Betty Rides exemplify this attitude in their desire to see women command their own own industries and direct their own futures. "I see girls' skateboarding taking shape on all sides," Bici says, "Not just the girls who skate but the girls who run the industry." In spite of this optimism, sexism remains as a discouraging barrier, and women riders, especially skateboarders, are often confronted with the reality of their minority position within a sport that has been slow to support their participation. It is rumored, for example, that *Big Brother* magazine offered seventeen-year-old skate phenomenon Elissa Steamer $500 to wear a dress on the magazine's cover, an offer Steamer saw fit to refuse. Similarly, the graphics company J.D.S. recently developed and circulated a bumper sticker stating simply, "Girls Suck Dick."[5]

Snowboarding, on the other hand, has been free to a large extent from the historical prejudices that color the hardcore male attitude of skateboarding, a sport characterized by its ties to punk rock and aggressive, rough riding. Due perhaps to its status as a new sport, snowboarding has taken on the mentality of the newest group of participants, in this case women, allowing for a far less exclusionary, and by default, less limiting, attitude. As these riders and entrepreneurs continue to resist stereotypes in favor of carving out their own place in popular culture, the desire to be a "betty", or a Girl Who Rips, offers a promising alternative for a whole new generation of grrls.

Notes
1. [*For Fierce*] *Women in General: The Magazine of Female Expression. www.wigmag.com.*
2. The ultimate irony: type any of the following girl company names into an Internet search engine and you will arrive at—where else—a porno site.
 Goddess
 Deep Girls
 Tasty
 Bombshell
 Dish
3. In 1972 Congress passed the Educational Amendments. One section of this law, Title IX, prohibits discrimination against girls and women in federally-funded education, including in athletics programs.
4. Hebdige, Dick, *Subculture: The Meaning of Style* (Routledge: London, 1979), p 95.
5. Donnelly, Trisha, "Why Don't More Girls Skate?" *Fabula* 1, no. 4. *www.fabulamag.com.*

Three:
Sex

Talking Dirty by Véronique Vienne

"Come in," said my friend. "I'll be off the phone in a minute. Then we can go to lunch." A features editor at a successful women's magazine, she is always busy, juggling multiple appointments and conversations with agents, stylists, consultants, and writers. So I stepped into her crowded office, sat down, and patiently killed time by staring out the window.

"We put a man on the moon," she was telling some freelancer at the other end of the line, "but we can't get him laid! What's the problem?"

I figured that she was talking to one of the writers of the magazine's famous sex advice columns. "We need to put more pressure on our readers," she went on. "You've got to tell them that they must make love to their husband or boyfriend at least three times a week."

I overheard some faint griping from the writer. "No, not two point five!" snapped my friend. "Three times. That's my bottom line." The way she slammed the phone down, you'd think she'd just made a final offer on a business deal.

Actually, she had. In our day and age, one can make a lot of money convincing people that there's something wrong with their sex lives. "You must be kidding," I told her as she was putting on some lipstick before grabbing her coat. "You can't seriously expect your readers to have intercourse three times a week on a regular basis with the same man. Come on, that's unrealistic."

"I know," she said, "but our job is to keep up the charade."

Young women, who are particularly vulnerable to suggestions, are always willing to buy products that promise to rev up their libido—and the libido of their mate. That's why the youth market is such a desirable one. Forget the kids' downy cheeks and sense of style. Gullibility is their main appeal.

Fueled by faux reportages that "change the names of the couples to protect their privacy," women's magazines engage in innocent skulduggery to raise the temperature of their editorial message. Whether they expose the wildly shocking, unbelievably sexy secrets of stars, or rate the ten most psycho

things readers do in the name of love, it's all wishful thinking. With sources that can never be traced, writers, often under phony names, are free to fabricate quotes, improvise survey results, or concoct Q&As. In a recent sex survey, for instance, I read that women my age make love to their spouse on the average twice a week. Get out of here. With a combined age well over a hundred years, my husband and I are lucky if we paw each other in the dark three times a month!

"We would fail our readers if we didn't help them feel sexy all the time," confided my friend as we waited for the elevator. "That's what they expect of us. In order not to disappoint them, we must come up with the same "How to Please a Man" story over and over. If we stop delivering the goods, our newsstand sales go down—and we lose our advertisers."

I chose not to comment. I knew better than to challenge the sanctity of the we-give-readers-what-they-want party line. Most magazines, in fact, are just as concerned to give advertisers what they want. Though editors like my friend are well aware of this predicament, they are reluctant to discuss the problem openly with even their closest associates.

Unfortunately for women, men, by and large, own the companies that advertise in their favorite magazines. More often than not, the conservative views on sex of these powerful captains of industry override the desires of female readers. For starters, women are never allowed to forget that Men Have This Thing. Gloria Steinem, who believes that sexual liberation means liberation from sex, failed time and again to attract advertisers to her feminist brainchild, Ms. magazine. And sure enough, magazines that get the highest number of advertising pages are the ones with coverlines that offer "25 Do-the-Deed Ideas to Take to Bed Tonight." Or promise to solve "Your Biggest Man Mysteries." Or ask "Are You Sleeping with the Right Man?" A recent issue of Marie-Claire had no less than four coverlines with the word "man" in them. Topping it all, the word "sex" was the same size as the logo. Not to be outdone, Glamour that same month flaunted four man-related coverlines—with, as a bonus, a swimsuit fold-out chart and a "Taste-Great & Touch-Me" beauty guide.

The indoctrination is so numbing, women have grown accustomed to it. By now, every woman in America knows that she has to do her Kegel exercises in order to strengthen her "love" muscles. Unless she squeezes her private parts ten times in a row at least twice a day, her vagina will become flabby. Perish the thought. She would be unable to tighten her internal grip around her lover's penis to increase the intensity of his orgasm.

"What turns your readers on?" I asked my friend as we worked our way up Madison Avenue toward her favorite Japanese restaurant. "How kinky do you have to get to keep them titillated? Phone sex? Prostitution? Voyeurism? Porn flicks? Cybersex? By now I assume that every one of your readers has a dildo stashed away in some drawer."

She wasn't amused. "These 'How to Make Love' articles are not soft porn," she argued. "They are very difficult to write. Few writers know how to stay girlish while being specific at the same time. To avoid the bodice-ripping genre, their tone must be all at once demure, cheerful, and matter-of-fact."

The sanitized words women's magazines choose to discuss sex reflect the sensibility of older male advertisers, not the sensibility of young readers. In real life, whether in the privacy of their bedrooms or online with their lovers, girls are not bashful when referring to the sacrosanct family jewels. And they describe their own antics in bed with verve, flair, and humor. But most important, they show real fondness for the men who drop their pants in front of them.

In contrast, in sex talk in women's magazines, tenderness is taboo. The fear of intimacy is so real, it's palpable. In a recent issue, *Cosmopolitan* promises an ecstasy exclusive on its cover: "Hot New Sex Position—a Move So Erotic You'll Wear Out the Mattress Springs This Month." Inside, the magazine introduces readers to the Amazing Cosmo Butterfly—a Kama-Sutra special sure to make him "feel supermacho." The fun and fearless female writer who bravely tried The Position lived to describe it. Her prose is brittle and exacting. She conjures up emotionally safe sex with a handful of colloquialisms (booty, lube, stud), plenty of teenage neologisms (superlift, nonacrobatic, superarousing, megahit), and, of course, scads of short words.

It makes you nostalgic for the robust and lusty language of male writers of yesteryears: Shakespeare, who described a woman copulating as "putting a man in her belly." Montaigne, who bemoaned the fact that "Our stubborn and proud member refuses to follow our mental or manual solicitations." Or Henry Miller, who confided that he thought his girlfriend "would burst into seeds" under his touch.

So visually permissive, our culture is verbally challenged when it comes to You Know What. In contrast to the provocative pictures of most fashion layouts, advertisements, and billboards, the words we use to talk about sex are downright prudish. President Clinton's sex scandal gave newscasters and commentators the jitters when they had to utter the word "semen" on television. This discrepancy between words and images is a lot more disturbing to me than the most explicit pornography-chic advertising campaigns. As far as I am concerned, reluctance to commit to the page the sensual beauty of sex is a form of censorship. Uninspired euphemisms have a muzzling effect on the soul. There is such a thing as poetic repression.

We've liberated images, now it's time we liberate language.

"One last question," I said to my friend as I unwrapped my chopsticks. "How do you come up with all those sex-by-the-number ideas month after month?" She looked over her menu. "We are a horny bunch at the magazine—none of us have time for sex, you know. We make up for it during our brainstorming sessions."

So that's it. To quote Hemingway: "The things you know well you can leave out and they will be there. The things which you don't know well you will probably over-describe."

Véronique Vienne is a freelance writer and author who lives in Brooklyn. Her essays on design, fashion, and cultural trends appear in numerous magazines, from Graphis *to* Martha Stewart Living *and* House & Garden. *Her books* The Art of Doing Nothing *and* The Art of Imperfection *were published by Clarkson Potter in 1998 and 1999.*

Death of a Porn Star by Nyier Abdou

A man walks into a trendy Manhattan lounge. He's decked out in seventies-era garb, meticulously chosen at just the right vintage clothing store in the East Village. It could be Gaultier and cost $400. It could be second-hand at the Army-Navy and cost $12. The ambiguity is the appeal. He's splashed it all up for the nineties, with Doc Martens, a well-groomed goatee, and a knowing grin that says, I'm working this because I choose to do so. He is greeted at the bar by a svelte product of New York chic (female variety): Little black tank and standard-issue black trousers. Could be Prada: $600. Could be the Gap: $23.95. She coos with delight, "You look like a porn star."

This is a compliment, by the way, an acknowledgment of a successful effort to ride the wave of an aesthetic sweeping through all areas of design—from mainstream advertising to the zebra-print bedsheets your friend proudly unveiled at his apartment last week, from the emergence of porn studies in university departments to the fascination with so-called sexual deviance. The image of the porn star has evolved in the cultural consciousness into an icon of sorts, a representation of fabulously outrageous behavior and pre-AIDS sexual indulgence.

The porn star is the mythical hero of an alternate universe, a hedonistic world where propriety and social mores are dwarfed by voracious sexual appetite. The porn-star hero raises sexual prowess to the level of a tool for success, prowling the land in a string of adventures, the populace at his libidinal mercy. This central concept, that one can conquer by acting on his most base desires, is instinctually attractive and has, through whatever means, been assimilated into the American mentality. There is a very real belief that lies latent in America's rapacious culture that equates "I want" with "I deserve," and finally concludes "I'll take." Greed is glamorous and shame is passé.

It is tempting to boil this trend down to the mundane truism that sex sells; more sex will sell more. If it doesn't sell a product, well at least it's

guaranteed eye-candy. The blatant sexual image has pervaded mainstream advertising in a crescendo of taboo-worship; in a conflation of the product with the thrill of something overt and unadulterated; in the ever-present "pornography chic." However, one can have too much candy and soon feel a little nauseous. An oversexualization in the constant stream of imagery bombarding the public consciousness will inevitably lead to a backlash against the sleazy and an appeal to the subtle-sublime.

The porn-star hero cannot thrive in our world. His powers of suggestion and triumphant escapades translate grotesquely in the blaring light of the mainstream. Depravity cannot sustain a glamorous image. The cleaner, slicker version of sex that is packaged and delivered on a billboard thirty feet high is sanitized for public consumption. The suggestive imagery remains but without the sordidness that is the inherent allure of pornography. What is subversive is by its very nature incompatible with mass appeal. The commodification of the look and feel of pornography is limited to an aesthetic—a style, an image—rather than a glorification of pornography proper.

It is not pornography that is chic, but a twisted and insidious aesthetic that draws on a celebration of tawdriness, a "disconnected, disaffected distance between emotional involvement and physical act that prevails in the faces of the performers. . . . modern and bored, false and funny . . . scary in a forgettable way," as William Hamilton described it in the *New York Times*.[1] However, this "pornography as style" loses its edge in trying to be edgy. Like the explosion of *Pulp Fiction*-style films that tried in vain to apply the grittiness and subversive style of a counter-cultural film to big-budget productions, an attempt to adopt only the sexual titillation of pornography is necessarily short-lived. The power of the subversive is that it remains on the fringes, partially hidden from view, to be indulged in with silent horror—a guilty fascination in knowing one's own depraved instincts.

The controversial sexuality of Calvin Klein's ad campaigns continues to belabor this point, highlighting an ineluctable brick wall facing the speeding train of pornography chic. The aggrandizement of pornographic imagery came to an anticlimactic end in the mid-nineties with the scandal raised around the 1995 Calvin Klein jeans campaign accused of crossing the line into child pornography. While the infamy sent jeans sales soaring, the pulling of the campaign set the marker for how far one can draw on the influence of porn. "Klein leaped over the line," wrote *Time* magazine's Margaret Carlson, "ultimately changing his image from avant-garde to creepy. These ads enter the heart of darkness, where toying with the sexuality of young teens is thinkable."[2]

Following on the heels of Calvin Klein's fiasco, a 1996 Guess? ad campaign was repudiated by *Marketing News* as being "pornography, pure and simple, worthy of *Penthouse* or *Hustler*," and an attempt to "outporn" Calvin Klein.[3]

The exercise was repeated in February of 1999, when Calvin Klein again acceded to pressures to take down a billboard in New York's Times

Square featuring two children clad in their underwear and standing on a couch—a significantly tamer and more lighthearted image meant to evoke a family snapshot. The *Christian Science Monitor*, pointing out the need for ad designers to "shock, stand out, and grab consumers in new ways," reported that "most people saw no problem with the pictures, thinking they were sweet and playful. . . . Still, many of them also believed the pictures could be seen as questionable when viewed in the context of the larger advertising culture."[4]

This hypersensitivity to the darker side of advertising—to what an image is meant to evoke, not just to what it looks like in and of itself—is rooted in the mistrust between a public that has become more design and marketing savvy and the designers who are trying to reach them. It is also the reason that pornography chic died before it could take root and grow into a true cultural movement. It was more like the "in" color of the season than a shift in the direction of design.

The tortured scuffle to stand out in advertising and design demands a gasp for the last frontier of sexual appeal. It is ludicrous to claim that sex could ever cease to sell; what changes over time is how we sell sex. While blustering conservatives bury their heads in their hands, calling our march into damnation, it is reasonable to consider the flip side of the trend: A plunge backward into imagery that leans heavily on understated, perhaps even wholesome, sexuality.

Thus, as the frenzy grows over the evolving aesthetic of overblown and forceful sexual imagery, the backward track is built alongside it, like a shadow culture, waiting in the wings. There is a growing thirst for a place where subtlety is king and the opacity of the sexual question swells into an erotic force. Inevitably, a reversion to the elegance of ambiguity will become a relaxing diversion from the exhausting tension of walking the line between art and corruption, a glimpse of Monet's *Water Lilies* after rooms of Robert Mapplethorpe. It's the stuff that backlashes are made of, and the aftershock of the death of pornography chic.

Nyier Abdou is a New York–based writer, currently residing in Cairo.

Notes
1. William Hamilton, "The Mainstream Flirts with Pornography Chic," *New York Times*, Sunday Styles (21 March 1999).
2. M. B. Carlson, "Where Calvin Crossed the Line," *Time*, v 146 (11 September 1995), p. 64.
3. Kirk Davidson, "Guess? Ads Cross Line from Fashion Art to Pornography," *Marketing News* (21 October 1996).
4. Alexandra Marks, "A Backlash to Advertising in Age of Anything Goes," *The Christian Science Monitor* (22 February 1999).

"I'll Teach You How to CK":
Madonna Sex by Michael Dooley

In November of 1992, Bill Clinton's presidential election was seen by
many as a triumph over conservative forces. Coincidentally, that was the
same month Warner Books released a 128-page book called *Sex*. It depict-
ed bisexual bondage orgies, toe sucking, ass biting, pubic hair shaving,
cross-dressing, oral and anal sex, masturbation, and rape. It even had teas-
ing intimations of golden showers and bestiality. But all the photos and
the writing were just make-believe, a collection of fantasies. As the book's
author, Madonna, proclaimed in her introduction, "Nothing in this book
is true."

Certainly, almost nothing in *Sex* feels genuine. That's because it's actu-
ally a fashion advertorial without the fashions: Instead of designer outfits,
it's selling the latest "style" of a pop entertainer. Like David Bowie before
her, Madonna has tirelessly reinvented herself for nearly two decades, each
incarnation extending her fifteen minutes of fame. Through a series of
shrewd maneuvers, she's managed to transcend the limits of her vocal
range and acting ability to become one of the most well-known women in
the world. Students of marketing could benefit as much from an analysis
of her career as from a study of Calvin Klein campaigns. Indeed, her book
shares the self-promotional spirit of Calvin-ism.

Calvin Klein has been generating reams of free publicity for as long as
Madonna has, mostly by pushing the bounds of acceptability in advertis-
ing. Back in the early 1980s, the company got the nation talking simply
by having Brooke Shields slyly contend that nothing came between her
and her jeans. Since then, to help promote its fashions and fragrances, the
company has used photos that hint at homoeroticism, heroin addiction,
and pedophilia. Inevitably, these campaigns are attacked by guardians of
civic virtue; even President Clinton publicly criticized a series that mimic-
ked the look of sleazy 1970s' teen pornography. And just as inevitably, the
attacks generate more sales.

Likewise, *Sex*—which includes Calvin Klein on its back-page "special
thanks" list—was released in a torrent of controversy that couldn't have
been better choreographed to achieve maximum media exposure. Religious
fundamentalists expressed heated outrage. Pundits discussed the book's
literary and sociological merits. Feminists debated whether it was
exploitative or empowering. And book critics responded with world-weary

boredom, with no effect on the bottom line: *Sex* was "review-proof." Retailing at $50, it sold half a million copies within weeks, and shot to the top of the bestseller lists.

Beyond the hype, another effective aspect of *Sex*'s sales strategy was that it came sealed in a Mylar bag. The bag—a foot wide and about fifteen inches tall—served several functions: It shielded the book from the eyes of minors, thus protecting distributors from obscenity charges, while forcing casual browsers to make a purchase to satisfy their curiosity. It also kept the promotional single—a tie-in with the release of Madonna's *Erotica* CD—securely inside the package.

The bag was literally brilliant as well: a shiny, eye-catching silver unlike anything else on display at the time. Madonna's face—reclined, lips parted, eyes closed, receptive yet tentative—commands the front of the wrapping. It's a remarkably compelling image: a steely blue blown-out, high-contrast photo in which all potentially distracting features have been dropped away, similar to a silkscreen "Marilyn" by Andy Warhol. The words "Madonna Sex" are centered in tastefully small, letter-spaced black Franklin Gothic. The come-on continues on the other side with a close-up of hands fondling flesh.

Although *Sex* was originally hailed by many as a taboo-breaking work, the fuss seems wildly excessive in today's climate, where a Gap jeans dress that came between a United States president and a White House intern is the topic of public discourse for several months. In retrospect, while the book is hardly transgressive, it does have certain merit as graphic design.

Through her career, Madonna has been paired up with highly talented designers such as Margo Chase, who produced the strikingly aggressive, yet elegant, vaginal iconography for *Immaculate Collection*, Madonna's greatest hits CD. *Sex*'s cover and layout is the creation of Fabien Baron, who, perhaps not so coincidentally, had become creative director for both *Harper's Bazaar* and Calvin Klein at around the same time he was working on the book. The package—hefty at a couple of pounds—offers a provocatively tactile experience, its contents suggestively sensed rather than seen. Gaining access gives the owner a pseudo-kinky interactive kick: The wrapping needs to be penetrated and torn, irrevocably violating its virgin state.

Once inside, the tone and texture becomes harsher as the reader is confronted with icy die-cut industrial aluminum cover and cardboard pages held together with a wire-o binding. Unlike a perfect-bound book, in which the spreads form inner thigh–like curves while nestling in the reader's hands, *Sex* doesn't need to be held to stay open; it simply splays flat. This mood of defiant arrogance is carried into the book with a full-bleed black-and-white photo of Madonna in mask and bondage harness gear. A nipple pokes out of the cutout of her studded leather bra as her right hand grasps her crotch between spread legs. She sucks on the middle finger of her left hand as she stares sidelong through a mask, avoiding the viewer's gaze. The copy on the facing page—Bauer Bodoni double-printed off-register so it appears agitated—explains, "I'll teach you how to fuck." The suggestion is of an instruction manual, with the emphasis on "manual."

The photos are by fashion's Steven Meisel, who has done ads for Calvin Klein, including the 1995 CK campaign than raised Clinton's ire. He had also depicted Madonna in a variety of Marilyn Monroe poses for *Vanity Fair* a year before working on the book. More imitator than originator, Meisel's ability to adapt genre styles makes him a natural match for the chameleonlike star. In one shot, he portrays her as a whip-wielding dominatrix in a camp parody of 1950s schlock fetish photographer Elmer

Batters. Her pose is stilted, her attitude is disengaged, bored, joyless. Rather than sexual heat, the scene raises jaded smirks at the calculated silliness of it all. The picture, and the book, is a work of postmodernism, with all the ironic distance and emotional sterility implicit in the term.

Of the book's many photos, the few that actually strike a note of honesty are those in which Madonna most thoroughly abandons herself to her narcissistic self-absorption, such as when she massages herself with a platform shoe or hovers spread-legged over a mirror. Mostly, though, her blond hair, pale skin, and makeup, her distance from others and mugging for the camera, all conspire to ensure that she's the focal point of almost every photo. In shots derivative of Meisel's fellow fashion photographers Herb Ritts and Bruce Weber, models become mere background props. Even celebrities like Naomi Campbell, Big Daddy Kane, and Isabella Rossellini are subservient to the Mistress of Manipulation. In the absence of any real engagement between individuals, much less passion, *Sex* is drained of any real sex. The book would have better justified its existence if it had been called *Ego*.

Speaking of ego, it's worth noting that Meisel, in a fit of hyperbolic chutzpah, claimed that, after *Sex*, no one else need do another photo essay on erotica. If he had been sincere about creating a classic of the genre, he would have been more demanding of himself in his selection of sources to appropriate. His portraiture could have been informed by the sensuality and tenderness of Edward Weston's nudes or the playful exuberance of Man Ray's. Similarly, his S&M club scenes could have shown some of the warmth and affection of Brassai's Parisian bar and bordello photos. Or, alternatively, he could have discarded artistic pretension altogether and mimicked the lowest of lowbrow sex rags with depictions of hot, sweaty, out-of-control bodies, while adding a subtext of wit and grace. Instead, all too many of his shots are hopelessly inert.

Baron's use of multiple exposures, word-and-image layering, color separation tricks, and other willfully crude devices may be a covert acknowledgment that so many of the photos are too banal to stand on their own. His high-school notebook graphic treatment of the text may also be a comment on the adolescent nature of Madonna's pornographic and philosophical ramblings. It's unlikely he believed he was contributing to an enduring work of erotic art, particularly since he must have been aware of the book's poor production values, which caused the metal spine to become mangled and the pages to fall out after just a few viewings.

So it is that, in the end, Madonna does teach us how to get fucked: Under the flashy makeup, *Sex* turns out to have been a whorehouse novelty act, one that was quickly used up and discarded. The madams publishers and authors—made their money and the johns—with their disposable income and questionable aesthetic taste—had their brief diversionary dalliance. And the pop-culture cycle of commerce was complete, primed for the next passing fashion.

Los Angeles–based creative director and Print *contributing editor Michael Dooley writes on a variety of topics for graphic design publications.*

Mind over Merkin by Francis Levy

It is only shallow people who do not judge by appearances.
 —Oscar Wilde, *The Picture of Dorian Gray*

Merkins are headed for obsolescence, if not total oblivion. Pubic wigs will
go the way of the Royal typewriter, the rotary phone, and the letter, if the
current crop of fashion photographers continues to propagate the image of
Kate Moss's childlike beauty as the ideal of womanhood.

The *New York Observer* runs a front page piece entitled "What's New,
Pussycat? 90s Women Adopt Sleek New Look Down Below." The puta-
tive subject is Manhattan's trendy J. Sisters International salon, which
attracts many well-known models and actresses for the "Brazilian bikini
wax," a painful process by which all pubic hair is removed.

Naturally, the celebrities who head the client list at J. Sisters, reflect an
idea of beauty that is engendered by fashion photography. The July 1993
issue of *Harper's Bazaar* heralded the " . . . new wave of waiflike, nubile
models who are increasingly peopling the pages of glossy magazines all
over the world. . . ." Photographers Mario Sorrenti, David Sims, and
Corinne Day made their reputations producing ethereal apparitions whose
innocence was deemed to be a rebellion against stereotypic depictions of
women with full breasts, buttocks, and the classic Venus mound. "I love . . .
things like bad posture, vacant stares, skinniness . . . they're normal to
teenagers. Women have forgotten what it's like to be young," Corinne
Day told *Harper's Bazaar* at the time.

The nude image of Kate Moss lying face down under the Calvin Klein
Obsession for Men logo represented a controversial culmination of this
trend. Significantly, it turned out that many of the models in cutting-edge
ads in magazines like *Ray Gun*, *Interview*, and *Detour* derived their emaci-
ated appearance from heroin. The phenomenon of "heroin chic" scandal-
ized the fashion industry when Davide Sorrenti, the wunderkind twenty-
year-old photographer and brother of Mario, died of an overdose of hero-

in, and Kate Moss, the child-woman of the Calvin Klein fashion show, ended up in rehab.

All photography provides ideal images whether they be representations of beauty or ugliness. Thus Jock Sturges's portraits of nude teenagers present one kind of beauty, while the fully developed females of Lee Friedlander's art photography, with their unshaven armpits and pudenda, exalt the notion of the mature female form.

Although the choice of subject is all-important, fashion photography depends on style, pose, and setting—which enable it to deliver its message or vision. In this regard, film has an enormous impact on creating the mythologies that have influenced so much fashion photography. The hirsute heroines of the Italian neorealist cinema, for example, created a fully ripened ideal of the female. To shave the armpits of an Anna Magnani would have been tantamount to clitoridectomy. Helmut Newton's work, with its penchant for revealing unshaven female bodies, is the most prominent example of the effect of Italian neorealism on fashion photography.

Fashion photography of the sort exemplified by the Obsession campaign derives its impetus not only from drugs, but from a radically different source. It's a product of the pedophilia that's evidenced in the pornographic cinema and in the burgeoning popularity of publications like Larry Flynt's *Barely Legal*. It's no coincidence that waxing is the style of choice amongst many porn stars and strippers today.

Youth versus age, nubility over development. It's not hard to understand why the fashion photographer has picked up on the same longing for virginity and untrammeled beauty that seems to drive the pornographer. Everyone wants to be young. What's perverse is the impossibility. Many of the models and photographers who initially provided the impetus for the images that filled the pages of both men's and women's magazines in the early nineties have become passé, but their legacy remains. The artificial notion of the woman who in the process of maturation is turned back into a girl continues to hold sway. The end result of this aging process, in which breasts, pubic hair, and a reproductive system are biological by-products, is a woman who through waxing and diet can be turned into a child. The fetish at the heart of the whole Obsession for Men phenomenon is the desecration of the prepubescent female, the rape of a child. Is it too far-fetched to assume that the offspring of such a union will not be that of the victim (who in this fantasy world is ostensibly as yet unable to conceive), but of the rapist himself—reborn as the eternal infant he or she has always wanted to be?

Francis Levy's criticism, humor, and short stories have appeared in numerous publications, including the New York Times, *the* New Republic, *the* Village Voice, *and the* East Hampton Star. *He recently completed a novel and a screenplay adaptation of Dostoyevski's* Crime and Punishment.

Shave, Wax, Depilate by Ellen Shapiro

There's no question that the curve of a breast is desirable. More than a curve, a mountainous descent, a cavern, between two breasts. The deeper and more mysterious, the better. Flat is out (more or less). Even perfect Elizabeth Hurley in Estée Lauder ads flaunts trailer-trashworthy cleavage. Just cleavage, though. No nipples or anything like that. No.

Everyone knows just where to stop. No blurred edges of areola peeking out. Even a fraction of an inch of ruddier, smoother skin? Never. Even in Victoria's Secret catalogs, the purpose of which is to celebrate and enhance such things, the most gossamer bra reveals . . . nothing. Under "our sheerest fabric ever" we cannot hint at—what? Mucous membrane? Tiny orifices out of which spurt bodily fluids? God no. We can't talk about that kind of thing, much less show it. I can't even write about it. My pen stops and I start to hyperventilate.

Hair is an even more curious phenomenon.

There is not even a shadow of pubic hair visible through the most see-through panty, Victoria's Secret or otherwise.

Once upon a time, I worked for two weeks at Frederick's of Hollywood. In the basement of an iridescent purple building on Hollywood Boulevard I pasted up catalog pages of crotchless panties and demi-bras and wrote captions like, "He'll want to plunge deeper, deeper . . ." Anyway, there wasn't a hair in sight, even in the wide welcoming gap of a crotchless panty. Mr. Frederick, a Puritan if I ever met one, would have never approved. Neither would the consumer.

How uncomfortable would that single hair make us feel? Would we get creepy-crawly—or excited? I can glance up at a hunk of male flesh on a Calvin Klein billboard in Times Square, and even with a modest bulge hinting at potentially great things, it doesn't affect me. I can walk or drive by without getting heated up. It's just an artificially sculpted body in a pair of white cotton underpants. But what if two or three dark, curly hairs peeked out? I would probably veer off the sidewalk in a daze, drive into a

parking meter. Little beads of sweat would pop out on my lip. No. No hairs to disturb my businesslike day, please.

The hair on one's head should be a mane, luxuriant and full. Losing it is a tragedy. Pity those poor schmucks who have each dead follicle replaced at the dermatologist's, plug by bloody plug. But elsewhere on the body it's verboten, taboo. Well, a touch of golden fuzz is allowed on male models' arms and legs. A shadow of scruffy beard on a rugged face makes a statement. All other hair: banished. Chest hair, out! Back hair, feh! Women must be as smooth as an alabaster statue of the virgin. Take your choice: razor, wax, depilatory, tweezers, electrolosis, laser treatments. Slavery for life. The makers of "Ultra Hair Away" claim that their $39.95 enzyme-based hair-removal spray is "the greatest invention of the 20th century." Advertising has it easy with digital retouching.

Last year the *New Yorker* ran a "Talk of the Town" piece on Madonna's wax technician. The rigors of Madonna's career require her to be regularly waxed from hairline to toe tips—brows, chin, lip, arms, underarms, "bikini line," legs, toes. No one notices those three or four hairs on your big toes. The camera does notice hers, though, poor thing. Ouch!

How did our culture get this nutty?

Richard Zacks may have touched on the answer in *History Laid Bare*, a book of anecdotes about sex through the ages (HarperCollins). "Virgin brides had all their body hair removed for the first time during an elaborate nude wedding shower held at the [Turkish] baths," he wrote. "Some scholars contend that the dark tufts and hairy legs on the teens were meant to act as a kind of sexual deterrent, a sort of hirsute chastity belt to ensure virgin brides."

That's it: a hirsute chastity belt! Exactly the opposite of Mother Nature's intent, which, as explained in college biology, is to attract members of the opposite sex with come-hither pheromones and such. "Unsightly," said two thousand men when asked about women's body hair in a survey sponsored by, as you might expect, the makers of Nair. "Yuck." "Repellent." Imagine Cindy Crawford with few bikini hairs peeking out, or hairy thighs, or a hair sprouting from her famed mole.

Although advertising and catalogs and television are constantly pushing the limits and redefining the rules (imagine those guys-taking-a-pee scenes in *NYPD Blue* happening even five years ago), there are some lines that apparently will never be crossed.

"Everyone knows what the rules are," said an in-house attorney at ABC-TV in New York. I pressed her for more details. Is there anything in writing? Any code? "No, nothing," she said. "We judge on standards of good taste."

I found that hard to believe, so I asked Alta Vista the question, "Are there decency codes in advertising?" It found 2,043,130 Web pages, most having nothing to do with the subject, several excerpting a 1998 United Kingdom survey that verified that a certain organization would remove offensive posters, should there be too many public complaints.

So I asked Alta Vista another question: "Why is there no pubic hair in

Victoria's Secret catalog?" I didn't get an answer at all. Instead I got sites like this: teen pussy black pussy sex hot celeb pamela lee kitty anderson traci lene nude teen pussy nude blow jobs *teen pussy black pussy young teen pussy phone sex ebony pussy gay pictures teen fuck anus hot teen pussy pamela anderson nude* . . .

Oops. Speaking of teen pussy, one of my friends reports that her fourteen-year-old daughter asked permission to shave off her pubic hair. Why? The poor, misguided (normal, healthy, all-American) girl thought there was something wrong with her body because *no one has any hair down there* in ads or catalogs. And you thought advertising featuring sexy, hairless models was a relatively harmless way of showcasing products? They're selling something else, aren't they? Something unattainable. Oh, but it *is* attainable, you say. All you have to do is starve yourself into thinness (keeping the breasts full and rounded, of course). And shave, wax, depilate, tweeze, electrically zap, or laser-remove yourself into hairlessness. Then, just have your nipples removed. You'll look just like the models. You'll be perfect.

Ellen Shapiro, a graphic designer and writer, is president of Shapiro Design Associates, Inc., and Alphagram Learning Materials, Inc. in New York City. She has contributed more than sixty articles to design magazines including Communication Arts, Print, *the* AIGA Journal of Graphic Design, Critique, *and* Garden Design, *and is the author of the books* Clients and Designers *(Watson-Guptill, 1990) and* Ready, Set, Read! *(Alphagram, 1999).*

Between Flesh and Hardware

by Nancy Nowacek and Elena Gorfinkel

Bauhaus Master Walter Gropius proclaimed in 1926, "We want to create a clear organic architecture whose inner logic will be radiant and naked, unencumbered by lies, facades and trickeries: we want an architecture adapted to our world of machines, radios, and fast motor cars, an architecture whose function is clearly recognizable in the relation of its form."

Amidst the sweeping modernization of the early twentieth century, it was impossible for Gropius and many of his colleagues to envision a world that was both decorative and mechanical. The delicately curved cornices, elaborately carved facades, and fragile twisting ironwork so prized by the architectural academy were, in Gropius's estimations, analogous to the deceptive and inhibiting bustle of women's skirts, and just as distracting. In a sense, the sensuality of design was under attack. In order for architecture to survive the technological advancements of the day, it would have to become more machinelike, and in doing so, strip itself of all unnecessary decorations and excesses. Any form would emerge naturally and logically from utility, rather than applied ornament. Sensuously detailed facades should be forgotten in favor of the inner workings of the structure, which when freed of its fleshy skin would become exposed and visible—support and surface.

In 1999, one again finds this same impulse, but this time in fashion. One may substitute "fashion" for architecture in Gropius's statement, and find a current trend, merging technology and the body. Well, at least for a season or two. "WORK IT: The modern thrust is for clothes to do a job. By fusing high fashion and function, designers are right on track with technically advanced sportswear. Vital details include Velcro, oversized hooks and eyes and magnetic fastenings," announces *Scene* magazine. Today, how we look and what we wear—our fashion identity—is as dependent on technology as Gropius had expected architecture to be. Or so advertisers would like us to think. Presently, our visual culture is saturated with images blurring the differences between flesh and hardware,

male and female. From the Gap to Prada, Madonna to Björk, an asexual mechanical corporeality emerges from the formal language of line, texture, surface, and material that veils conventional archetypes of sex, gender, and embodiment.

Fashion has historically been concerned with carefully honing archetypal versions of Male and Female, filtered through the glamorous lens. Fleshy, curvaceous, big-haired femininity was embodied by Marilyn Monroe in the 1950s, Brigitte Bardot in the 1960s, Charlie's Angels in the 1970s. Rough and muscular masculinity followed the celebrity continuities of John Wayne, Robert Redford, Clint Eastwood. As late as the 1980s, we find these archetypes fully intact, from the *Dukes of Hazzard* to *Moonlighting*. Desire was induced and circulated by these gendered typologies.

The eighties also exemplified the limits of spectacle and excess in fashion. Almost baroque in its extravagance of moneyed style, Versace's fashion was infamous for its glitz and impracticality, with heavily beaded and sequined surfaces, fiery colors, and intricate cuts. Stiletto heels and shoulder pads further embellished the female form, even in work wear, while the flowing line of generously proportioned suits masked the male musculature. Expensive Italian loafers, worn leisurely without socks, were meant for anything but walking. Every trapping of style in the 1980s was more concerned with showcasing wealth than serving a need. Liberace never intended to go grocery shopping in his rhinestone-studded fur coat in the hot Las Vegas sun.

A decade later, we've found ourselves swept along in the current of technological change. The laptop has revolutionized café society; the cell phone and Palm Pilot have made information and communication portable. Perhaps Gropius was right: It's far easier to move with the current than against it. The fashion world seems to agree. Streamlined forms and hybridized fabrics (synthetic and/or translucent) recall the modern while merging with the digital. The coded uniform of the young urbanite reinforces an allegiance, a utopian belief in the democracy of technology. It began with Nike's reflective silver Air Max sneaker. Nike parlayed its dominance as producer of high-tech athletic wear into a sub-brand called All Conditions Gear, and Adidas, Speedo, and Puma quickly followed suit with various iterations. The staple of every fashion-forward wardrobe now begins with a newest model of cross-trainer. In turn, Prada has pioneered a streetwise scuba boot featuring a one-piece molded rubber sole comforting to the contours of the foot. Extending the ethos of utility, Helmut Lang and Miu Miu, amongst others, offer strap-on arm- and legband purses—no longer a separate entity like the handbag or tri-fold wallet, but attached directly to the body, as prosthetics.

Technology has infiltrated not only the design of clothing but also our conceptions of glamour. The current fashion climate rejects past incarnations of sex and desire. Fleshy curves have been stripped away to reveal the honesty of the skeleton. Accordingly, models' bodies now represent this utilitarian economy of form. Whereas the conventional male figure was strong, solid, and broad-shouldered, and the female, curvaceous and

feminine, their ideals have merged into a sinewy, exoskeletal prototype. Whereas in earlier eras, women strove to emulate Brigitte Bardot, as teased-hair seductresses in order to win the affections of compatible "Steve McQueens" (and vice versa), today both women and men strive to look as functional as possible. Decadence has been whittled down to austerity. Self-discipline and efficiency are prized over self-indulgence. The closer we can come to the mechanical, or even the digital, the better.

Fashion in turn impels this newfound inclination. Both male and female models assume the composure of automatons, presented in an androgynous manner, with stiff posture and deadpan expression. For example, Gap ads serially feature models in denim and cotton, their figures isolated against a white seamless ground, staring blankly past the camera's eye. A Dolce & Gabanna ad displays male and female, centered in the frame, flanked by identically draped windows and dressed in almost identical clothing and matching lockets—giving the impression of identical genderless mannequins carefully composed in a storefront.

Most extreme in their pretense are recent Prada ads. One features a male model awkwardly posed in a monochromatic suit, set flush against a blank background, an airplane window receding behind him. Another juxtaposes a leaping woman against a skyscraper, the woman's body dwarfing the building. Embellishing the body's relation to the translucency of the building, the image appears on semitransparent heavyweight vellum. The vellus page is followed by a most minimal, almost blank, white page, branded solely by a thin red line, an 8-point "Prada" reversed out of it. As is demonstrated here, in fashion's affair with technology, fashion effaced itself in deference to utility and efficiency. (This season.)

In promoting an aesthetic of technological assimilation and displacing the Playboy bunny pinup model of sexuality and desire with one of ostensibly functional and spare form, fashion has declared technology and "high performance" the currently desired ideals. The sexed materiality of the body is now one, as Gropius had hoped, for speed, machinery, and the future. Next season is another matter . . .

Nancy Nowacek is a designer with an M.F.A. from Virginia Commonwealth University. She currently resides in Brooklyn.

Elena Gorfinkel is a Ph.D. candidate in Cinema Studies at New York University. Her previous publications include articles in Merge, 21C, Zed, *and* Flesh Eating Technologies *(Semiotext(e) forthcoming).*

I See London, I See France, I See Calvin's Underpants . . . by Pamela A. Ivinski

An obsession with underpants is essentially childish, whether it takes the form of kids' rhymes or the behavior of Freud's classic fetishist. Horrified by the woman's lack of a penis because this means his own organ could be lost, the fetishist fails to become a successful adult heterosexual, instead investing his desire in some substitute for the missing female phallus—the underpants that cover the female genitals, for example.

Calvin Klein has made a career out of an "obsession" with underpants. His personal sexuality, though often commented upon, is not at issue here. His exhibition of (or implication of the absence of) undergarments on the bodies of children (or models understood by the public to be children) in advertisements is my concern. Our reaction to these images, and in particular, our horror at the 1995 CK Jeans print and TV ads likened by observers of all political persuasions to "kiddie porn," reveal that his obsession is no less ours. The fetishist, according to Freud, is marked by a need to believe in two contrary ideas at once: He knows the underpants are not the "real thing" because he's seen so with his own eyes, but his fear of the real thing is so great that if he were to admit his delusion he could no longer have any pleasure. The story of Calvin Klein, his "kiddie" models, and his/their underwear, now nearly twenty years in the making, is rich in seemingly contrary ideas and positions: Ads or porn? Children or adults? Amateurs or professionals? Real or staged? Straight or gay? Accidental or calculated? Avant-garde or obscene? Klein said of another controversial product of 1995, Larry Clark's movie of unbridled, underaged sexual conquest, "Not only do I see similarities between our ads and *Kids*, but I guess [Clark and I] both see something that a lot of people don't want to see"(*New York*, September 18, 1995). What did *we* see—and at the same time refuse to see—in those 1995 ads? And what did Klein actually show us?

The answers suggest that we, like classic fetishists, know we didn't see the "real thing," but to admit as much would be to call into question issues far beyond the propriety of a single ad campaign. Whether our personal

beliefs follow a strict Freudian path, lean toward a feminist reading of castration anxiety as resulting from the loss of blissful unity with the mother's body and an ongoing fear of death, or whether we think that Freud, like many a child's underpants, was completely full of shit, there's no denying that Klein's 1995 CK Jeans campaign pushed everyone's psychological buttons. This may be because it showed us that we are so deeply invested—psychically and fiscally—in consumer capitalism that even the worst transgression, a crime against childhood innocence, must go unpunished. We've literally bought into Klein's obsession, and our wailing about it merely serves to cover up the high price of business as usual.

Klein first flirted with pedophilic obscenity in 1980 when he cast fifteen-year-old Brooke Shields as the star of an ad campaign hyping his line of designer jeans. "You want to know what comes between me and my Calvins?" Shields asked in one TV commercial, titled (ironically?) "Feminist II." The answer—"Nothing"—was shocking, rather than coyly ambiguous, to some, especially in combination with camera work that stayed close to the curves of her body. The allusion to a pantyless Brooke, the idea of intimate contact between her private parts and a pair of pants so cozily denoted by the designer's first name, was too much for some viewers, who saw child pornography, not advertising, despite the "high art" credentials of Klein's collaborator, Richard Avedon. The spot was restricted to after 9 P.M. in some markets and withdrawn in others, and the episode led to the resignation of the president of Klein's manufacturer, Puritan Fashions.

Yet Shields at that moment could not be characterized as embodying a puritan persona. A few years earlier, in the movie *Pretty Baby*, she had played a nineteenth-century New Orleans prostitute's daughter who was auctioned off to a photographer obsessed with her. Even before that, Shields had posed naked for a photo in the book *Sugar and Spice* (as in "that's what little girls are made of"), published by *Playboy*. (She later sued the photographer to prevent further dissemination of the picture.)

The 1980 Shields campaign played upon the ambiguities (Child or adult? Innocent or experienced? Getting dressed or undressed?) that would come to dominate Klein's ad aesthetic. The artifice of a child mouthing lines more suited to an adult took full advantage of Shield's childish innocence. At the same time, the lines counter claims of exploitation by making references to her real-life worldliness. In another commercial from the 1980 series, she claimed, "Whenever I get some money I buy Calvins, and if there's any left, I pay the rent." The idea of the glamorous, successful Shields barely eking out a living seems ludicrous, as does the idea of this clearly pampered fifteen-year-old having to choose between designer jeans and rent money, yet part of the Shields discourse at that time centered around the idea of Brooke supporting her divorced mother, Teri, the very definition of a stage mother.

A third commercial from the 1980 campaign prefigures the 1995 "kiddie-porn" campaign in its inclusion of an off-screen character. A male voice comments, "I always thought beauty must be as isolating as genius,"

to which Shields replies, "My mother warned me about boys like you," and then, addressing the camera, "Mama said he's only interested in my Calvins." Invoking "mother" twice for protection, the lines emphasize the childishness of the speaker. Yet the warning is disingenuous when one knows that Shields's career was built upon her mother's willingness to rent out Brooke's precocious sexual appeal.

Undergarments—or lack thereof—in Calvin Klein ads attracted controversy on a number of additional occasions between 1980 and 1995. Boygroup singer turned actor Marky Mark Wahlberg became simultaneously an object of intense female desire and a gay icon when a billboard outlining every bulge of his pumped-up physique dominated Times Square. Kate Moss appeared in numerous ads in which she revealed her bare bottom or cupped her naked breasts. If Shields as a child possessed a remarkably adult beauty, Moss represents the reverse: an astonishingly childish appearance for a fully adult woman. Klein has drawn criticism for using Moss, accused of promoting both an unreachable ideal of "waifish" beauty by featuring her unusually slim appearance and drug use by placing her in ads identified with "heroin chic."

The pinnacle of "heroin chic" (if such a thing is possible) was closely connected with Klein's ads for CK One, the "unisex" perfume that enjoyed one of the most successful fragrance debuts in history. The ads incorporated a lineup of multicultural and pansexual androgynes, shaved, tattooed, and pierced in places your mama warned you about. In fact, they seemed calculated to separate the mamas from the boys in a way the ads for "Calvins" never did. While the Shields campaign strove to appeal to consumers of all ages, the physical accoutrements of post-grunge culture were clearly employed in CK One ads to mark a distinct boundary between the target audience and its parents.

The CK One ads also differed from their predecessors in the use of "real people" (something stressed by both those who supported the ads and those who opposed them), despite the fact that a few professional models, including Moss, were mixed into the crowd. Klein employed these "real people" in the CK One and CK Jeans ads, he told *New York* magazine in 1995, "So the world can see this is the way it really is. And I think that's why people have identified with a lot of our images—because they're very real; there's nothing artificial. And sometimes they're frightening." Frightening here is synonymous with threatening, guaranteed to scare parents for instant kid credibility.

"Real people" also starred in the 1995 CK Jeans campaign, but parents, conservative organizations, and the paternalistic media were suddenly frightened for, rather than frightened by, these youngsters. John Leo declared in *U.S. News & World Report*, (August 28–September 4, 1995) "These are creepy pictures . . . Some of the teens look coaxed into posing. Others seem like they're wearily going through the motions for a customer. It's not just in our face and totally inappropriate on buses. It's decadent." Margaret Carlson, in *Time* magazine (September 11, 1995), noted, "These ads enter the heart of adult darkness, where toying with the

sexuality of young teens is thinkable. One of the most offensive segments poses a young man alone, his face in that numb, deadened look associated with films that can be bought only in an adult bookstore." Even NAM-BLA (North American Man-Boy Love Association) supporter Camille Paglia proclaimed in the *Advocate* (October 31, 1995), in response to Klein's statement that the ads were meant to demonstrate the "real strength and character" of today's young people, "The Klein ads couldn't care less about the individuality or inner life of the young, who are shown caught and caged by manipulative, jaded adults. It's the banality and claustrophobia of these images, not their adolescent eroticism, that makes them so unpalatable."

Most commentators, like Leo and Carlson, refused to distinguish between real porn scenes and the self-conscious allusions to porn scenes portrayed in the CK Jeans ads. Despite Klein's assertions that his images were "very real" and "there's nothing artificial" about them, the 1995 campaign could not have been more deliberately constructed. Larry Flynt was one of the few to note that "none of these kids was nude, and none of them was engaged in sex . . . Dirty minds are jumping to conclusions" (*Advertising Age*, September 18, 1995). But the audience, in this case, chose not to see the artifice, knowing that to see that these ads were not the "real thing"—were actually pornography—would be to admit complicity in advertising's exploitation of children and to negate many of the unacknowledged pleasures of consumer culture.

The 1995 CK Jeans campaign had its genesis in a *L'Uomo Vogue* pictorial feature on men's bathing suits shot by Steven Meisel, best known for his work on Madonna's controversial *Sex* book. Two scrawny male models vamped in a setting reminiscent of a seventies "rec room," complete with purple carpet and panel-covered walls. This setting, transferred unchanged to the 1995 ad campaign, was universally identified as signifying "porn," though how many of us are willing to admit that we're familiar enough with porn to make this call? Kris Coppieters, in an essay published online at Emory University's *alt.journal* site, was bold enough to describe the print images as "extremely evocative of what are sold in the backs of porno magazines as 'picture sets'—crude snaps taken in someone's suburban basement and sold as masturbation material," and explains that such images "often escape prosecution as pornography for the simple reason that while the photos are often purposefully suggestive and sometimes even accidentally erotic, the models are often not even naked."

Meisel, Klein, and creative director Fabien Baron, working with Klein's in-house advertising entity, CRK, translated the *L'Uomo Vogue* pictorial into a campaign comprising TV commercials using the same "rec-room" setting to simulate amateur porn-movie auditions, and a set of print ads featuring images that resembled stills or snapshots from that amateur movie set. According to *Time*, Meisel planned to hire the host of a gay-porn video review show to narrate the commercials, an idea nixed by Klein. But the anonymous, never-seen figure who lewdly questions a young woman whether she likes to "take direction" and urges a young

man to rip off his shirt sounds sufficiently pornographic in his
intentions to raise the suspicions of viewers. And the print ads seemed
obscene even to viewers unaware of the porn-movie audition premise of
the TV commercials.

Why did the print ads seem so indecent? Or, to be more precise, why
did the models in these images seem to be more exploited than the barely-
clothed young people in countless other ads? To my eyes, it's the invisi-
ble—but implied—adult presence in this campaign that inspired panic.
We're accustomed to seeing sexualized young people in print ads, com-
mercials, movies, and TV shows, but we have little reason to consider who
is responsible for presenting them in that way. In the CK ads, however, we
are confronted with a surrogate exploiter or pedophile: the narrator or
"director." This figure's identity remains in doubt because he's never on
screen. Hysterical media commentators and religious organizations were
quick to identify him as Klein, but his invisibility also means that he could
just as easily stands in for the complicit voyeur/viewer/consumer/parent—
for us, in other words.

Even without the sinister voice of the off-camera narrator, the CK print
ads imply a controlling adult presence. In spite of the reference to amateur
pornographic picture sets, nothing could be less "accidentally erotic" than
these ads. It's difficult to see the underpants peeking out beneath a young
man's shorts or the hem of a young woman's skirt without imagining some
stylist yanking at them to arrange for just the right amount of exposure.
Compared to the models in the original *L'Uomo Vogue* pictorial, who romp
in campy fashion, the young people in the CK ads do seem "caught and
caged," as suggested by Paglia, their images cropped closely, their bodies
posed motionless and backed up tightly against the vertical bars of those
tacky paneled walls. While each *Vogue* image is aligned vertically on a
single page, most of the CK ads take up two-page spreads, with models
arrayed horizontally and stapled in the middle like centerfolds. One of
the *Vogue* models has shocking-pink hair, the other tugs at the back of his
own skimpy trunks like a Coppertone baby grown up and gone bad; each
is depicted at least once with a cigarette in hand. And while clearly dis-
played for the leering gaze of the reader, these young men leer back. The
CK models, in contrast, stare more enigmatically at the camera, their faces
blank enough to receive the projections of viewers. (One of them, the
young man with the dolphin tattoo and black fingernail polish, appeared
in both the *L'Uomo Vogue* spreads and the CK Jeans ads.)

These pictorial devices—tight cropping, exposed undergarments and
bodies, blank faces—are conventional advertising tropes. What else makes
the images from this particular campaign appear so lewd? After all, the
picture of the young woman on the floor with fingers at her mouth is but
another variation of Brooke gyrating in her Calvins. But here we have
young men. Their visual display still gets a rise out of us, though we're
quickly becoming inured to the physical charms of well-muscled male
models, usually displayed participating in pseudo-aristocratic outdoor
activities (in Ralph Lauren ads, for instance). The young men in the 1995

CK ads, however, repudiate both the hypermasculinity and upper-class pretentions of most designer clothing ads, and this conjunction of gender and class anxiety pushed the ads beyond the pale.

Adweek's Barbara Lippert was one of the few who understood this, writing, "Girls have been objectified forever. But an old man with a gravelly voice in a basement questioning a boy, that's creepy. It's the grunge, antidesign, white-trash-chic message Klein was after" (September 18, 1995). The link between the fear of a predatory sexuality and an amoral underclass is located in the basement, the unconscious of the American home. We find dusty old canvases that turn out to be million-dollar paintings in our attics; we find garrotted baby beauty queens in our cellars. What we've consigned to the basement is not so much our fear of pedophiles or Jerry Springer's America, or our inability to imagine homosexuality as anything other than something forced upon young people. Rather, it's the acknowledgment that we, no less than Teri Shields or Patsy Ramsey, participate in the exploitation of children, sexual and economic, nearly every time we buy an item of clothing or a magazine, or attend a movie, or allow our own children to do the same. The CK Jeans ads stage this exploitation, allegorically representing how the advertising industry takes advantage of children.

These ads seek a response from adults similar to that felt when watching the scene in *Boogie Nights* in which Julianne Moore, in "real life" a very good actress in a critically respected film, plays a very bad actress playing a cheesy porn scene: The "joke" turns on our recognition of the scene's self-reflexivity. Most kids didn't catch the porn reference in the CK ads, as interviews with them indicated—but they probably didn't find the situations depicted to be all that unfamiliar either, living as they do in a world where their sexuality is constantly appealed to but denied, and accustomed as they are to adults' intrusive questions and controlling gestures. Adults who should have seen through the staging, such as Richard Martin, curator at the Metropolitan Museum of Art's Costume Institute, demonstrated how unwilling even fashionistas were to get it. Martin declared in the *Los Angeles Times*, "In these ads, Klein projects no false hope of *Our Town* white-bread proprieties or buffed physiques favored by the middle class, but instead a raw reality of disenfranchised life, bored, contentious and listlessly disestablishment. One day, these Klein images will be the poignant testimony of our Jenny Jones Show time, akin to the Farm Security Administration photographs of the 1930s" (September 3, 1995). Raw reality? Farm Security Administration photographs? Calvin Klein as documentarian? And we thought he was just trying to sell jeans!

Sell jeans he did, and the continued success of Calvin Klein, Inc., points to the hypocrisy of our protests against his ads. A society that truly believed he had gone too far would have put him out of business long ago. Instead, Klein has been able to expand his teen and children's lines, and to court new controversies, such as the March 1999 billboard and print ad portraying two little boys at play in Calvin Klein infant

undies. A negative response was inevitable, given Klein's long-standing efforts to create the automatic association of his name with underwear and (child) sexuality.

At the same moment the billboard came under fire, the *Journal of the American Medical Association* published a new survey on American sexuality that failed to attract much attention, perhaps due to the distractions of the Clinton/Lewinsky scandal. Among the results was the astonishing figure that 43 percent of women suffer from "sexual dysfunction," meaning they find sex painful or not pleasurable enough, or simply lack interest in it. Pain is one thing, but how does anyone, even a scientist, quantify how pleasurable sex should be, or how interested we should be in it? Forty-three percent is such a high number as to make one wonder if in fact we're expecting too much from sex. But that's what's so great about the idea of sex, as opposed to the "real thing"—our ideas about how often and how pleasurable are purely subjective. Therefore, it's fairly simple to encourage us to feel like we're not getting enough, and that getting enough, or some substitute for it—like sexy underpants—will make us feel better about ourselves.

Far more obscene than the image of little boys in their Calvin Klein underpants is the thought that anyone would dress a preschool child in $12 designer underwear. After all, who's going to see it? Not a daycare worker, God forbid! Lauren R. Tucker, in *Critical Studies in Mass Communication* (1998), posits that the media's characterization of the 1995 CK Jeans campaign as kiddie porn "constructs Klein as a straw man who symbolically pays the price for hailing young people as independent consumers and for acknowledging that the young have some modicum of cultural and economic power." Yes, young people do have some power, but how independent are they as consumers, given that most of their considerable resources come straight from the pockets of their parents? And how much designer stuff is bought by parents as a way of assuaging their own feelings of inadequacy?

Klein, though purporting to create mere "advertising," succeeded (perhaps in spite of himself) in showing us "the way it really is" by making explicit the fact that there are no easy ways to tell the difference between child/adult, gay/straight, masculine/feminine, exploiter/exploited, enough/not enough, professional/amateur, dependent/independent, powerful/powerless—and as the adults responsible for helping children to negotiate these terms, we're not doing a very good job. Faced with this realization, most adults chose to demonize Klein rather than examine their own behavior and consider their own participation in an economy that, because it must constantly increase its markets, now targets even the youngest children. We may or may not be the ones directly exploiting youngsters, but almost every time we make a purchase we open our front doors to those who do, and happily point them in the direction of the basement. The media has recently reported on a spate of new techniques for marketing to children, such as brand references inserted in textbooks to make math problems more "real," exclusive soft drink

contracts in school cafeterias, and consumer surveys that take place in the classroom. Kids who can't yet read already recognize—and demand—the Nike logo. Soon enough we'll be striving to reach consumers in utero. What more noble pursuit for the designer gene industry?

Pamela A. Ivinski is a writer and editor specializing in graphic design, art, and popular culture. She is currently writing a dissertation on the artist Mary Cassatt.

Don't Ask, Don't Tell: Repressed Sexuality in Late Twentieth-Century American Advertising and Marketing

by Jack Krause and David Vogler

In April 1999, the FOX Network—America's arbiter of taste and expert zeitgeist rider—ran a special featuring TV ads hitherto considered too sexually explicit to be run in the United States. This get-ready-for-sweeps special was essentially the advertising equivalent of the network's perennial favorite *When Animals Attack*. In any event, the ads—most of which came from Uruguay, Australia, or the United Kingdom—were surprisingly funny and clever (unlike the show host's material). If the program proved anything, it confirmed the notion that Americans are the most sexually hung-up wretches in the world. The American consumer lives in a sexually repressed wasteland, often devoid of humor. Hence the need for acting out, irrationally and excessively. How else to explain the antics of Bill Clinton and Jerry Springer, or Trent Lott's assertion that homosexuals can be "converted"? This uniquely American brand of sublimated sexual tension has now polluted our advertising seas. Normal, healthy sexual expression has somehow become boring to Americans.

Too much *Baywatch* has left Joe and Jane Sixpack wanting more of what is exciting and frightening to them, but they feel afraid to ask for it. Agencies have smelled Joe and Jane's pheromones from a mile away (eeew!) and are now presenting the forbidden fringe. And they're masking it in ways unseen since the Cold War. Sex in advertising is actually edgier than ever. However, it's presented in a more subversive manner. Much of the sex that mainstream America sees is enshrouded in jargon, free-associative images, and inside jokes, or figure-headed by inappropriate spokespersons. This isn't exactly the old subliminal ad trick—it's the use of selective omission, complex subtext, and inside references that give audiences a new thrill.

But why would advertisers go to all the trouble? Perhaps it relates to America's fear of open, healthy sexual discussion. For example, Americans like to say they aren't homophobic, that Ellen DeGeneres is to be commended, but God forbid their son came home from college with a

same-sex partner to meet Mom and Dad. Still, these people will gawk at daytime talk shows covering this very issue. Turn off the TV? Bite your tongue! Paradoxically, Americans do seem to be interested in different forms of sex, but they're afraid to say so. Advertisers are sensitive to the public's fears, so rather than blatantly use sex in the ads, they often just kind of surreptitiously sneak it in, or so they think. As a result of this attempt at subtlety, sex in the American ad has not only become over-the-top; it's become flat-out absurd. When media historians study the ads of the late 1990s, they won't see signs of an edgy, iconoclastic, sexually adventurous and sophisticated populace. They'll see a bunch of sexually confused fools indicating a need for Dr. Ruth to work overtime. Point: Late 1990s ad sex isn't innocuous, titillating, or even offensive. It's absurd. To illustrate this carnal chaos, we will focus primarily on three spots that ran in 1999: Bob Dole's stomach-turning endorsement of an erectile dys-function drug; Phillip Morris's public service announcement that blurs the social ramifications of smoking with those of being ugly; and finally, the ultra-inside, fabulously, and flamboyantly gay ads of Old Navy. To provide adequate sexual context, we'll probe some others too. After the climax of this exhaustive romp, we're sure you'll agree that sex in advertising has never been weirder.

On the Dole: Viagra

Viagra, the miraculous erection-inducing, K-Y-sale-enhancing, marriage-ending potency drug has been the topic of way too many late-night talk show monologues to be funny anymore. Yes, like incontinence, erectile dysfunction is eternal water cooler/e-mail bad joke fodder. And as the drug is in demand, so is a salient marketing strategy. What Americans ended up with, though, I doubt anyone saw coming, so to speak. Here is an agency cognitive model for an agency brainstorming session:

Viagra + bad joke = Bob Dole.

Why, of course. Why didn't we see it all along? Who needs a hand-some, silver-haired movie star to peddle a boner drug? Let's give it to a one-armed war vet whose dignity is only beginning to spontaneously regenerate after his incoherent talk-in-the-third-person-like-Bo-Jackson campaign marathon, which culminated in his inadvertent stage dive, all before getting shellacked by the most libidinous man in America. And now, ladies and gentleman, a few words from Bob Dole on not being able to get it up. (Is it because the word "Dole" is synonymous with "banana" in American consumerville?)

This ploy is revolting, regardless of which side of the political and/or sexual fence one stands. We know, theoretically at least, how Bob Dole will/would test the drug: Our "nude mouse" (to borrow a phrase from the scientific community) is none other than another presidential hopeful. No, not George Bush's son, but Elizabeth Dole. We think we speak on behalf of all our countrymen (and women) when we say that we'd rather envision our own parents knocking boots than suffer through the image of Mr. and Mrs. Dole fumbling through the act. Good Lord! Elizabeth Dole,

insecure enough to chastise Leslie Stahl for calling her "Liddy" on *60 Minutes*, is cool with this? It kind of makes you feel like crying. For heaven's sake, the elderly should enjoy sexual relations on their own terms. Bob knows advertising!

I Guess I Won't Get This Smoked Anytime Soon

The hollow posturing of Philip Morris doing an antismoking campaign targeting youths is shameless enough. Just as PR is often advertising disguised as news, Philip Morris is doing advertising disguised as PR. In other words, they are pretending to illustrate an unfavorable outcome by using a cause and effect scenario, while keeping a hidden agenda. The ostensible equation is as follows:

Boy + Flirty Girl = possible score

Boy + Cigarettes + Flirty Girl = strikeout

A young teen in a soda shop, roughly fourteen years old, trades come-hither glances with a girl of the same age. After a few back and forths, the girl leaves her group and walks toward the boy. As she approaches, he takes out a cigarette. She gives a look implying less gross-out than a condescending "Oh, you foolish boy."

The problem is, it isn't the cigarette, or even the failed come-hither stare, that will stick with teen boys, specifically. Folks, the girl is wearing a skin-tight dark T-shirt with a decal positioned directly over her breasts. The camera accentuates this as blatantly as a movie poster's positioning of Jennifer Love Hewitt's bosom. Be you man or woman, boy or girl, you aren't watching the girl's face (for a while, you can't see it), nor are you wondering about the dynamic between the two kids. You are looking at that girl's chest, whether in clinical assessment, Humbert Humbertian longing, or Jesse Helmsian Bible-thumping disgust.

The other problem is, the viewer can't help but wonder if the girl's revulsion comes from the cigarette or the poor youth's greasy complexion. They didn't cast a young Jason Priestley for this one. A teen is unlikely to think, "Put the cigs away, man! Put 'em away! You're losing her, yo!" The voice of his thoughts is more likely to sound something like, "Why's this loser flirting with her? Why is—*Dude*! Look at those."

One wonders what set of emotions the male adolescent viewer is left with at the ad's conclusion. Does he sit in pensive silence, mulling over the thwarted attempt at love, or does he decide instead to flick off the TV and lock himself in the bathroom for a while? But we digress. The point is that the viewer can't blame the girl for walking away from this geek. It's unlikely that Philip Morris's attempt at assuaging parental cig fears will dissuade any teen from smoking—especially since the poor lad in the commercial is so homely that it seems unthinkable that she wouldn't walk away, even before he had a chance to whip out his package. (Of cigarettes.) Our modified subtextual equation then, is as follows:

Flirty Ugly Boy + Flirty Cute Girl = utter futility regardless of cigarette presence

The cigarettes don't make the kid any uglier or more handsome, and

Viagra + Bad Joke = Bob Dole

Philip Morris's sales are unlikely to suffer. Thanks for looking out for our kids, Big Tobacco.

Grownup cigarette ads are kind of funny too. Remember "Winston Tastes Good Like a Cigarette Should"? Well, we can't show people smoking anymore, so we have print ads with a male arm dangling down way, way in the ad's forefront with a cig sticking upward out of his fist. A Vanessa Williams look-alike leers seductively. Big Tobacco can rest easy, Joe Camel or no Joe Camel.

In the Gay Old Navy

Old Navy ads are arguably the trippiest TV experience to be had in the late 1990s. They are the most wonderfully campy ads of the decade, period. And folks, lest anyone wonder, they are brazenly gay, gay, gay. These pieces feature the Chelsea/West Village ideal of white picket fence gay America brought alive in a hallucinogenic splendor. A dog hero. A New Yorky garment industry hag. Morgan Fairchild in a sexless role. Inside references to bad musicals. And it is raining men. In one, a handsome man is daydreaming. The hag inquires as to his thoughts. His answer? "Cargo Shorts!"

What does Middle America say to such an ad? A kid is likely to say, "Look, Mommy! He's just like my art teacher!" It is unlikely that the discussion, or thought, goes any further than that. Don't ask, don't tell. But make no mistake, these ads are layered. We have bad choreography, bad dialogue, butt-ugly lighting, and freaky blocking. The ads, scored by the late genius Tom Pomposello (who, after years of *Nick at Nite* work, knew his camp), are a collective parody of Broadway bombs—and the (Old) Navy has launched them right into the heartland. To be on the safe side, squeaky clean families were brought into the picture toward the end of one ad. In case there were any eyebrows raised in the heartland, this touch assuaged all momentary queries: "Oh, them's is a family! Gay men don't

Boy + Flirty Girl = Possible Score

$$\left\{ \begin{array}{c} \textbf{Boy} \\ \textbf{+} \\ \textbf{Cigarettes} \end{array} \right\} + \begin{array}{c} \textbf{Flirt} \\ \textbf{Girl} \end{array}$$

believe in nothin' like that!"

The largely homophobic population of Middle America wouldn't take too well to an ad saying, "Affordable, stylish, preppy apparel—just like the gay guys in New York City wear." So the Old Navy campaign presents a viable alternative. We have the ad equivalent of the film *Waiting for Guffman*—Middle America is so confused, it doesn't recognize gay culture when it sees it. And Old Navy stuff is selling like hotcakes. Good.

Does She or Doesn't She Today?

We admit it. There are exceptions to our rule. Happily, we've tied them in with our repressed sex premise. In 1956, Clairol's hair dye catchphrase "Does she or doesn't she?" made copywriter Shirley Polykoff of Foote, Cone, and Belding an industry legend. The ingenious innuendo of this campaign required the storyboards to include shots of "She" with her children, acting essentially as a Donna Reed with a secret or two. Donna Reed as Doris Day, as it were. But Clairol's tactics have changed with the times. Today, Herbal Essence shampoo, which in the seventies was given Beach Boys–rip-off jingles, now features the "Totally Organic Experience" line. (Organic! Orgasmic! I get it!) In the ad, a woman stays home just as proper girls did once upon a time to forego dating to "wash her hair." And, unremarkably, we see a woman massaging the white froth in her hair while screaming "Yes! Yes! Yes!" The pun is obvious; it's not even original (everyone is sick to death of Meg Ryan's faked climax in *When Harry Met Sally*). But if the truth be told, the line can in fact stand on its own: a totally organic experience. Without the overkill of froth-induced masturbatory overtones, the phrase is pretty good, although the sexual aspect kind of shoots its load (pardon the phrase) with the over-the-top acting and direction. Duh.

There are other blatant ads. They fall into three categories: 1) dumb; 2) smart; and 3) Faustian. For "dumb," we've got to hand it to 3COM, which

Flirty Ugly Boy ✚ **Flirty Cute Girl** ═ **{ Utter futility regardless of cigarette presence }**

Strikeout

is placing artfully shot naked women in fetal positions, ostensibly trying to hide behind palm-sized computer hardware. Please. Does this demonstrate to computer geeks that there's something else they can hold in their palms? For "smart," we've got Victoria's Secret. Before they came along, lingerie was tacky, wear-trenchcoat-when-buying stuff. Lingerie is now respectable. But Victoria's Secret has set another precedent. They have made the world safe for Larry Flynt's budding porn warehouses. If Rudy Giuliani is going to make America's former porn capital, Times Square, into a clean, family-friendly environment, Larry Flynt is going to try to make porn outlets as clean as, well, Times Square. His megastore in Los Angeles is as squeaky clean as The Gap, with a coffee bar as nice as what you'd find at Barnes & Noble. Is this healthy? We say yes. It's not targeted at kids, it fosters an open, comparatively healthy attitude toward sexuality, and the farther away we can get from the aforementioned Philip Morris and Viagra stuff, the better. As for "Faustian," the number-one shameless soul-selling entity is still Calvin Klein. To think: Audiences were once shocked when Brooke Shields declared, "Nothing gets between me and my Calvins." Calvin Klein tries sexual ambiguity with unisex fragrances. It dresses anorexic models to look like heroin addicts (not too hard a feat). It gets into trouble for that, so chooses instead to grease them down and shoot them in light that makes them look malnourished, dirty, and jaundiced. In the black-and-white ads, they just look dirty and malnourished, since (visible) jaundice isn't an option.

We really shouldn't forget gym ads, like those of Bally's, either. But they're not really dumb. More fake orgasms, yes, but a person working out does sound something like a person having sex, and a lot of gymgoers go to the gym to make themselves more salable in the sexual marketplace, so . . .

Do today's ads appeal to the prurient interest? Hard to say. It seems at times as though they're trying to. The Philip Morris PSA certainly does.

The fake orgasm ads try to. The Bob Dole ads—well, we'd rather not say. But if it's sex that you're selling, why not just sell it? All the dirty ads that FOX recently aired really weren't very dirty at all. And if they were, so what? We do exist in a sexualized society, but we're uncomfortable with it. The repression will continue for a while, and we're just going to have to weather it. Until then, maybe we can visualize Pamela and Tommy Lee instead of Bob and Liddy.

As vice president and creative director at Nick at Nite *Online, David Vogler knows a thing or two about classic TV and pop culture. His favorite* Brady Bunch *episodes are the ones that feature Marcia dancing in provocative skin-tight spandex bell-bottoms.*

Jack Krause is a New York agency man whose writing has appeared in HotWired, Nickelodeon *magazine, and a few other publications he'd just as soon not mention. His television credits include Nickelodeon, fX, and Romance Classics. Jack first collaborated with David Vogler as a Nickelodeon staff writer in 1995.*

Got Sex? by J. D. Biersdorfer

Talk about the Internet for any length of time and sex will probably enter into the conversation. Of course, the Net is not just about sex, although with the Web's population exploding since the mid-1990s, one might be able to get away with the argument, "It is too about size." Type the word "sex" (or "porn") into a search engine and you'll get back something like "AltaVista found 12,505,558 Web pages for you," along with a banner ad featuring a glimpse of some mammoth mammaries.

Porn is hot. Yes, *that* kind of hot too, but leading-the-zeitgeist-tango-hot as well. Even established leather-elbow-patch publications like the *New Yorker* and the *New York Times* have noticed and published stories about the mainstream acceptance of the once forbidden frontier of hard-core porn, tossing in Freud and Foucault for egghead mojo.

It used to be that nobody would talk about this stuff, outside of admitting that they "read *Playboy* for the articles." What changed over the past fifteen years? Did people finally relax about admitting that they liked sex after enough evangelical preachers got caught with hookers, or in sympathy with Pee-Wee Herman's bust at the X-rated picture show in the early nineties? Did enough people get comfortable with expressing physical intimacy after buying those purportedly educational "Extraordinary Sex" videos whose ads (which always feature wedding rings on the pictured man and woman) have turned up in publications ranging from cheesy, chirpy *Us* magazine to the respected *New York Times Book Review*?

I'm going to go out on a limb here and suggest that the Internet might have had something to do with it. Invent a new medium, and *BANG!* see how long it takes someone to come along and mix a little sex in with the technology. "Cable, video and the Internet are creating a new culture," *Hustler* publisher Larry Flynt told the *New York Times* in its March 21, 1999, story about how pornography has become chic. "We're witnessing something very profound."

Profound in its undying persistence, the human sex drive can be a

rather insistent muse. It was not long after the invention of the camera that photographers started making naughty pictures available to the masses. And the first stag film wasn't too far behind the invention of moving pictures. The Federal Communications Commission kept the horndogs mainly in check for television but, as Flynt pointed out, cable television gets away with more. Besides, everyone knows that network TV exists to sell beer and trucks. So now we have the Internet, especially the Web, firmly working its way into everyday life. A wild, boundary-free network of the collective consciousness of everyone with access to it, the Net doesn't quite know if it's a print or a broadcast medium. Quite frankly, neither do lawmakers, which is part of the problem but a whole 'nother story.

History shows that tolerance for sexual freedom has had its ups (the 1920s and 1960s) and downs (the 1930s and the 1950s), but there hasn't been an entity like the Internet to factor into the equation before. "Anything goes" attitude aside, one of the Internet's biggest influences on the rest of society is that it gets your attention in a variety of ways, unlike traditional print or video forms. "The difference between online and print, is really the interactivity of online. It can really engage the user," observes an advertising account executive for a men's entertainment Web site. In addition to allowing the user to have some say in what content is presented for viewing, the Web also knows how to get your focus in the first place: animations, pop-up boxes, sounds, videos, quick-reading text. It's the perfect medium for a world with an increasingly short attention span and far too much going on at any given moment. Even those horny little banner ads that pop up on your search engine page when you have the word "sex" in your search are called "targeted" ads, and they're aimed right below the belt (but in a *good* way). The Net provides hyperlinks for a hyperactive world.

It has also carried with it the no-holds barred attitude handed down from the techies and chipheads who pioneered the early development of the Internet in an unregulated time. One might postulate that since these guys never got laid anyway, they figured out a way to relieve their tension and share the joy over a network connection, killing two birds with one stone. Academics were also early adopters of the Internet, however, and their influence is also visible, even when it comes to sex. Nerve.com is a nicely designed Web site that offers well-written "literate smut," as it likes to refer to its wares. Produced by established authors and photographers, the erotic stories and images posted there give a sense of class and scholarly sophistication to what are still essentially "one-handed reads."

Despite the advanced prose stylings and expensive lighting, though, the ultimate goal is still the same as those less highbrow outlets. There may be a wider selection of verbs and adjectives, but the action isn't much different from a peep show in Times Square, or even from those badly printed back-of-the-newsstand digests offering such tales as "My Lez Stepmom Seduced Me over Spring Break." But with the Net, you get instant gratification—privately—right at your desktop. And nobody (theoretically) knows it's you.

Part of the Net's bad reputation with conservatives, though, is that

often, sexually aggressive advertising will find you, even if you're not look-
ing for it. Aggressive advertising is nothing new, but post a message in a
quilting newsgroup on Usenet, and a week later you get porn spams filling
up your mailbox from the spambot that was trawling around the Web
looking for e-mail addresses. This isn't targeting, this is carpet bombing.
It's like donating to public television and then finding oneself not just on
the mailing list of every liberal charity organization in the state, but also
that of every vibrator manufacturer in the world.

Print advertising can't follow you around as closely, but some of the
looser attitudes about sex and sexuality that have become more accepted
in certain parts of the country are now turning up in ink. This, of course,
cannot be solely attributed to the influence of the Internet, but to an
emerging generation of people in their twenties and thirties with their
own ideas about taste and behavior as well. Many folks (present company
included), in the aptly named Generation X, came of age shortly after the
free-love fest of the sixties and the open pre-AIDS hedonism of the sev-
enties and didn't have the hang-ups about sex that the previous generation
may have grown up with. Living with one's lover (of either sex), the ability
to talk openly about one's body and desires, and the willingness—perhaps
out of the aforementioned short attention span and boredom—to experi-
ment is commonplace with many Xers these days.

The print world reflects this. Look at one of Jockey's recent display ads:
Several muscle-bound male firefighters standing around in their (very
tight) underpants. The homoeroticism of the ad would have petrified
Madison Avenue twenty years ago, but with today's blasé attitude, it's
right there in a mainstream magazine. Heck, even one of the wholesome
"Got Milk?" ads features a female model bravely standing in the middle of
Times Square wearing a tiny bikini along with her milk mustache.

As daring as print advertising thinks it's getting, the Internet—
untamed, mostly unregulated, and growing at a phenomenal rate in terms
of both users and innovative technology—is where the action is. No mat-
ter if it's an arty celebration of the body's desires or cheaply shot hijinks
with farm animals, sexually explicit material has risen above the stigma of
plain-brown wrappers and rumpled raincoats. The easy access and less-
ened fear of discovery that the Internet provides has obviously brought
sexual content out of the murky shadows and more into the mainstream.

The underlying fact of the matter is that sex in just about any medium
sells, has always sold, and will always sell. The Internet is just the new kid
on the block and is merely showing off to the rest of the neighborhood,
with its bells and whistles and continually developing technologies. The
Net happened to be in the right place at the right time with the right
stuff. It's direct, to the point, immediate, and interactive. Come to think
of it, it's a lot *like* sex.

J. D. Biersdorfer, who has written for the New York Times Book Review
and Rolling Stone, *felt vaguely guilty while doing the Internet research for
this essay.*

Four:
Feminism

Girlzines: Sex and Morality
in Print by Teal Triggs

*Shocking Pink editorial wishes to announce the failure of the attempted merger
with Bride magazine. It didn't prove commercially viable due to the increasing
unpopularity of marriage.*
 —Shocking Pink *(1988)*

"Sex, scandal and other wild things" is only one of the nineteen "stolen"
"sex-led" coverlines that appear on the front of the May 1999 issue of the
British youth culture style bible *i-D* magazine. *i-D* began in London in
1980, as an *A4* photocopied fanzine. Its main intent was to return "control
over fashion to those who wore it," which it achieved successfully by cap-
turing the attitudes of Britain's 1980s street culture.[1] In this "piss-take"
cover, lines from April issues of publications including *Details*, *GQ*, *Front*,
Stuff, *Cosmopolitan*, *Sky*, and *Glamour* are juxtaposed with a black and
white photograph of Victoria's Secret model Heidi Klum brandishing a
bikini and *i-D*'s trademark "wink." The underwear company model's cover
appearance on magazines such as *Glamour* and *Sports Illustrated* reportedly
catapulted these issues into some of the biggest sellers for over a decade.
However, her appearance on *i-D*'s "The Skin and Soul Issue" goes beyond
the strategies of marketing and sales departments. *i-D* enjoys a dual posi-
tion within the marketplace. Not only has *i-D* been absorbed into the
mainstream commercial world, but it still manages to maintain a fanzine-
like status, capturing the alternative and street-level aspirations of youth
culture and disseminating them back out to the general public. This is
achieved, for example, with playful editorial pranks including the appro-
priation of Heidi as sex sales appeal, but also with the stolen sex lines,
which are recontextualized and reassigned new meaning. Here, sex still
sells, but as parody, inviting a reevaluation of socially constructed images
of sex and morality in print.

This playful recontextualization of sexuality and beauty consumerism
has been going on for some time. Back in 1987, the British feminist

THE SKIN & SOUL ISSUE NO.186

cover star: heidi klum photographed by max vadukul may

£2.80 US$7.2

9 770262 357044

LIRE 13,500 DM 18.00 PESETAS 890 D K

i-D

bad se

size does matte

what scare
men in be

sex, scandal an
other wild thing

obscene amounts
of sex

wild life - kinky sex
among animals

mountains o
molehills: the grea
big tit debat

constant stiffies

teach the wife t
bellydanc

why men are
scared of you

any woman
any time: pick u
tricks that never fa

sexy husband tricks

do you and hi
equal great sex?

make your ow
sexy vide

get weird in bed

readers on th
rampag

tight little bums

not new reasons
to have sex

twice as much sex
who's having i
how to get

131

VIBRATOR TONING BULLET
FOR SATISFYING RELAXATION

Unique new bullet-shape cordless vibrator reaches difficult areas with its gentle, penetrating action. Try this stimulating new tool for toning throat muscles and other facial areas. Delicate, soothing action aids in relief of daily tensions. Use as a spot vibrator for tired feet. 7" hand-size Tingle Bullet in pink plastic operates on two C size batteries not included.
6470—Tingle Bullet$2.98

fanzine *Shocking Pink* produced a special insert in the "It's Our Choice" issue based upon the popular British girl's teen magazine *Jackie*. *Shocking Pink* promoted itself as the "voice of 'young women' in the feminist movement in the U.K.," and, as such, often commented upon issues, such as beauty and health, that were of concern to its readership. Visually, *Shocking Pink* employed the by now familiar fanzine "cut-'n-paste" approach as a way of manipulating words and images taken directly from the pages of the popular press. In its spoof on *Jackie*, for example, this co-option was combined with *Shocking Pink*'s own brand of visual play and political commentary. A photobooth portrait of four young laughing teenagers from *Jackie* is captioned: "It is estimated that one in four women are sexually abused within the family. *Jackie* ignores this." Similarly, alongside cutout photographic images of young teenage girls appropriated from *Jackie*'s fashion spreads, a handwritten addition states: "The average age of a *Jackie* reader is twelve. She is told twenty-two times in each issue to buy more makeup."

Like other feminist-inspired girlzines, *Shocking Pink* provided a site for girls and young women to present interpretations of the female body and female sexuality that were outside the mainstream construction of teenage femininity. Despite the care with which editors from British magazines such as *Sugar*, *Girl*, *Shout!*, *Honey*, and *Just Seventeen* carefully consider their articles, which address the serious concerns of a young teenage girl, it is worth remembering that these texts appear within a context of fashion and style consumerism. In order for teen magazines to be produced at all, they often have to rely on advertisements and product endorsements, in particular, those that promote fashion, cosmetics, beauty, and hair care. In this way, traditional sex-role stereotyping is reinforced. The world in teen magazines is often glossed over, asserting a "class-less, race-less sameness" of what would be presumed to be a common and shared experience of girlhood.[2] This is the very myth that *Shocking Pink* in its *Jackie* insert was attempting to dispel.

Shocking Pink was one of the old guard feminist 'zines. When we come to look at the 1990s, girlzines were subverting three main types of advertising. The first type consists of spaces that are actively sold to external advertisers. These advertisements often relate to editorial content and

appear throughout the publication. The second type is adverts created by the fanzine editors themselves that are about promotion. These may be for an independent record label affiliated with the fanzine itself or, in advertising gigs, for other related genre bands. The third type is that which is appropriated from mainstream advertising and often used to illustrate editorial comment.

What's new is the audience of these parodies. the 1960s' and 1970s' British countercultural magazines such as *OZ*, *It*, and *Frendz*, had an audience that was primarily male and whose subversions of advertisements, frequently involving sex and beauty, appealed to the male gaze. And in quite a sexist fashion. As the writer Roger Sabin has observed: "Generally speaking, however politicized hippie men may have been on subjects like Vietnam, ecology, and drugs, when it came to sexual politics there was often a surprising ignorance and insensitivity.[3]" Oftentimes the products that were advertised in these publications also presented conflicting viewpoints in terms of female liberation and female sexuality. Highly sexual and suggestive illustrations not only established an ideal that celebrated the beauty of voluptuous women, but also promoted male sexual fantasies. As if to reinforce this new set of values, sex toys, such as vibrators and S&M rubber wear and lacy lingerie, were made available through the classified advertising pages and product endorsements of each publication. "Free love" in this particular case was a product of a male consumer marketplace.

"The Revolution is Female."—*Drop Babies* (1993)

By contrast, 1990s' girlzines are designed for young women and transmit a certain Riot Grrrl attitude. They tend to target companies that represent different aspects of the beauty industry, such as health, fitness, and cos-

metics (e.g. hair and skin-care products, breast enlargements, personal hygiene, unwanted hair, and wrinkle creams), as well as femininity and glamour (e.g. nylons and lingerie). Inherent in girlzine production is the need to break taboos or artificial barriers of female sexuality. *FAT!SO?*, *Bust, Ben is Dead, Jane, Drop Babies, Heavy Flow, Ablaze!, Rollerderby*, and *Radium Dial* are largely "do-it-yourself" American and British publications that have ushered in a new version of the 1970s sexual revolution while highlighting new attitudes toward the female body, sexual identity, and the male gaze. In the process of producing fanzines, 1990s girlzine editors have challenged socially constructed images that defined their mothers' generation as "dumb blonde," "femme fatale," "homely housewife," and "devoted mother." They have introduced new agendas for "womanhood" based largely upon personal viewpoints and experiences and seek to move beyond patriarchical boundaries promoted by the mainstream media, addressing the "politics of sexuality" as well as the "politics of representation." In this case, "sex" is not that which is sold, but rather the knowing construction of sexuality.

Nowhere is this made more evident than in the American girlzine *Bust*, whose special issue "This is Girls on Sex" (1998) used advertisements appropriated from past issues of general interest, soft pornography, pinup, and women's magazines. Girlzines like *Bust* continue to celebrate femaleness and the potential for women and their careers, and to address women's health issues, sexual orientations, and practices. They also question ways in which the "official" version is made visible. As part of this process, mainstream media representations become the focus of visual theft—a form of "bricolage" that dislocates rather than imitates. *Bust* attempts to highlight issues and political positions inherent in the new sexual revolution by taking them out of established contexts. For example, a 1970s advertisement with the copy line "Vibrator Toning Bullet" is repositioned as an illustration for an editorial spread on the advantages of owning this sex toy titled "The Vibrator Chronicles." On the other hand, *Bust*'s editorial on "do-it-yourself" herbal facials is illustrated with an advertisement from the John Robert Powers School, which offered the 1960s woman an opportunity to "Learn the Secrets of Exciting New Loveliness!" *Bust*'s creative director comments that one of her reasons for utilizing advertisements from the past is to highlight their seemingly innocent use of language. She suggests, "The vibrator ads from the 1950s. . . were being sold as 'facial massagers' . . . or abortion pills were advertised as cures for 'pesky menstrual irregularities' . . . but of course everybody knows what they really were."[4]

The appropriation of "retro" advertising brings together past and present codes, which not only subverts the essential newness and nowness of beauty and high fashion but also establishes a dialogue between past and present constructions of femininity.[5] For example, advertisements from the classified sections of American 1940s and 1950s mainstream magazines illustrate the then dominant stereotype of woman as the "perfect housewife and mother." These, in turn, construct her sexuality as either seduc-

tress or married woman. By the same process, feminine sexual style is seen in British girlzine *Jane* (1995) and its feature "The A-Z of Beauty." Turn of the century advertisements for "Claxton's Ear-Cap" and moisturizer for "Cracked Skin" as well as late 1930s' adverts for "Odol" toothpaste establish historical precedents for every woman's beauty kit. Here the selling of sexuality is defined by beauty—a commodity that is integral to the construction of womanhood and subsequently personal relationships. As the cultural theorist Janice Winship has observed, "A woman is nothing more than the commodities she wears: the lipstick, the tights, the clothes and so on are 'woman.'" [6]

On the other hand, *Bust*'s issue "She's So Money: Broad$ on Buck$" (1999) is an attempt to redefine sexual stereotypes in the workplace. *Bust* co-opts a quarter page advertisement from the McConnell Airline School of Minneapolis, Minnesota. The advertisement, which appeared in popular American women's magazines in the 1950s, is a call for interested applicants to join their training sessions to be air hostesses. McConnell Airline School promises "Romance! Travel! Adventure! Fun!" as well as, upon completion of the four-week program "a free placement service." As air hostesses, women would be able to fulfill their aspirations and desires to be both glamorous and financially independent. *Bust* juxtaposes the air hostess on a single page with other vintage advertisements that promise the young female viewer access to a career as a hotel hostess or a greeting card saleswoman, or offer opportunities to earn extra cash by selling their own "human hair—12" or longer." With the McConnell air hostess advertisement repositioned in a new editorial context, *Bust* subverts its original intentions. Careers in the travel and leisure industry are no longer seen only as opportunities but rather as reminders of the constructed hierarchy of the job market. The prospects for women in the advertisements on this

BE AN *Air Hostess*
Romance! Travel! Adventure! Fun!
Train in just four weeks for exciting flight and ground positions. Airline-trained teachers. Free placement service. 21st year. WRITE TODAY for FREE CATALOG and YOUR "Ticket to Success."
McCONNELL AIRLINE SCHOOL
WARDESS-RESERVATIONIST • AIR CAREER TRAINING
Nicollet Ave., Rm. G-15, Minneapolis, Minn.
e... Age..........
ess...Tel. No.................
...State....................

page are less than satisfactory, offering only positions of service, not of power. Within the context of a feminist-inspired publication, *Bust* and other girlzines draw attention to the advertisements themselves, which accepted and constructed society's images of women. They are questioning established conventions of "what it means to be a woman."

Equally, these advertisements are chosen for their kitsch and entertainment value, ultimately providing comic relief. Representations of women in 1950s' advertisements, for example, are seen today as "over-the-top." Although advertisements like the McConnell one attempted to make women look "ordinary" and therefore to present an accessible image, many models came off as "painted ladies." Highly glossed pouting lips, severely plucked eyebrows, and perfectly set hairstyles matched the pearly white smiles that were painfully stretched across their faces. These women do not appear "real" to us today. In the same way, seemingly outdated typographic treatments and what may now be viewed as "corny" headlines and body copy merely heighten the outmoded notions and social contexts of these advertisements. These types of advertisements are in themselves ideal for parody.

This last point is an important one, since humor is the main weapon in the girlzines' armoury. Lisa Jervis, in her "Media Whore" column for *Bust*, warns: "Note to smarmy men's rag editors everywhere. If you're going to do satire, it has to be funny."[7] By poking fun at a situation, women take charge of the contexts in which they are viewed and, as a result, are empowered. This happens in a way that is not possible in mainstream women's magazines. Indeed, the appropriation of advertisements is ideal for girlzine editors, who are always looking for cheap, quick, effective means by which to present politicized commentary.

Of course, nothing in and of itself is new. For girlzines it is the context and manner in which viewpoints and experiences are seen which (re)presents old messages about sexuality in fresh ways. Front cover sex-lines and imagery will always sell mainstream magazines, but in girlzines this kind of manipulation is exposed, and sex and morality can be dealt with in a more "honest" and open manner. Control over womanhood is now back in the hands of those who can make a difference. As the editor of *Bust* suggests, "We've still got a long way to go, baby. . . . But, vibrators in hand, we're ready to go out and fight the good fight."[8] Okay girls, let's do it.

Teal Triggs is director of postgraduate studies and research in the School of Graphic Design, London College of Printing. She is also a design historian who writes and lectures on graphic design, feminism, and popular culture.

Notes
1. William Owen, *Magazine Design* (London: Laurence and King, 1991), p. 120.
2. Angela McRobbie, *Feminism and Youth Subculture* (London: Macmillan Press Limited, 1991), pp. 83–84.
3. Roger Sabin, *Adult Comics: An Introduction* (London: Routledge, 1993), p. 224.
4. E-mail interview with Laurie Henzel, creative director, *Bust*, 19 May 1999.
5. Myra MacDonald, *Representing Women: Myths of Femininity in the Popular Media* (London: Arnold, 1995), p. 214.
6. Janice Winship, "Sexuality for Sale," in Stuart Hall, Dorothy Hobson, Andrew Lowe, and Paul Willis, editors, *Culture, Media, Language* (London: Hutchinson, 1987 reprint), p. 218.
7. Lisa Jervis, "Media Whore," *Bust*, no.10, (Winter/Spring 1998), p. 21.
8. Celina Hex "The Second Sex," *Bust*, no. 10, (Winter/Spring 1998), p. 4.

Dressing Love's Wound:
Purple Magazine and
Post-Feminist Porn by Peter Hall

When *Purple*, a squat, potent little magazine of art and fashion, was first published in Paris in 1992, it smoldered with ambiguity. Initially titled *Purple Prose*, a homegrown art magazine, it sounded almost self-deprecating, alluding apparently to the purple passage (the good part) of a terrible novel. Was it full of bad writing, or just a selection of brilliant flashes sifted from the quagmire of contemporary prose?

But purple is also the color of eros. In Shakespeare's *A Midsummer Night's Dream*, it is the color of the magic flower, Love-in-Idleness—once milk-white, now "purple with love's wound." Love in idleness seems to pervade *Purple*'s pages. The subjects of its fashion shoots are wistful, natural beauties, caught amid some everyday activity: half dressed, playing, ambling along a beach, lost in thought. It tries to be sexy without seeming to try.

Purple is also the color of ceremony, of Catholicism, of guilt. It was the Catholic-raised, radical French historian Michel Foucault who wrote, in 1978, that our society is "under the spell of an immense curiosity about sex, bent on questioning it, with an insatiable desire to hear it speak and be spoken about." Foucault came to apply the model of the Catholic confession to Western culture's portrayal of sex through history, arguing that we are in constant pursuit of a confessional "truth," in which sex abandons its discretion and reveals the secrets of its pleasure. Magazines like *Purple*, which evolved out of the snapshot aesthetic of early nineties fashion and art photography, seem to have constructed a myth of realism in pursuit of the same goal. They lead us to believe that their photographic subjects are normal people (not models) who reveal their sexuality while going about their daily business of dressing, undressing, and playing on garden swings half naked. Because the abandonment of discretion in *Purple* is presented as a natural or artistic event, the magazine reader is given the opportunity to be a voyeur, sans guilt.

Purple is the self-funded project of Elein Fleiss, an exhibition curator,

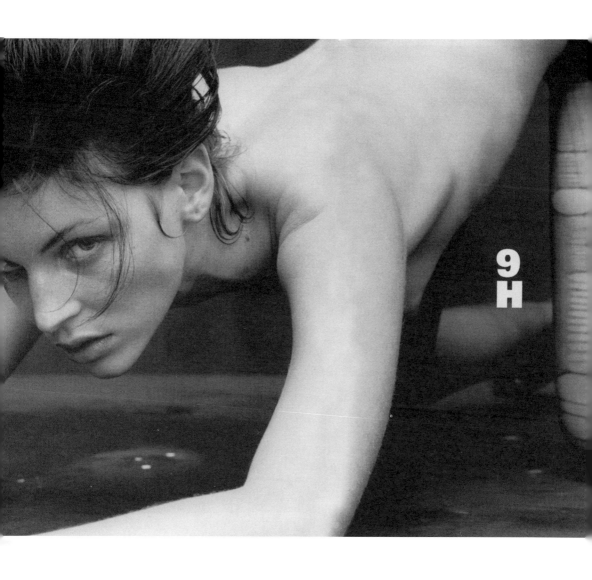

and Olivier Zahm, an art critic. Their original aim was to create a title inspired by art and contemporary cinema, but not too slick, and with an emotional aspect. "Magazines weren't reflecting what we liked," explains Fleiss. "We wanted to do something new, not just hip, like English magazines, but something with more feeling and content, fresh and not too sophisticated." Its unrefined tone and modest, pocket-sized format, inspired by "Hong Kong teenage girl magazines," as Fleiss put it, found a cult following, and the publication was supplemented with fiction and fashion editions. Finally, and most controversially, they added *Purple Sexe*, which set out to explore "contemporary eroticism," if not the innuendoes raised in *Purple's* text and images. First published as separate volumes, *Fiction*, *Fashion*, *Prose*, and *Sexe* were finally combined into a single, thicker and slightly slicker perfect-bound book, *Purple 1*, in the summer of 1998. *Purple 2* followed in 1999.

Art-directed by Fleiss, Zahm, and Christophe Brunquelle, photographs in *Purple* were first printed on uncoated stock and characterized by unprofessional lighting and the kind of cropping that gave the impression that the photographer had tripped while hitting the shutter release. Even in current, glossier issues, which carry advertisements from fashion giants like Helmut Lang, Comme de Garcons, and Issey Miyake, *Purple* carries the air of a homegrown 'zine. Camera shake and red eye persist. The settings are pointedly banal (the bathroom, the kitchen, a drab beach). Unlike more mainstream magazines, it features older models (women in their forties are not uncommon), while sexual orientation and even gender are sometimes conspicuously ambiguous. Nakedness and seminakedness are treated as a matter of course; bare breasts and pubic hair are casually incorporated, with studied nonchalance. In *Sexe*, the subjects are often caught off guard, as if amid a truth-or-dare game of exhibitionism, or self-consciously baring their sex organs for the camera.

Essays in *Purple* are similarly unslick, often revealing a writer's struggle to define aspects of postmodern living: suburbia, premillennial tension, and post-feminist porn. On page 73 of the summer 1998 issue comes this unbridled confession from writer John Hall: "Every time I jack off to pornography I am committing a transgression against the world of equality that I want to live in." Hall (no relation) cites a passage from *Feminism Unmodified*, by the antipornography, procensorship feminist Catherine MacKinnon: "What pornography does goes beyond its content: it eroticizes hierarchy, it sexualizes inequality. It makes dominance and submission into sex. Inequality is its central dynamic . . . " Thus damned, Hall plunges into a masochistic fantasy advocating selective castration of men (including himself) judged unfit for reproduction. A Freudian interpretation might note the author's subconscious desire thus to transgress (Hall even uses the word) and join the female species.

Is *Purple* pornographic? If we judged it according to explicitness, the magazine wouldn't make it past customs. But explicitness is an unreliable guide to porn. As the various international editions of *Vogue* illustrate,

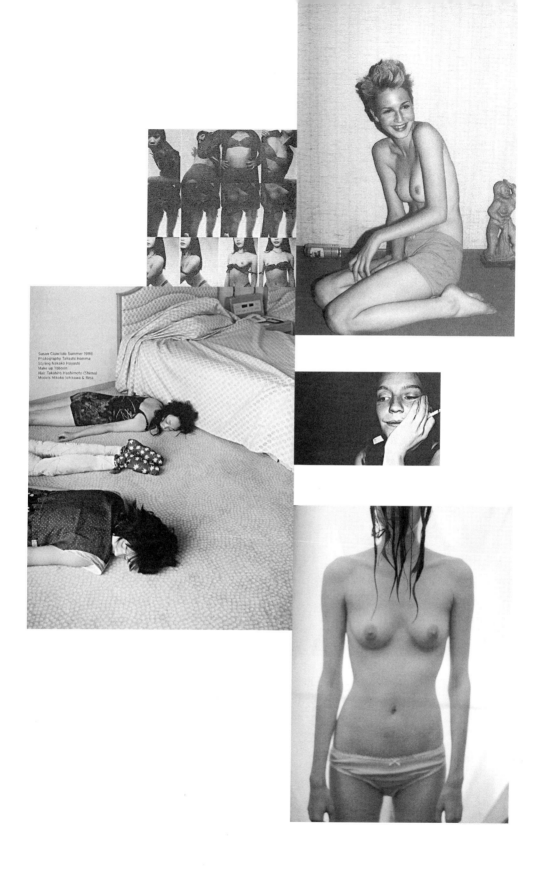

Susan Cianciolo Summer 1998
Photography Takashi Homma
Styling Nakako Hayashi
Make up Yoboon
Hair Takahiro Hashimoto (Shima)
Models Mikako Ichikawa & Rina

what is explicit varies from country to country. A bared nipple on a Parisian billboard will raise barely an eyebrow. In fact, what is shown is usually less important than what is implied. Stephen Meisel's notorious photographs of half-dressed teenagers in their Calvins were really decried as pornographic because of their kiddy porn connotations (and their high profile)—they appeared to present teenagers as sex objects. Sally Mann's portraits of naked children were likewise controversial not just because the children were naked but because they seemed so candid, their expressions so knowing. Defining connotations can be equally slippery, however, as Justice Potter Stewart indicated with his notorious definition of porn in the 1964 case *Jacobellis v. Ohio*: "I don't know what it is, but I know it when I see it." One person's pornography is another's erotica: What arouses Justice Potter may have no effect on Sally Mann.

The intent of *Purple Sexe* is less to arouse than to test our notion of what is erotic, through metaphor and ambience. Featuring the work of several photographers, its early monotone (green ink) and low-budget reproduction suggest outtakes from some lost home video or artful documentary more than calculated porn: a photograph of a woman sucking someone else's thumb; an out-of-focus shot of a kneeling nude male holding a flaring match; a bucket; a flower; and a journal. It is unlikely, however, that *Purple* would pass a MacKinnon test. For one, the majority of models are female and, for two, they are often shown in classically submissive roles.

On the other hand, *Purple* arises out of a decade that has shown a markedly more liberal view toward pornography. It is, after all, a form of safe sex. On a moral level, anticensorship feminists like Linda Williams, professor of film studies and author of *Hard Core* (1989), argue that the antiporn polemic of MacKinnon and others is based on the flawed position that female sexuality is a natural state "outside of history" repressed by a falsely ideological, sadistic male sexuality. Citing Foucault, Williams counters that men and women are both constructed within discourses of sexuality, and that porn's hyperbolic, patriarchal language should not be censored but deconstructed.

The fragmented images of *Sexe*, then, could be seen as an echo of the porno movie's quest for "truth," à la Williams. One series of video-captured stills of stripteases, in fact, resembles Eadweard Muybridge's early photographic studies of movement, which Williams considers the origins of pornography. Muybridge progressed from studies of horses to studies of nudes, Williams notes, discovering in the supposedly scientific process the voyeuristic thrills of seeing a naked figure moving on screen.

The idea of the decontextualized outtake, increasingly popular in fashion photography (thanks to Cindy Sherman and the VCR pause button), works so well in an erotic image because it engages the viewer to imaginatively construct the hidden narrative. *Purple* is not selling glamour, romance, or sexual fantasy in the manner of the traditional posed centerfold. Its discourse is one of banality, low life, "realism." Clearly, this is as much a construction as the *Playboy* centerfold girl who awaits the viewer

on blue satin sheets, but for the thirty-something *Purple* reader, it has its appeal. It offers an alternative to the fantasies peddled by the mainstream media, posing instead as the antithesis of the capitalist fashion and porn industries.

Alternatives, of course, are quickly commodified. "Porn chic," the romanticized revival of 1970s' sleaze, has meanwhile invaded the news-stand. William Hamilton noted in the *New York Times* in early 1999 that the language of the porno movie had gained a new currency in fashion and advertising: "It is about the appropriation of the conventions of pornography—its stock heroes, its story lines, its low-budget lighting and motel room sets." In *Vogue Hommes International*, for instance, one fashion feature is based on the behind-the-scenes crew of a Los Angeles porn shoot, with the camera focused on the film crew and their clothes rather than the naked women casually sprawled across beds and walking off set. The same aesthetic pervades *Richardson*, an arty porn magazine first published in Japan in December 1998 by Terry Richardson, a fashion stylist for *The Face* magazine and occasional photographer for *Purple*. In a markedly less modest manner than *Purple*, Richardson features an array of pornographic styles, some in faux-documentary black and white, some styled like outtakes from a porn movie, as well as raunchy stories, articles, and an interview with a porn star. The magazine's appearance in New York art bookstores signifies a decisive shift in the definition of taste.

The portrayal of sex in the fashion and pop music worlds has gone through a dramatic cycle of change since MacKinnon wrote *Feminism Unmodified* in 1987. Women are no longer to be seen giving head to chocolate bars, lipstick, and lollipops in advertisements, but Madonna and her academic supporters, such as Camille Paglia, have helped usher in the same metaphors into a new context. Girl-power sexuality has become another advertising cliché, and the suburban housewife stereotype of the fifties has been superseded by the empowered party girl and the proud hooker.

These dramatic shifts in the media set the stage for *Purple*'s emergence. After the exaggerated expression of gender, what was left but the denial of gender? Suddenly, in the early nineties, fashion was full of images of androgynous teenagers, flat-chested girls and doe-eyed boys. It was as if by showing the similarities between men's and women's bodies, we could undo all the gender politics. The androgynous being has the unique ability to see from both sides; he/she has been constructed in the image of men and women.

Like the mid-nineties' "heroin chic" of skinny models slumped against peeling walls, the move to deny gender took its stylistic cues from the faux-documentary approach to portraiture pioneered by photographers like Corinne Day, Jurgen Teller, and David Sims. British writer Chris Thomson has identified the aesthetic's relation to the French phrase *nostalgie de la boue*— "a fantasized identification with poverty or criminality." In *Purple Sexe*, the fantasy is displaced into eroticized slums, where peeling walls and buckets themselves become fetishes. In one shot in *Sexe*,

photographer Takashi Homma shows us a vagina-shaped stain on a peeling wall, Georgia O'Keeffe style. When nude models appear in the surrounding pages, we are drawn into the narrative. As cultural critic John Berger pointed out, banality is "essential for any great sexual image of the naked."

But while adopting the same influences, *Purple* appears to have bypassed fashion's self-destructive impulses. Cigarettes, alcohol, and drug references are conspicuously absent from its photography. An interesting comparison is how the mainstream fashion world also cleaned up its act, but remained conscious of its past fashion's white period of white rooms and white eye shadow, which suggested a rehabilitation clinic. Corinne Day's documentary-style photography gave way to Richard Avedon's passionless compositions and space-age haircuts. In 1997, *Purple* was showing its models smiling, thinking, and playing aux naturel; Italian Vogue was featuring the forlorn, wide-eyed looking model Audrey Marney caught midflight on a lunarlike landscape by Steven Meisel. "Even the whiteness of the clothes—the postal-service sackcloth seams of a smock pulled over bare legs and fur-trimmed moon boots," wrote Neville Wakefield in *Frieze* magazine, "calls to mind the straitjacketing of an institution . . . "

In a brief report in the gay magazine *Out*, writer Elise Harris praises *Purple* and its contemporaries *Dune* and *Self Service* for heralding the "end of heroin chic" and "eschewing doom and gloom for an emerging aesthetic of childhood and Edenic outdoor romps." There is a profound sense of optimism in *Purple*'s photography that, in light of mainstream fashion's cynical excesses, seems naive. It is as if, in its quest to escape gender politics, it ended up in the garden of innocence. *Purple 2* has several shoots of women in pastoral, bucolic settings, playing flutes or "accidentally" flashing their underwear. Before sin, before gender was constructed, there was innocence.

It would be comforting to imagine that contemporary photography in titles like *Purple* had somehow established a means of portraying sex with-

out its connotations of power and inequality. But one point on which Williams and MacKinnon and, probably, Elein Fleiss would agree is that the 1990s presentation of the female form is still largely defined by historical tradition. In European painting, as John Berger, points out, men are fighting, talking, writing, and fully clothed whereas the women are nude and invariably there to be looked at. "A man's presence suggests what he is capable of doing to you or for you . . . By contrast, a woman's presence expresses her own attitude to herself and defines what can and cannot be done to her." Porn chic makes no bones about sustaining this tradition. In the *Vogue Homme* porn shoot, the film crew is almost entirely male, dressed, and hard at work. The women, on the other hand, are almost entirely naked and lying down, wandering aimlessly, or receiving men. Berger summarizes the time-honored convention in five words: "Men act and women appear."

Purple certainly does not exist outside of such discourse, either. Its pages are filled with images of women *appearing*. Manet's *Le Déjeuner sur l'Herbe* is revisited, the nude woman now a casual ingredient of a picnic scene (without the men). The female models do not grab at their crotches in a parody of male prancing; they expose themselves in the act of playing—trying on clothes, crawling across grass, even hanging upside down, buttocks bared, on a garden swing, in an inverted homage to the erotic power of Fragonard's painting *The Swing*. The voyeur/reader is looking through the garden gate peephole into a bucolic world of innocence. The difference here is that the men, too, though few are to be found, are caught in the act of *appearing*. In a Viktor & Rolf photo shoot two male models pose for the camera in absurd positions on a kitchen table. It has the appearance of parody, as if the men were mimicking the way women appear in 1999 ads for the New York shoe company Kenneth Cole.

Compared to other experimental magazines, notably Britain's *The Face*, which has pushed the concept of the fashion shoot to its absurd limits,

STILL LIFE
MARCH 95
THE DEHUMANIZING ASPECTS OF CULTURE CREATED BY THE MEDIA
AND ITS USE OF THE ADVERTISING, COSMETICS,
AND FASHION INDUSTRIES TO EMPHASIZE LONGEVITY AND IMMORTALITY
PARALLELS BETWEEN THE IMMORTALITY OF VAMPIRES AND THE IMMORTALITY CREATED
IN ADVERTISING AND THE MEDIA AT LARGE THE INFLUENCE OF RELIGION ON CINEMA
IN THE FIRST HALF OT THE CENTURY, IN HORROR AND VAMPIRE MOVIES
ART DECO AND FILM NOIR REFLECTED THE SENSE BEAUTY AND MURKY ATMOSPHERE
OF THE PERIOD PRINTS RECALL '30S AND '40S FILM COMPANY EMBLEMS

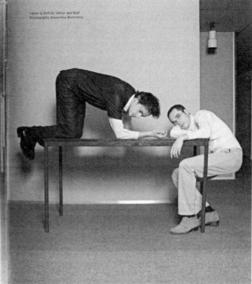

Purple is in a raw, confessional, early mode. It is less established, less focused, and yet, in this unvarnished state, seems more revealing. It isn't quite sure of itself. And perhaps the best example of this is that *Sexe*—the most politically dubious of its experiments—in order to avoid distribution problems because of regional censorship laws, was removed from *Purple* 2, to reappear on its own. In its place is the safer, duller, but probably more commercial (in the age of *Wallpaper* magazine) *Purple Interiors*.

In fashion, after sexism, after girl power, after porn, after asexuality, after gender, there were empty rooms with no models at all.

Peter Hall is a journalist and design critic based in New York. He wrote and co-edited the book Tibor Kalman: Perverse Optimism *(Booth-Clibborn Editions, 1998) and has contributed essays to* Websights *(RC Publications, 1999) and* Architecture and Film *(Princeton Architectural Press, 2000). He also writes for* I.D. Magazine, *the* Guardian, Print, Joe, AIGA Journal, *and* Creative Review.

Lock, Stock, and Barrel:
Sexing the Digital Siren by Katie Salen

She's supposed to be beautiful, but she's still a pig. There's something kind of riot grrrl about that.
 —riot grrrl Annaleen on Ms. Piggy
Women are now saying, "Yeah, I'm a girl—so what?"
 —grrlgamer Alana Gilbert

Riot grrrlzines such as *Girl Germs* and *Drop Baby* were instrumental in adopting and reorganizing the "codes" found in women's commercial magazines in the late 1980s. Ten years later, these same codes of power and beauty are undergoing reorganization within the male-dominated world of action and adventure digital gaming. The recent visibility of female leads such as Lara Croft (Tomb Raider I and II), Elexis Sinclaire (SIN), and Laura Lewis (Enemy Zero) highlights the game industry's interest in creating a space for empowered female representation while meeting the needs of gamers hungry for testosterone-driven play. Unfortunately, it also signals the difficulties inherent in any transition from one form of expression to another, particularly one drawn along gender lines.

These lines, effectively blurred by riot grrrls intent on exploring new expressions of femininity and feminism, have regained their rigidity in the transition from the edge of punk rock to the center of commercial gaming. Girl Power, once a concept that embodied riot grrrls' charged interruption of consensual definitions of attractiveness and desirability, is now used in the gaming sector to market bodacious virtual babes. Case in point: Lara Croft, heroine of the multi-million selling Tomb Raider and Tomb Raider II, and the gaming industry's idea of a "feminist" action hero. Released in 1996 amidst the Brit "girl power" crush of the Spice Girls' commercial agenda, Tomb Raider broke with gaming tradition by offering an action-adventure game with a female lead. "At the time we created Tomb Raider, I don't think there had ever been a good game with a heroine," remarked Toby Gard, Lara's creator. "Most women in games

1

before Lara wore thigh-high boots and thongs." Originally conceived as a cross between riot grrrl icon Tank Girl and British pop star Neneh Cherry, Lara developed into a buxom female version of Indiana Jones. The end result, according to Gard, is "an empowered woman . . . not a smutty sex object, but an inaccessible, gun-toting bitch."

While Lara certainly knows her way around a gun, there is more to this digital siren than quick reflexes and a cool demeanor in the line of fire. Lara's, ahem . . . physical arsenal is fully loaded as well. Co-opted by the gaming masses as the late twentieth century's newest pinup girl and sporting a virtual body that owes more to Barbie than to Courtney Love, Lara's popularity may rest less in her kick-ass attitude than in her DD cup size, lending a questionable edge to her feminist positioning. More important, her popularity reveals what can happen when the brave new world of commercial feminism meets advertising's unbending bottom line.

Historically, female players have long been featured in computer games, and fighting games in particular, but few would ever have been termed "self-empowered." Ms. Pacman was the first to warrant this distinction, and an important lesson can be drawn from her popularity. Players weren't concerned with her gender—male or female, she took no prisoners, and that's what counted. But the explosion of computer gaming into a billion dollar industry changed the face—literally—of character development. As one game designer noted, "Targeting is noble, but sales are the bottom line, so it only makes sense that Lara would also be hot."

Sex certainly sells, but to reduce the argument to a mere economics one ignores the component of social exchange inherent in interactive game play. The social implications of sexualized female characters in digital games, especially online games such as Quake, go far beyond marketing's quest for capital. Conversations with female gamers reveal that when an emphasis is placed on sex in marketing female characters, it often gives young men the wrong ideas about girls who like to play video games. Alana Gilbert, a female gamer and member of the PMS All Grrl Quake Clan, noted that, "When a female character has been sexualized, really young men will act accordingly—usually 'talking down' to the women or making lewd comments because they don't know what to say. It basically becomes a high-stress social situation for them." So what of this girlish offensive? For women gamers, the reality is simple: They don't want to play a game in which "their character's looks solicit unwelcome responses from men."

Hot or not, the question remains as to how women are interacting with their virtual counterparts. Sex may be the market's mantra, but it has little to do with how the game is played. Unless Lara's breasts get in the way of her guns, serious women gamers could care less about her appearance. Most women I spoke with expressed a desire for characters with an attitude, whatever gender. Completely unenamored with the fantastical dimensions of the women they play on screen, their interest effectively lies in being the one with the guns, the ammo, and the skill to win.

With the exploration of more female characters comes a promise to

3

2

expand the possibilities for women's public self-expression, a return to the riot grrrl desire to challenge and empower women more generally. Online resources such as GrrlGamer (www.grrlgamer.com) and ChickClick (www.chickclick.com) offer young women who are new to computers the opportunity to share in developing their own definitions of Girl Power. And in spite of a need to step beyond the images of cartoonish empowerment offered by Lara Croft and her curvaceous posse, the presence of strong female characters in gaming may allow otherwise shy or introverted girls to gain confidence by playing these women. The girls may regain their grrowl, after all.

Katie Salen is an Assistant Professor of Design at the University of Texas at Austin and the editor and designer of the [design] journal Zed. Her research focuses on utilizing a broad design practice to investigate ideas about the dynamic relationship between cultural identities and their expression through visual language. She can be contacted at zed@mail.utexas.edu.

Circuits of Desire:
Techno Fetishism and Millennial
Technologies of Gender

by Laura Frost

Nineteenth-century technology seems to have been designed to inspire eroticism: the steamy thrust of a locomotive, the vibrating pistons of an internal combustion engine, not to mention the safety pin, the zipper, and that irrepressible signature of kink, barbed wire. It's no coincidence that the Victorian period was the golden age of sexual fetishism (classically defined as an excessive libidinal attachment to an inanimate object), with an iconography that remained essentially unchanged for a hundred years. Twentieth-century technology is pitched in an entirely different register. Its historical arc shows an increasing distance between people and objects via invisible force fields, electromagnetic waves, and encrypted signals: radar, lasers, satellites, atomic reactors, computers, microchips. Late twentieth-century technology is to eroticism as the Quick Cam is to a Luddite.

Still, the libido finds a way. Despite its inherently alienating structures, the new technologies have inflamed erotic imaginations. What was the first question most journalists posed when virtual reality was invented? "Can we have sex with it?" The libidinal variations produced in recent years are stunning examples of how even the most erotically inhospitable forms of technology can be cathected and assimilated into a new erotic lexicon. The most elaborate example is "cyber" or "techno" fetishism, the erotic subculture that has materialized in the past five years or so, anticipated by William Gibson's 1984 novel *Neuromancer*. New York's Click and Drag is one of a number of clubs that fashions itself as a "new nightlife hybrid, an . . . exploration of technology, fetish, and the territory in between." The establishment's formal dress code suggests the mission of techno fetishism: "Sexy robot, fetish, anime, glam nerd vs classic nerd, gender-hacking, cyberslut, trekkie, post-apocalyptic, Victorian, cyber punk or access denied!"

Traditional fetish fashion accentuates the body's shape: the latex catsuit and the corset, for example. Although it may create the impression of an

impenetrable body, it nonetheless emphasizes the corporeality of the human form. Techno fetishism is different. These costumes incorporate technological components—mechanistic design and computerized tropes—in order to morph the body into a hybrid entity. Equipped with screens, switchboards, and headsets inspired by virtual reality, these "bodies" sprout wires and complicated circuitry. A keyboard is grafted onto an arm, a logic board serves as a breastplate, a motor of unidentifiable origin is wired into a headpiece. The resulting effect is a body fragmented into interlocking mechanical parts bound together by a rhizomic network. Techno fetishism does not merely embellish the erotic potential of the machine, but rather strives for a physical merging with the machine itself, a libidinalized grafting of technology onto the human body.

Japanese pop culture is rife with images of "sexy robots." The Japanese illustrator Sorayama is known for his techno versions of Vargas girls bursting out of robot costumes. Films such as *Tetsuo—The Iron Man* and animated series such as *Armitage* and *Battle Angel Alita* feature voluptuous female robots who seek to seduce and ultimately destroy men. Techno fetish culture draws from the anime scene and translates these fantasies into real-life costumes. The primary material of the techno body is metal, a substance whose relation to eroticism is indirect at best. Some techno fetish costumes retain standard modern fetish materials—PVC, leather, and rubber—but radically alter the form. Full-enclosure leather or rubber bodysuits distort and fuse limbs into grotesque shapes featuring strange growths and protuberances. These prosthetic appendages aren't human or identifiably functional; they are more like vestigial limbs, gesturing to an unspecified time in the past or sculpting an unknown future. Breathing tubes are quite common. In one instance, a sarcophagus-like body bag is hooked up to a portable vacuum. Another techno fetish costume (by Regulation) consists of an enormous futuristic inflatable sphere with a zipper for entry; a gas-mask breathing apparatus threaded through the balloon suspends the wearer's body inside, with only his head, shoulders, and arms protruding from above. Many of these costumes serve a sensory-deprivation function, but the hoses, masks, and tubes are carefully incorporated into the sartorial aesthetic and are calculated to produce an otherworldly, nonhuman effect.

Techno fetishism, American and Japanese alike, can be traced back to a filmic prototype: the gleaming metallic goddess in Fritz Lang's 1926 *Metropolis*. This tall female robot with jointed limbs (which nonetheless have a seamless, smooth surface) and molded breast cups is the creation of a scientist, Rotwang, who intends to replace human labor in the futuristic city Metropolis with a force of mindless androids. In a climactic scene that makes great use of a "modern" laboratory set and graphic demonstrations of electric currents, the external features of Maria, the workers' heroine, are grafted onto the robot. In an Art Deco nightclub, the robot-Maria does a striptease for the leaders of Metropolis and then, rebelling against the orders of Rotwang, causes a libidinally fueled riot among the workers.

Metropolis established several key tropes for twentieth-century figurings

of technology and culture: the machine that promises to improve life but goes awry, the imagining of the machine in sexualized terms, and the association of robots with predatory and feminine qualities. Lang was building on themes already present in the late nineteenth and early twentieth century. E. T. A. Hoffman's early nineteenth-century story "The Sandman" features an alluring female automaton, Olympia (who inspired Freud's essay on "The Uncanny," with its assertion that women, whether mothers, machines, or prostitutes, produce in men an ambiguous feeling of dread and sexual longing). F. T. Marinetti's 1912 "Technical Manifesto of Futurist Literature" includes a sadomasochistic love song to a "little machine gun" likened to "a fascinating woman . . . sinister . . . divine."

In *After the Great Divide*, Andreas Huyssen proposes that Lang's treatment of technology in *Metropolis* is related to castration anxiety aroused by female sexuality and a central fear of women usurping "phallic" power. By the interwar period, Huyssen argues, "Women, nature, machine had become a mesh of significations which all had one thing in common: otherness; by their very existence they raised fears and threatened male authority and control." Huyssen sees the creation of the "machine-vamp" in Metropolis as a displacement of "the much deeper libidinal desire to create that other, woman, thus depriving it of its otherness." Indeed, the self-generating "bachelor machines" that recur throughout modern art and literature demonstrate the desire to bypass women in reproduction. The man-made "machine-vamp" holds at bay generative dependence upon women and usurps threatening female sexual power.

Seventy years later, the themes have changed very little. Images of women in anime and cyber culture have for the most part continued in the soft-core direction of early sci-fi pulp novels and *Barbarella* space porn. Perhaps they have a harder, laser-toting edge, emulating Lara Croft, but they are cartoonish in their emphasis on gender. The male techno body, meanwhile, tends toward a more angular, mechanistic, and androgynous aesthetic. The cyber designer Garo Sparo, for example, shows women's outfits called "Betty 2060" and "Nebulatrix" that are not substantially different from standard fetish outfits, while the men's ensembles, such as "Galactic Servant," are decidedly asexual and even eunuchlike, as if shoring up the wearer against a dark, hostile universe: the coldness of space, the last frontier.

The most evident contemporary inspiration of techno fetishism is *Star Trek* and its endless spin-offs, especially *The Next Generation*, which has introduced a number of nonhuman species overtly imitated by techno fetishism. The most notable of these is the Borg, a particularly aggressive species of cyborg that operates in a collective form (thus the singular). The Borg multiplies its numbers through "assimilation," a pernicious assumption of other species achieved by injecting tubules under the skin, which release "nanoprobes" that infest and replace the victim's bloodstream. Techno fetish culture takes the Borg concept of "assimilation" quite seriously: It is the operating principle of the bricolage fusing of technological components onto the human body.

Borg culture is something like a beehive: a horde of interchangeable drones serves a Borg Queen. In the film *First Contact*, the Borg Queen is a sadistic, strangely beautiful, and grotesque creature. She makes her first appearance as a glistening, bald head (with delicate, classical features and external arteries) floating across a room on a short piece of spine that waves like a tentacle. She plugs herself into her body—a shapely gunmetal-gray mechanical suit—and sets about her task: intergalactic domination. The drone Borg are far less individuated. Their bodies, although retaining human form, are shaped out of undistinguished mechanical parts. Unlike the queen, Borg drones have no facial expression other than one of vague menace. Interestingly, men's techno fetish costumes tend to emulate the drone Borg rather than the individuated queen. The trademark drone mechanical eyepiece over one eye and the layered, mechanistic frigidity of the drone body constantly appear in men's techno fetish costuming.

Star Trek both influences and responds to techno fetish culture. In season four (1997-98) of the television program *Star Trek Voyager*, a Borg named Seven of Nine (played by Jeri Ryan) joined the Voyager crew. It was a revealing appeal to sexual undercurrents of techno culture. Seven is a statuesque blonde in a skintight silver jumpsuit. Her "nanotechnology" is mainly internalized, leaving her with a pinup exterior blemished only by a partial Borg eyepiece. Like the robot-Maria in Metropolis, Seven is a paradoxical creation: a machine whose hardware is hidden under comely human female skin. But Borg she is. In an episode called "Revulsion," a member of the Voyager crew is attracted to Seven's human exterior but is reminded of her true nature by her response to his advances: She informs him that the Borg has no need for seduction because it forcibly assimilates anything it desires. The Borg theory of sex encapsulates the terrifying allure of Seven. She is a perfectly engineered goddess who takes no prisoners. Between her lack of affect—her icy Amazonian demeanor—and the calculated casting and costuming, Seven is clearly reminiscent of a fetishistic type: the dominatrix. This raises some important questions: Is techno fetishism just a technologically updated version of stereotypical S/M fetishism? And why is it that the female robot or cyborg seems to be the most visible linkage of technology and sex?

Fetishism is precisely about the power of inanimate objects to excite sexual desire, stoking the libidinal fires by way of obstacles and substitutions. However, in its most extreme forms (the full-body suits of rubber or metal), techno fetishism seems to work excessively against eroticism. Its scaffolding and its deflective material severely curtail erotic and autoerotic possibilities: Just as no one can touch the techno body beneath the machinery, the techno body can't touch itself. (In the case of Seven or the robot-Maria, where the technological components have been internalized, the machine's programming is distinctively antierotic or asexual.)

In this respect, the dynamics of the millennial techno culture are one more example of how AIDS has changed the culture of sex—how it has induced an eroticized libidinal frustration. Hence, techno fetish is not simply a rarefied, bizarre subculture but, rather, is a more explicit articula-

tion of trends in urban culture at large. One way to make the relation evident is to view techno fetishism in terms of its progenitor, S/M. While S/M culture and fashion were once limited to the domain of sex clubs and private dungeons, in the early 1990s high-profile couture fashion designers sent pale imitations—carefully studded leather dresses and color-coordinated dog collars—down the runways. It's unlikely that any designer (except perhaps Thierry Mugler or Alexander McQueen) will start mass-producing robot or inflatable sphere suits the way Versace coopted S/M fashion for his 1992 "bondage lite" collection. But the aesthetics of techno fetishism are already making their way into the mainstream.

Photographer Helmut Newton, whose work appears in several mainstream fashion magazines every month, is arguably the best known promoter of fetish fashion, and his recent photographs experiment with techno fetishism. After a phase in the seventies of photographing women with saddles on their backs, Newton settled into a steady pattern in the late eighties of creating tableaus of nearly naked women in impossibly high stilettos. Newton is fond of shooting these Amazons staring down bland-looking puny men in dark suits, their faces often obscured. Although Newton's images overtly depict women as dominatrix types, he has often been accused of objectifying and demeaning women. There is some credence to these critiques, but Newton's take on gender and female empowerment is by no means straightforward. He seems to be responding to his critics in his work of the nineties, which strikingly involves an exploration of women's relationship to technology.

Newton's recent photo shoots for American *Vogue* address the apparent paradox of his early work, in which he showed "empowered women" who "suffer" for fashion. In a notorious layout ("High and Mighty") for the February 1995 issue of *Vogue*, Newton photographed Valkyrie model Nadja Auermann wearing a series of couture stilettos (Blahnik, Chanel, etc.) that visibly hamper her ability to move. In one photo, Auermann reclines, spidery legs crossed, in a red velvet–lined wheelchair. An anonymous black-suited man pushes her. Newton shoots the image from below, so that the wheelchair takes on an exalted stature; its shiny spokes and armrests are magnetic and almost voluptuous. In another shot, Auermann, perched on stilettos, hobbles with a cane on a jointed, polished silver leg brace very similar to the one Rosanna Arquette wears in *Crash* (the one that conceals the gaping wound with which the James Spader character copulates). In another photograph, Auermann leans against a car on one leg, an attractive matching prosthetic leg slightly off-kilter beside her. Newton remarks in an accompanying pull-quote, "A woman who wears these kinds of shoes has a tough time walking by herself." These images suggest that the sexualized body of the nineties cannot appear without restrictions, restraints, or prosthetics. And yet, these obstacles are surmounted and ultimately eroticized.

The common ground between Newton's work and the techno fetish aesthetic is even more clear in the photographs illustrating an article in *Vogue* called "The Machine Age." One photograph imitates the composition

of Duchamp's *Nude Descending a Staircase*, except that the model is wearing a Thierry Mugler couture silver robot suit. In another, the female model, wearing a Chanel corset dress, is stretched supine on a black leather "Panasonic Virtual Reality Massage Lounger" with a set of virtual-reality glasses over her eyes. The scene is a remarkable example of how the impulses of techno fetishism are translated into a more palatable mainstream register, how the fetishized body is traded in for the commodity fetish. Another photo in the series dramatically illustrates the confluence of classical fetishism and new techno fetishism. Three women appear in a chalky white room. In the center of the photo, a woman dressed in a Norma Kamali gym suit is working out in a state-of-the-art "ROM chrome and black steel" exercise machine. To her right, a woman wearing modern fetish staples, a black patent-leather catsuit (by Mugler) and stilettos, perches on the gym apparatus and shouts through a megaphone. To her left, the silver robot woman stands unsteadily against the machine. Two ages of fetishism flank Newton's favorite Amazonian type. Which way will she go?

And what does techno fetishism mean for feminism? Sexual fetishism itself has been thought to be, until very recently, the exclusive domain of men. As a compensation for castration anxieties and encouraged by a natural inclination for objectification ("the male gaze"), sexual fetishism just wouldn't make sense for women, or so psychoanalytic theorists thought. Women participate in techno fetish culture, but their relationship to it appears different from men's. Techno fetishism offers women a chance to "become" the "machine-vamp," but the mold is still Rotwang's. Donna J. Haraway's "Cyborg Manifesto: Science, Technology, and Socialist-Feminism in the Late Twentieth Century" declares, "Cyborg imagery can suggest a way out of the maze of dualisms in which we [feminists] have explained our bodies and our tools to ourselves . . . It means both building and destroying machines, identities, categories, relationships, space stories." The feminist potential of techno fetishism, then, would be a deconstructive one: the taking apart of stereotypical circuits of desire and the creating of new ones that are more conducive to female power. So far the stereotypes—"cyberslut" and Seven of Nine dominatrix—are still in place. Perhaps the contemporary eroticization of the machine is the prerogative of those who do not feel estranged by technology, those who have been initiated into the world of programming. As of today, the highest echelons of computer culture are predominantly masculine.

In a recent interview published in the online journal *Salon* (Joel Stratte-McClure's "At Home with Helmut Newton"), Helmut Newton announces that he's finished with photographing nude women: "Today I have a strong desire to photograph women clothed from head-to-foot with hardly an inch of flesh. It will be a challenge to work under such restraints." This sexualized aesthetic of restraint, shared by techno fetishism, is a way of soothing anxieties about technological alienation by making it a part of one's libidinal repertoire. Although the fantasies that infuse techno fetishism at present are primarily male, that may well change as the

institutions of technology change. In fact, given another ten years, techno fetishism, in a slightly different guise, may be inevitable. In the words of the Borg Seven of Nine: "You will be assimilated. Resistance is futile."

Laura Frost is Assistant Professor of English at Yale University, where she teaches courses in twentieth-century literature and culture.

Technologies of Undressing: The Digital Paper Dolls of KISS

by Elena Gorfinkel and Eric Zimmerman

. . . for it is precisely a specialty of the Japanese package that the triviality of the thing be disproportionate to the luxury of the envelope . . . It is as if, then, the box were the object of the gift, not what it contains . . .
—Roland Barthes, *Empire of Signs*

Input: keyboard and mouse. Output: sound and visuals. The distinctive challenge of interactive cultural products lies in the liminal space between the boundaries of input and output, the space in which rigidly defined choices unravel, beyond all design, into the emergent complexity of culture. Case in point: KISS.

Forget Gene Simmons. KISS is a computer program for dressing and undressing digital versions of paper dolls. It is noncommercial freeware, distributed freely over the Internet. Originating in Japan, KISS enjoys an international following of loyal fans who continue to propagate its technical and visual culture.

KISS is eminently interactive. In a digital context, "interactivity" usually refers to the navigation of a system by way of designed choices. But in an extended definition, interactivity acknowledges the larger social and semiotic structures of which the interactive object is a part. KISS demands an interdisciplinary reading that incorporates both technological and cultural analysis. And as interactive culture, KISS is radically hybrid, a transcultural synthesis of disparate parents.

KISS and Kisekae

The word *kisekae* in Japanese means "changing clothes." Kisekae paper dolls can be found in the backs of manga, the thick comic-book magazines that saturate Japanese mass culture. In 1991, a Japanese programmer with the moniker "MIO.H" was inspired by the cutout dolls in a girls' manga to create KISS (KIsekae Set System), a software for viewing and playing with computer versions of paper dolls.

In Japan, kisekae is an activity for little girls. But in the transformation from paper doll to computer doll, from kisekae to KISS, a diverse audience has emerged. Expanding quickly from a highly localized phenomenon, KISS has in recent years acquired an international fandom among anime lovers, digital art hackers, and pop culture aficionados.

KISS has been retooled since its origins on Japanese NEC computer architecture to become cross-platform freeware distributed over the Internet. Versions exist for MAC, Amiga, DOS, and a variety of Windows platforms. Its most visible audience is the largely male artist/programmers who develop the visual and technical culture of KISS. Over mailing lists and Web sites in America, Japan, and France, they discuss the latest KISS dress-up dolls while hacking the bugs in the newest KISS software release.

The Envelope of Innocence

KISS software is divided into "data sets" and "viewers." Each data set features an illustrated dress-up doll. A KISS viewer is the program that allows you to look at and play with the data sets. Superficially, KISS seems to offer the same kind of play that can be found in its paper progenitor. The dolls can be dressed and undressed by dragging clothes and accessories from the margins of the computer screen onto the body.

The technical wit of KISS is that it is not purely flat, but exists in a two-and-a-half-D space: Each item of clothing "knows" where it belongs in the third dimension relative to all of the other elements. This means that all the clothes combine seamlessly: A jacket will never fail to fit over a blouse, regardless of which item was placed onto the doll first. Click and drag a cigarette into the naughty schoolgirl's outstretched hand, and it will fit over her middle finger and under her index finger. Drag it onto her mouth and the filter end will disappear beneath her pouty upper lip.

The resulting interaction is both satisfying and addictive. Many of the costumes are fantastically intricate, with layer upon layer of interlocking garments. Manipulating the clothing on the sheathed virtual bodies is sinuously intoxicating. An effortless engagement ensues as the user moves and removes clothes, gliding them across the flat nonmateriality of the computer screen.

While the occasional giant robot doll can be found, KISS data sets overwhelmingly feature adolescent girls. Rendered in a variety of Japanese cartoon styles, KISS dolls range from plaid-skirted schoolgirls to pointy-eared pixie elves to leather-clad dominatrices. Some are popular animated characters, from the Japanese Sailor Moon and Ranma 1/2 to the American Batgirl and Pocahontas. Their bodies are posed in the fashion of glamour pinups and manga heroines, making for a curiously double sexuality. Miming the porn archetype of the underage schoolgirl, KISS dolls are at once garishly innocent adolescents and hypersexualized objects, a complicity of awkward pubescence and demure seduction. The doll bodies come with a staggering array of clothing, jewelry, pocketbooks, footgear, and undergarments, as well as occasional samurai weapons, sci-fi

armor, and bondage accessories. The taxonomy of objects extends into fetishized minutiae, including tiny gem earrings, multicolored hair barrettes, spaghetti-thin belts, and even a soiled sanitary napkin.

Undress-up Dolls

Unlike its paper counterpart, the primary activity of KISS is to undress, rather than to dress, the figure. This trajectory is hardwired into the interactive structure of the software. Removing the clothing is easy, but putting together a complete outfit is a painstaking task: None of the intricate garments "snap" into place. Although the clothes combine seamlessly, relative to each other, they have to be placed precisely and carefully on the body in order to become part of the array.

Each data set comes with several different "cells," or pages, each page offering the doll in a different set of clothes. When the computer user opens a new page, the doll pops up on the screen fully dressed. This means that the user's first action is invariably to take off a piece of clothing. Exploring the range of possible looks is as simple as paging through the prearranged outfits. Actually dressing the doll becomes a redundant activity. The inevitable gravity of a KISS interaction is to dismantle the prefab outfits, the cursor slipping each garment off one by one. With a fluid ease, the clothes move from the body, the undergarments quickly becoming visible. And the open-ended play of paper dolls shifts into a game of interactive striptease.

But at the expected climax, there is a sudden obstacle: The undergarments do not come off. A special feature of the KISS software is that bras and panties on most of the dolls actually resist the cursor's tug of removal. Only after a protracted struggle of twenty or thirty clicks-and-drags does the underwear relent and slip off of the body.

Sexual Technologies

The desperate clicking and dragging necessary to strip the doll is a richly perverse spectacle, advancing the interactive trajectory towards an inevitable ending. Both cursor on screen and hand on mouse wiggle in parallel masturbatory motion, frantically stroking the crotch and breasts. The implication is absurd: Rub the hot spots enough and the doll will be coaxed into taking it all off. In a spiraling crescendo of strange sexual technologies, the gestures of the user are conflated with the on-screen narrative of soft-core foreplay.

But once naked, the body itself is a disappointment. With no garments left to maneuver, there is no more interaction, no more simulation of pleasure. There is nothing left for the user to do. An impenetrable plastic surface, the pubescent KISS doll simply gazes back at the user with Japanimation eyes. The sought-after body is merely background, its flatness indivisible from the computer screen.

The KISS doll as sex object is a ripe metaphor for the fetishized objects of everyday digital life: the keyboard, the monitor, the mouse. KISS simply makes explicit the sensual interaction between user and computer, a

tableau for the obsessive relationship between culture and its technological tools.

The most obvious reading of KISS's sexual narrative is the structuration and frustration of male desire. But the subtle interactive contradictions of KISS make this straightforward digital rape scenario problematic. In KISS, it is the activity of undressing, as programmed into the interaction, that is privileged as a source of pleasure, not the doll body as object.

The adoring audience of KISS is largely male. So why are these guys playing with dolls? In the unforgiving glare of conventional wisdom, boys who play dress-up with dolls endanger their heterosexual adult masculinity. Sexualized as KISS may seem, the eventual disappointment of having "nothing to do" with the passive doll body signals the limit of male heterosexual interaction. The Freudian distinction between narcissism and desire, between "to be" and "to have," becomes muddled. Girls' presumed "identification" with dress-up dolls, redirected at KISS's male otaku audience, imbricates cross-gender and queer readings.

The few KISS sets that do deviate from the typical female adolescent play out these possibilities. In them, bugs, cakes, spaceships, and robots can be dissected, de- and re-constructed. The "KISS Set for Tough Men" features a bald, weakling KISS doll whose questionable masculinity can be replaced with female features, hair, or clothing. Such a set mocks the gendered presumptions of KISS, literalizing the possibilities for cross-gender identification within the content of the data set itself.

The Cultural Body of KISS

The radical disappointment of the revealed doll body results not just from frustrated desire but also from KISS's status as a collection. The KISS doll is a virtual object defined by the layered garments that trace and conceal its form. As the user undresses the doll, clothing accumulates around the edges of the screen, each stiff garment an effigy of the body. Through the play of KISS, the body is produced and reproduced, cloned and replicated. But it is never really complete. An effect of interactivity, KISS is not a set of separate, beautiful items, but a collection of objects that are contingent on one another through movement, association, and organization, a collection, a series of parts that flirt with coherence but ultimately resist closure. KISS is a collection of clothes that frame a body, a collection of pages that describe a doll, a collection of dolls on the Internet. This diffusion and multiplication displaces the fixation on the singular body, realigning pleasure in favor of many forms and their interrelations. The body becomes a layer among many others.

Any collection presumes to be a collection of wholes. At the same time, any collection presumes radical incompleteness, staving off chaos as it gathers and organizes. KISS plays out this double identity in a particularly exquisite fashion, all parts clearly visible but none of them resolving into self-containment.

Contrast KISS to the collectible phenomenon of Barbie. In Mattel Media's Barbie Fashion Designer (Barbie's most successful digital product

to date), the user composes a complete Barbie outfit from an impressive array of open-ended possibilities. However, the final output of the game is a noninteractive 3-D animation of Barbie modeling the user's style choices, all parts distilled and compressed into a seamless phallic fetish. KISS, on the other hand, works in reverse fashion, displacing coherence, troubling the divide between made and unmade.

Japanimation Eyes

During this century, particularly after the war, the standards of beauty that many Japanese have aspired to have been not those of Asia but the West. Round eyes, as opposed to the graceful, simply curved Asian eyes with their epicanthic fold, have become a sought-after commodity because they are regarded as more expressive.

—from *Manga! Manga!* by Frederick L. Schodt

Although anime does often strike us as utterly different, or "other," it also quite noticeably resembles—and is influenced by—American mass culture and generic narratives. That Americans might be interested in looking at their own culture through Japanese eyes tells us that Americans' feelings about their own culture are deeply bound up with America's evolving relationship with Japan.

—from "Magical Girls and Atomic Bomb Sperm—Japanese Animation in America" by Analee Newitz in *Film Quarterly*

It is now impossible to write or even conceive of "Japanese" popular culture without involving much of the rest of the world, just as we have never been able to isolate the "popular" or "cultur" itself outside of its complements.

—John Whittier Treat, *Contemporary Japan and Popular Culture*

As a process of culture, KISS is a hybrid phenomenon, mutating beyond the problematic dichotomies of East and West, Japan and America. There is a certain play between these geographic bodies and the graphic body, between national cultures and the culture of KISS. This play is nowhere so exquisitely stylized as in the eyes of the dolls.

Eyes are the most prominent feature of manga and anime characterization—massive, dewy orbs that dominate the cartoon face. Grossly stylized Western anatomy, these Japanimation eyes have paradoxically come to represent the whole of Japanese popular culture, and they are themselves part of a larger set of Westernized features. Pert Aryan noses, elongated bodies and legs, and blonde, brown, and red hair have all been enveloped into the retinue of Japanese pop representation.

The eyes of manga, anime, and KISS characters are symbols that combine and reposition the shifting self-images of Japan and the West. Within the eyes is the infinite reflection of a cross-cultural imagery, distended through globalized media and computer networks. Just as the strange interactive technologies of KISS embody sociosexual seduction, the impossibly large eyes point to perversity manifest in visual style, the style of the transcultural hybrid.

Making the Strange

A hybrid object presents itself curiously, not as an aesthetic object, an object of contemplation, but as an object that is both the source and subject of effects. The hybrid object is constituted by its network of relationships, existing as a function of the experiences it produces. There is a way in which all of popular culture is in some way hybrid, to varying degrees and extremes.

One effect of hybridity is disorientation—a pleasure in displacement. In *Re-Made In Japan*, Mary Yoko Brannen comments on the recontextualization of Disneyland from California to Tokyo. She finds the Japanese version of Disneyland a construction of cultural consumption "that takes two forms: making the exotic familiar and keeping the exotic exotic."

This logic of the hybrid resembles ostraniene, a notion put forward by the Russian formalist literary theorist Vicktor Shklovsky. In Shklovsky's Theory of Prose, translator Benjamin Sher explains ostraniene as a "process or act that endows an object or image with 'strangeness' by 'removing' it from the network of conventional, formulaic, stereotypical perceptions and linguistic expressions." With a machinic vortex of diffuse desire, KISS induces a highly specific form of ostraniene. Wresting the activity of paper dolls out of its traditional context, KISS voraciously hybridizes, from the radical appropriation of its anime aesthetic to its decentering mode of production and distribution.

Recombinant Naming

June 25, 1996 (Tuesday)

Some users are under a notion that there is a large gap between Japan and where they are. This is absolutely wrong. Most Japanese companies have a subsidiary or branch office abroad . . . As for me, I travel abroad a lot and have many acquaintances overseas . . .

June 24, 1996 (Monday)

Many people have been asking for more KISS sets. But if you try to make some yourselves, you'll know that it requires some time. If you do not have time yourselves, or cannot draw yourselves, it is the same here in Japan. There is no company developing KISS sets. These sets are made during developers' spare time . . . In all, if you are having problems, I am too . . . We would be really pleased to see more KISS utilities. Since there are more people outside Japan than in Japan, there should be more people able to draw as well. We are very disappointed that there are still so few. I would appreciate more mails on what you have done instead of empty talks on what you want and what you want to do. Nevertheless, we will be making more KISS sets here in Japan.

—selections from Web postings by H. Ozawa, KISS developer

It is not easy to create a KISS data set. Constructing the doll and the garments that wrap it requires both visual and programming acumen. The developers of KISS necessarily combine two disparate skill sets. This hybrid skill set reverberates into the personas of the KISS creators. A downloaded list of KISS artists reveals a blend of anonymous cyberhan-

dles, anime appropriations, and Japlish stylings: "A7M2," "Five Pennies," "G Hammer," "Ghost Attack," "Light," "Mb," "Mimimi," "Nifty," "Oh!Ze," and "Soi and Tonto," among others.

Programmer Melody-Yoshi's home page provides a further example. At this bilingual Web site devoted to KISS, visitors can peruse information, enter a short comment to a discussion group, or view Melody-Yoshi's personal profile, where the programmer's real name is revealed to be Hirohito Yoshimoto. Hirohito's fictive female name, "Melody-Yoshi," combines English and Japanese into an alias that resembles nothing so much as a KISS character name. Compare it to KISS dolls like "Bunny Gal Usa," "Karen-Chan," "Belldandy," "Cotton," and "Yoshinga Sally." Melody/Hirohito is a case study in interchangeability. The developer smoothly blends author and subject, appropriating the very hybridity of the artifacts s/he creates.

The most comprehensive KISS Web site, "The Big KISS Page," is maintained by American student Dov Sherman. In addition to extensive data on KISS, an early version of the site contained a photo album where Dov strutted his stuff dressed as Edward Scissorhands, Barbarella, and a Japanese schoolgirl in miniskirt and tights. Dov's enthusiasm for KISS and for fantasy costuming links the world of digital dress-up with the realm of style and transvestism.

Production and Proliferation

Radical interchangeability is hardwired into the structure of KISS, spilling into the relationships between its fans and its developers. Its status as a freeware entity, divorced from commercial production, means that the consumers of KISS are also responsible for its proliferation.

This movement from viewing to producing constitutes the online discourses of KISS. On Dov Sherman's Big KISS Page, the information structure of the main menu proceeds from downloading a viewer and data sets to downloading the tools and resources for making them. E-mail list discussions often bristle at the divide between devoted developer and mere user. The true KISS connoisseur engages the material, but only in the service of creating new works.

The economy of production is geared to the public domain instead of the marketplace. Being a viewer comes with a certain responsibility: to propagate and evangelize KISS in the world. Other fan cultures, such as those of *Star Trek*, sci-fi, anime, and especially fanzines, provide a populist precedent. But the decentered, noncommercial software of KISS makes it a ready-made circuit where fans blur into manufacturers and distributors, collapsing the space between a commercially made product and its consumers. As a fledgling node of pop culture, KISS elegantly blends the production of culture with the culture of producers.

Play by Design

Technology. Aesthetics. Desire. Hybridity. The pleasure of KISS is the play of KISS. In a 1995 interview, Paul Virilio distinguishes between two

kinds of play. On the one hand, there is the rule-bound play of a game like a board game, where players follow the rules in order to experience the play of the game. The second kind of play is the "free play" of a steering wheel, where the play exists as the interstitial space of freedom between rigid structures.

KISS embodies both kinds of play. It is at once a systematized game, constituted by its interactive structure and programmed code, and radically hybrid, interstitially playing between desires and modes of production, between digital code and cultural codes. Dressed in the garments of pop culture, KISS arranges and rearranges, collects and reproduces, undresses—almost—and plays on.

Eric Zimmerman is a commercial game designer, artist, and academic exploring the emerging field of game design. His recent projects include the award-winning computer game BliX (www.stationblix.com), Life in the Garden, *an interactive paper book (Razorfish Studios, 1999) and* RE:PLAY, *a conference Eric directed about game design and game culture (www.eyebeam.org/replay).*

Socialization and Imagemaking

by Kim McCarten

When you're born in a time of progress, you never expect things to go backward. It's like you're on a train: At first, you don't really know in what direction the train is going, but you can look out the window and see the scenery changing. Then, as the train picks up speed, you realize you're not only going in the wrong direction, you're going there fast. And it's going to take quite some effort to turn the train around.

We who make our living in the design and advertising fields are among the imagemakers in society. Yet we are not in control of the images that we make. We are products of our culture. We take in prevailing ideologies (coming at us incessantly from our TVs, movies, and magazines) whether we're aware of it or not. Our socialization is seeping into our work and shaping those images, and unless we are aware of this, we cannot even attempt to transcend it. Without an inquisitive, fairly suspicious mind, we allow the dominant perspective into our work. And our industry is not questioning this influence enough.

A main component of that dominant perspective is sexism. Other components—racism, homophobia, antisemitism—rest on the foundation of sexism, the oldest form of discrimination. Because sexism is now growing in our culture in a more insidious form than ever before, it has seeped into the design and advertising industry like the Ebola virus. It's something men ignore (or don't see in the first place)—assuming, perhaps unconsciously, that their perspective, as shown by the images they create, is objective or universal—and something many women don't want to acknowledge at all.

In an issue of *GD:USA* (September 1998), several prominent women designers were asked about their role in the industry, their careers, and their work. As noted in the article, not one of them wanted to make an issue out of her gender. Can you imagine a group of black designers denying that racism or that their race negatively impacted their careers in some way? What can explain this level of denial? A quick look at the exploitative

images in our culture, the rise of date rape, and the growing problem of sexual harassment, shows that we're living in a time of backlash against women. Why are women afraid to see this? Perhaps it is part of the normal reaction that humans have to random violence and injustice: There's a need to distance oneself, to believe that the victim did something to deserve it, and therefore, it could never happen to me. It helps one feel in control, even when one is not. The belief that the images all around me of women as naked, powerless, docile, nonthreatening beings won't affect how people see me, or my daughter—or how I see myself—is absurd. The belief that if I just work hard enough and don't make any trouble, I will be successful and respected—even as salary surveys consistently show that women in all fields, not just ours, are paid less than their equally-trained and -experienced male counterparts—is delusional. These problems can't be willed away. The denial of these women designers was startling.

Another survey, in the same issue of *GD:USA*, showed that women now make up a majority of the design industry. So why hasn't the imagery changed? Because imagemakers bring their socializing with them, and women designers are still taking on a male perspective. Perhaps that's why there is a paucity of outrage about this exploitative imagery and about the still-stereotypical portrayal of women making dinner, doing laundry, and taking care of the family when they're sick. Women are raised in a predominantly male society, and they create images that reflect this. Since our culture teaches us to consume women visually, women make images from the perspective of being looked at, often reflecting a picture of womanhood that has been defined by men. But it's so pervasive a "reality," it's often not even noticed.

A key reason for the predominance of this imagery is that men, until recently, have been the primary imagemakers. Images are reflective of what gender has made the photograph, painting, TV show, and so on. This imagery is not due to the mythical "demands of the market." We all know that we shape and create the market to a large extent and feed the "intensity habit" in our culture. And since women have not been allowed to openly "own" their sexuality and look at men, there are rarely images of men posing nude for our observation.

There are more components to this trend. Men have been taught a sexuality that dissects women into body parts, taught by pornographer imagemakers whose goal was not to overthrow puritanical repression but, rather, to make a buck (or two million). It is not a coincidence that these images have peaked at a time of great political and economic progress for women. These men wanted to get back at women who had rejected them (and others who were "threatening" them with their demands for shared power) by humiliating, controlling, and literally "owning" women through these images. Paper pimps like Hefner and Flynt told everyone they were being "liberated"—but this "liberation" occurred with other people's bodies. The recent growth of so called men's magazines (*Details*, *Playboy*, *Maxim*, even *GQ*, to name a few) feeds the idea that women can be consumed—and the growth of these images is coinciding with the

mainstreaming of stripping and prostitution as "career options" for young women to pay for college, the growth of date rape and domestic violence, and the sexualizing of twelve- and thirteen-year-old girls. In addition, we have the highest rate of rape, STDs, and teen pregnancy in the world. This is no revolution.

These imagemakers are portrayed as "sexual liberators" (despite their lack of credentials) and offer up an adolescent focus on breasts, passivity and control—but only in fantasy. They have convinced people that watching others have sex, instead of actually having it themselves, is liberating. Their social acceptance is clear evidence of the power of both imagemakers and the propagandistic quality of images (in this case, promoting backlash against feminism). We went from too many rules about sex to no rules at all, and we called it revolution—exactly what one would expect from our perpetually adolescent American selves. And the people who made this happen were twisted, greedy imagemakers. Countries that have healthier sexual cultures (like Scandinavia, for example) have egalitarian societies that respect women. (Men who respect women, elect women, share household duties, and so on, will find that women like them more—and want to have sex with them more! It's not brain surgery.) These cultures have more balanced representations of women and men in their media and some stable social institutions that check the power of those images. But this is not the case in our country—imagery and the resulting propaganda reigns supreme.

Design annuals regularly feature layouts from *Penthouse* and *Details*—aesthetics are separated from content. It's not deemed important that these magazines whore women, twisting both male sexuality and female self-concept. How is this separation possible? Perhaps it is part of another lie taught to men by our culture—the myth of compartmentalization. Why not feature a really well-designed spread from *Klan Monthly*? Why not a brilliant minimalist book cover for *The Turner Diaries*? How are they different? If it were only black people who were naked in these publications, do you think the pattern would be attributed to what the market likes or what African Americans choose to do? Do you think this pattern would be ignored to focus on how the typography compliments the photos? Any time there is a pattern there is, at least, a question to be asked and, at most, a systemic ill to be addressed.

Imagemakers in other media are following this same course. In movies, the roles for women have come to routinely involve actresses showing their tits—there has been an exponential increase in the amount of "incidental" female nudity in film. Roles for women regularly include parts for strippers and hookers (and are often recognized with Academy Awards—Elizabeth Shue, Kim Basinger, and Mira Sorvino to name a few). Just compare the movies of today to movies made as recently as the eighties and early nineties, and the pattern and the timeline for this shift becomes clear. Many movies from the last decade feature unapologetically strong women. But this progressive trend has been replaced with a cunning technique, which now distracts attention from what is really going on: Show

one strong woman in exchange for one naked, nonthreatening one (but give her some strong dialogue so no one perceives her as being exploited). Give it with one hand, take it away with the other. The same thing has happened to African Americans, with more and more movies featuring one-dimensional, buffoonish stereotypes. Coincidence? I think not.

So why all this focus on the images of women, and in particular, nudity? Because female-only nudity is quite literally a representation of the problem. This is not about sex, it's about money and power. And the people with the power have their clothes on—and are making the money. If it is about sex, why is it that actresses who finally succeed in their careers rarely continue showing their tits? And if it is truly about liberation, why is it that few men show their penises in a movie or on a billboard?

It is no coincidence that at this point in history, when women are no longer "tokens" in the military, the government, and the workplace, but are actually moving into these areas in droves, that the level of sexism in visual imagery has increased. It's like men are trying to reassert their power through corporate mergers and taking control of the media, the same way you do in a war—consolidate your forces and control communications (almost more important for getting control of a country than dropping bombs). Since women are perceived as threats, there are more derogatory images that bash feminists and depict women as submissive, sexualized playthings—not threatening at all. Society's response is to legitimize the formal exploitation of women through imagery. Socialize men and women to consume women (women's images), get men turned on by a particular "look" or body part, and get women to abandon their recently made gains and go back to spending their time dieting, exercising, and being looked at. Get women to create the exploitative images, and threaten those who protest with labels such as "prude." Get women to whore themselves and tell everyone it's about "choice."

It's not that men aren't being exploited, too. This manipulation hurts men in terms of their ability to see women as human beings and to relate to women, and it stifles their development as full human beings. And it certainly impacts the images they make of women.

No one debates that violence desensitizes us, but the effects of exploitative images of women is still an open discussion. The media either has the power to impact behavior and beliefs or it doesn't—you don't get to pick which behavior you think is affected. (Of course, they don't have these discussions at ad agencies or movie studios; they already know the answer.) The rise of corporate mergers, Congress changing the laws to allow this consolidation, and the irrefutable effects of our Jerry Springer culture are occurring at a particular point in our history and are NOT a coincidence.

It makes our awareness as imagemakers that much more important. As designers in the new millennium, we need to be more aware of the beliefs we are bringing to the imagemaking process. We have the power to significantly shape and alter people's perceptions. And when you live in a time of backlash (not only against women, but against African Americans,

homosexuals, et al), you need to wield that power responsibly. All problems between men and women, or any groups, are about power. You'd think we'd be at a more balanced place at the end of this century, but we're not there yet. We need to fight this devolution for the sake of both genders.

Feminism is a 500-year revolution, scholars say—the biggest revolution in human history. It's not just a political, industrial, or information revolution, but one that affects the entire species in every aspect of our lives from dating to child rearing to the workplace, education, and government. Maybe it's really a compliment to the power of feminism that it gets this kind of backlash—we would be ignored if this wasn't important. But should women be helping that backlash along? Should men? No one can win if this continues—and the gulf between women and men will only widen if it does.

Kim McCarten is a freelance designer and writer in Chicago and founder of Merge, *a 'zine that tries to encourage dialogue about media messages, culture, and gender issues.*

Not Even a Woman's Hand: Sex in Advertising, Middle East Style by Shem Friedlander

In the opening pages of the 1985 book *Olgivy on Advertising*, we are shown a billboard ad that ran in Paris. A beautiful woman wearing a bikini stands on the beach in front of the sea. The only copy reads, "Next week she will take her top off." All of Paris was talking about this advertisement. The public watched and waited with great anticipation. The next week a new billboard was displayed, and indeed the woman stood in the same position minus the top of her bathing suit. The copy read, "Next week she will take her bottom off." Again the billboard ad was the talk of Paris. And the next week the woman stood naked but turned around, facing the horizon. The copy read, "Billboard advertising: we deliver what we promise."

The rules of advertising are different in the Middle East, where the culture is more conservative and religion is an integral part of daily life. About the same time as this Parisian ad, an Egyptian advertising agency (still a rather new concept in those days) was asked to develop a TV commercial for a vacuum cleaner manufacturer. The ad was to be shown in Saudi Arabia. The restriction was that no women could be seen in the ad. "Not even a woman's hand?" asked the ad director. "No, not even a hand."

Although today women can be seen in TV commercials and print ads in Saudi Arabia, they must wear long dresses with sleeves that come to the wrists, and their hair must be covered. During the holy month of Ramadan, (when Muslims fast during daylight hours), no women are shown on Saudi television. An ad cannot even have a woman's voice. An ad for Drakkar, a cologne for men, ran in the West with a woman's hand holding the unclothed arm of a man, indicating a kind of intimacy. When the same ad ran in the Arab region, the man was wearing a jacket.

Restrictions regarding women in advertising differ from country to country in the Middle East. While in Saudi Arabia, only the hands and face are allowed to be shown, in Lebanon, where television is privately controlled, a partially naked woman or one in transparent clothing can be

seen in commercials and print ads.

In Egypt, all local television, movies, and books are censored by the government, which controls the media. Magazine ads are more flexible than television. You can now see women in bathing suits in print ads in Cairo. No sexual scenes are allowed in advertising in Islamic countries and any implicit sexual scenes in Western films are edited out before they are released to the public. Saudi Arabia has no cinemas, and only edited versions of movie videotapes are sold. There are no television ads for alcohol, although beer ads are allowed in newspapers and magazines.

Satellite television allows for more revealing ads and movies, but there remains a strict enforcement regarding sex and politics in locally produced ads and programs. Orbit, a private international satellite network that is largely owned by members of the Saudi royal family, and other satellite networks offer protection for the viewer in a rating system (similar to the one in the United States) by which symbols and verbal warnings precede movies. There are also smart cards with pin numbers that allow the viewer to choose which programs are to be viewed. Remotes are also equipped with parental control buttons. Because the multiplicity of channels does not allow for tight censorship, the idea of choice has emerged. Censorship will be replaced by choice for the elite, who can afford pay television, and normal, censored television will become the media for the poor and illiterate.

All Middle East advertising agencies must approach advertising acknowledging these restrictions. The agencies in Cairo attempt to circumvent some of the restrictions by creating ads that are visually and verbally suggestive without being explicit. A Tang ad had a lovely woman drink the juice and then exhale heavily in a satisfied manner. After some complaints by the public, which usually take the form of newspaper articles, the censors removed the ad. A Cairo ad for Fayrouz, an apple-flavored carbonated drink, showed a group of young men in a café ordering Fayrouz from the waiter. A beautiful girl walks by their table in full view. The waiter brings the order. As the men discuss the various delicious qualities of Fayrouz, the young woman passes their table again and heads for her friends at a nearby table. As she approaches, her friends say, "Ah, Fayrouz, we are glad to see you." The double entendre is clear, while there is no explicitness that would provoke the censors.

Coca-Cola attempted a milder version of the Paris billboard ad in an Egyptian TV commercial. A glamorous woman emerges from the sea. She is shown from the waist up and is wearing a red T-shirt topped with an unbuttoned long sleeve shirt. The "wet look" emphasized her breasts and caused enough complaints for the censors to take the commercial off the air.

Because of conservative religious values in the region, and the fact that these enduring values are unlikely to change, it is unlikely that we will ever see nudity, sexual scenes, or even extreme intimate relations between men and women on national Arab television.

Shem Friedlander is a senior lecturer and director of the Apple Center for Graphic Communications at The American University in Cairo.

ion 5

Progress

The Sexual Evolution, 1900–2000

by Mary Domowicz

Pornography is the representation of directly or indirectly erotic arts with an intrusive vividness which offends decency without aesthetic justification.
 —George Elliot

Over the past one hundred years, advertising and graphic design have exemplified the evolution from sexual repression to sexual permissiveness in America. This timeline shows how sexuality has been exploited and the human body has been provocatively used to sell products and illuminate editorial content. To get attention, images keep pushing the edge of acceptability, and society has become increasingly accustomed to the result. What was unthinkable one decade is commonplace the next.

Mary Domowicz is the principal of The Domowicz Company in New York City, which specializes in smart corporate collateral and editorial design. She has been AIGA/NY cochair of the Women in Design Special Interest Group (SIG), the Book Forum SIG, and the Small Talk series.

References

Ewen, Stuart. *Channels of Desire*. Minneapolis: University of Minnesota Press, 1992.
Foerstel, Herbert. *Banned in the Media*. Westport, Connecticut: Greenwood Press, 1998.
Goldman, Robert. *Reading Ads Socially*. London: Routledge, 1992.
Messaris, Paul. *Visual Persuasion: The Role of Images in Advertising*. London: Sage Publications, 1997.
Twitchell, James. *Adult USA: The Triumph of Advertising in American Culture*. New York: Columbia University Press, 1996.

1898 **Advertiser: Duke Cigarettes**

1890 Designer/Illustrator: **Will H. Bradley**

1898 Designer/Illustrator: **Will H. Bradley** Publication: *The Chap Book*

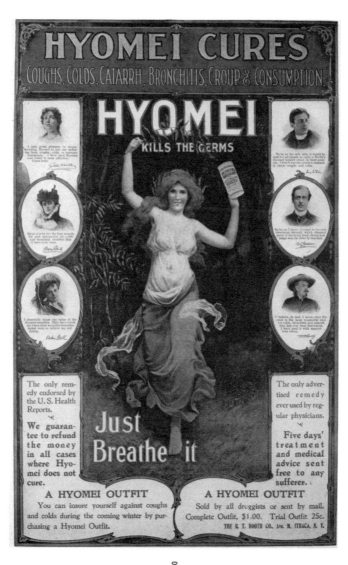

05 **Publisher: Burr Publishing Company**

06 **Publication:** *Life*

11 **Illustrator: Starmer**

BEFORE YOU LEAVE FOR YOUR VACATION

see that your hosiery wants are supplied in the very newest and most desirable numbers of

 "*Onyx*" *Silk Hosiery*

With the "POINTEX" Heel

No matter where you live you will find good selections at your favorite dealers because leading stores throughout the country feature the "ONYX" brand.

Wholesale *Lord & Taylor* *New York*

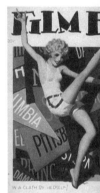

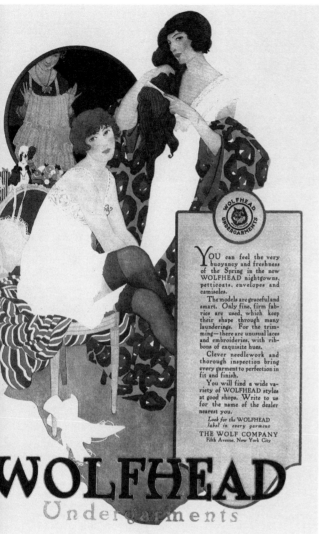

WOLFHEAD
Undergarments

The ad text:

YOU can feel the very buoyancy and freshness of the Spring in the new WOLFHEAD nightgowns, petticoats, envelopes and camisoles.

The models are graceful and smart. Only fine, firm fabrics are used, which keep their shape through many launderings. For the trimming—there are unusual laces and embroideries, with ribbons of exquisite hues.

Clever needlework and thorough inspection bring every garment to perfection in fit and finish.

You will find a wide variety of WOLFHEAD styles at good shops. Write to us for the name of the dealer nearest you.

Look for the WOLFHEAD label in every garment

THE WOLF COMPANY
Fifth Avenue, New York City

19 Advertiser: Wolfhead Undergarments

20s Advertiser: Coca-Cola

30 Illustrator: Sylvia Whale Advertiser: Black Cat Cigarettes

183

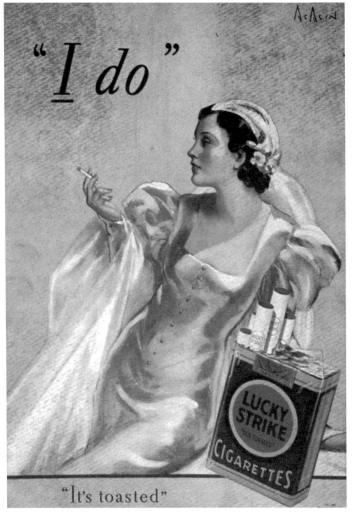

"*I* do"

"It's toasted"

30 Advertiser: Lucky Strike Cigarettes

28 Illustrator: John Held, Jr. Publication: *Life*

30 Advertiser: Old Gold Cigarettes

34 Photographer: Edward Steichen Advertiser: Matson Line-Oceanic Line

38 Advertiser: Johnson's Wax

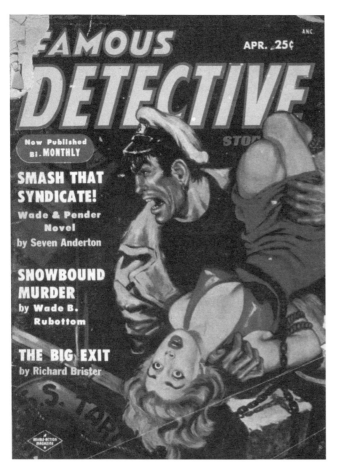

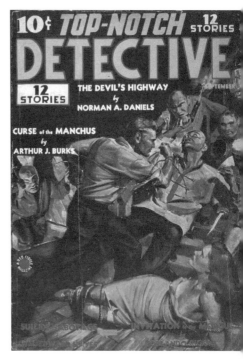

40s Illustrator: Elvgren Advertiser: Coca-Cola

40s Illustrator: J.C. Leyendecker Advertiser: Jantzen

40s Advertiser: Spring Mills

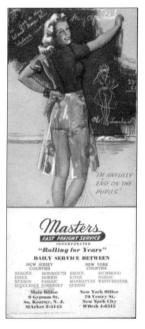

40s Advertiser: Masters Freight

40s Advertiser: *Buxom Melons*

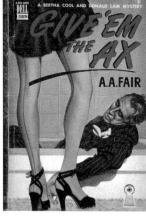

40s Publication: *Give 'Em the Ax*

40s Publication: *Jungle Stories*

Collier's

MARCH 29, 1947 · TEN CE

MR. SECRETARY MARSHALL

BY JOHN HERSEY

47 Publication: *Collier's*

40 Publication: *Coronet*

40s Illustrator: Alberto Vargas Publication: *Esquire*

40 Publication: *The Body Missed the Boat*

40 Art Director: Alexey Brodovitch Photographer: Herbert Matter Publication: *Harper's Bazaar*

41 Art Director: Alexey Brodovitch Photographer: Louise Dahl-Wolfs Publication: *Harper's Bazaar*

42 Art Director: James Yatess Photographer: Russie Green Publication: *The Saturday Evening Post*

43 **Publication:** *Collier's*

45 **Advertiser:** Trushav

48 (matchbook)

49 Publication: *Woman's Home Companion*

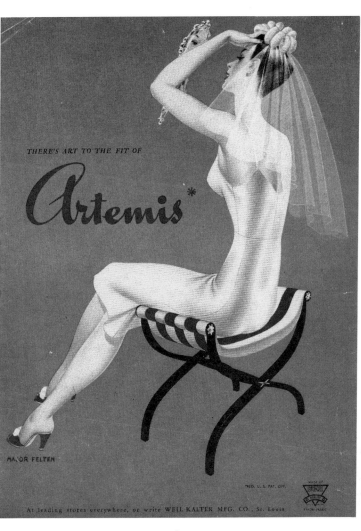

46 Advertiser: Artemis

49 **Art Director: Ambrose J. Kennedy Photographer: Mitchell Bliss Advertiser: Kislav**

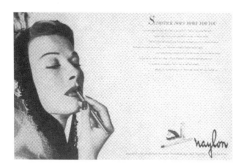

49 **Art Director: Arthur P. Weiser Photographer: John Rawlings Advertiser: Naylon**

49 **Art Director: Cipe Pineles Photographer: Francesco Scavullo Publication: *Seventeen***

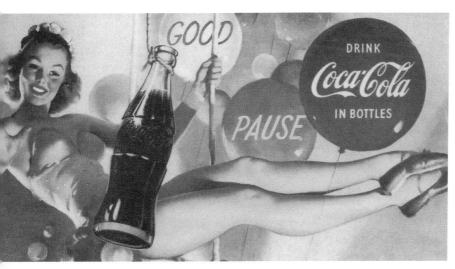

50s **Illustrator: Elvgren Advertiser: Coca-Cola**

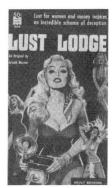

50s **Publication:** *Lust Lodge*

195

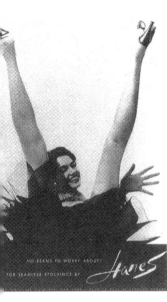

VOGUE

1950

MID-CENTURY
FASHIONS
FACES
IDEAS

TRAVEL
HANDBOOK

Price 50 Cents

January 1950

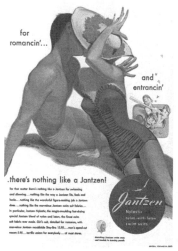

for romancin'...

and entrancin'

...there's nothing like a Jantzen!

For that matter there's nothing like a Jantzen for swimming and slimming... nothing like the way a Jantzen fits, feels and looks... nothing like the wonderful figure-making job a Jantzen does... nothing like the marvelous Jantzen swim suit fabrics... in particular, Jantzen Nylastic, the magic-moulding fast-drying special Jantzen blend of nylon and lastex, the finest swim suit fabric ever made. Girl's suit, detailed for romance, with marvelous Jantzen mouldable Stay-Bra 15.95... man's spend-at ease 5.95... terrific colors for everybody... at most stores.

Jantzen
Nylastic
nylon · with · lastex
swim suits

50s Publication: *Swank*

50 Art Director: Alexander Liberman Photographer: Erwin Blumenfeld Publication: *Vogue*

51 Illustrator: Peter Hawley Advertiser: Jantzen

197

53 **Advertiser: Columbia Pictures**

55 **Publication: *Esquire***

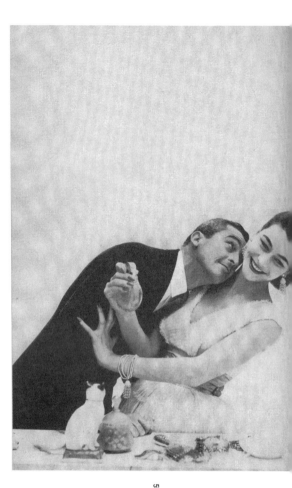

55 **Art Director: Bradbury Thompson Photographer: Mark Shalo Publication: *Mademoiselle***

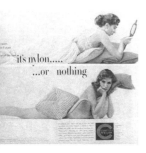

56 **Advertiser: Chemstrand Nylon**

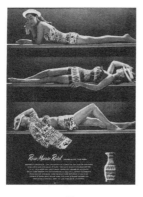

56 **Advertiser: Reid Swimwear**

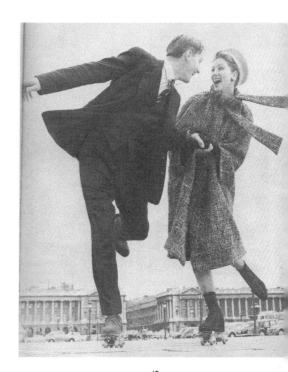

57 **Art Director: Alexey Brodovitch Photographer: Richard Avedon Publication:** *Harper's Bazaar*

52 **Art Director: Gene Federico Advertiser: *Woman's Day***

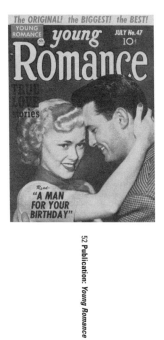

52 **Publication: *Young Romance***

53 **Publication: *Playboy***

57 **Art Director: Allen F. Hurlburt Photographer: Milton Greene Publication: *Look* magazine**

58 Designer/Art Director: Henry Wolf Photograher: Dan Wynn Publication: *Esquire*

58 Designer/Art Director: Art Kane Photographer: Saul Leiter Advertiser: I. Miller & Sons Inc.

58 Designer/Art Director: Onofrio Paccione Photographer: Dan Wynn Advertiser: Wallace Silversmiths

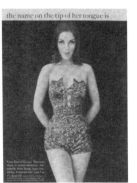

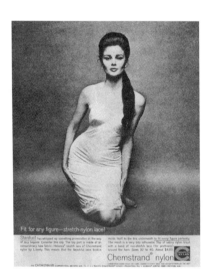

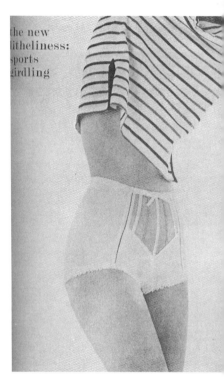

60s **Advertiser: Petti Sweaters**

60s **Advertiser: Chemstrand Nylon**

60 **Publication:** *Charm*

202

61 Art Director: Edward Rostock Designers/Artists: Gene Federico, Bill Helburn

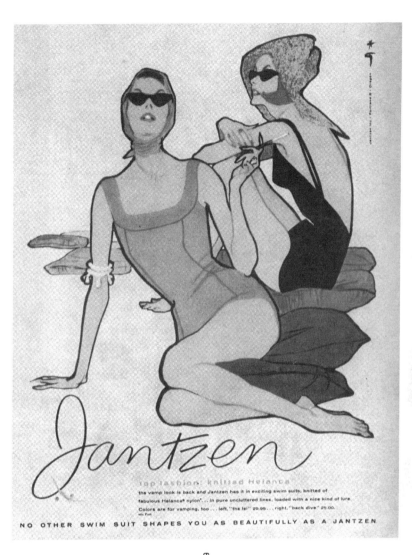

61 Art Director: Elizabeth Eyerly Artist: René Gruau Advertiser: Jantzen

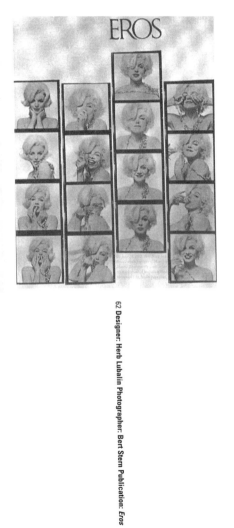

62 **Designer: Herb Lubalin Photographer: Bert Stern Publication:** *Eros*

62 **Designer: Herb Lubalin Photographer: Bert Stern Publication:** *Eros*

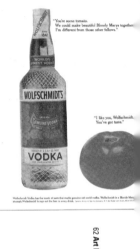

62 **Art Director/Designer: George Lois Advertiser: Wolfschmidt's Vodka**

left-hand partial ad text:

...est doll, I appreciate you. I've got taste.
...g out the real orange in you. I'll make you famous.
...e."

"Who was that tomato
I saw you with last week?"

...dt Vodka has the touch of taste that marks genuine old-world vodka. Wolfschmidt is a Screwdriver is an orange at ...Wolfschmidt brings out the best in every drink.

68 **Publication:** *Avant Garde*

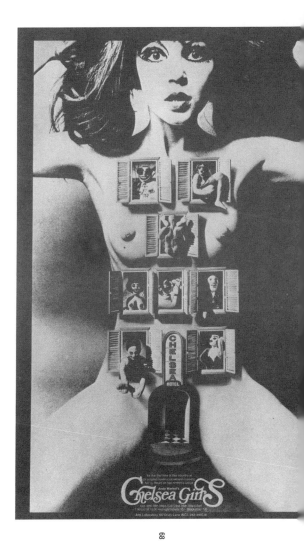

68 **Advertiser: Chelsea Girls**

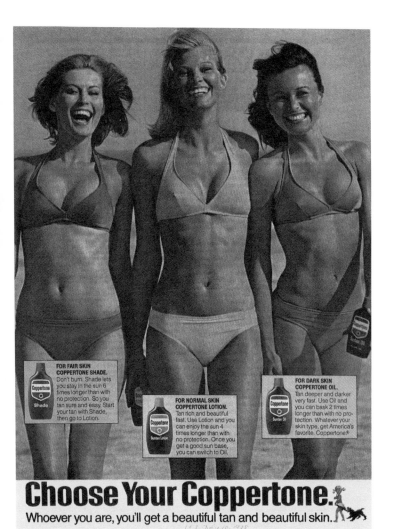

FOR FAIR SKIN COPPERTONE SHADE. Don't burn. Shade lets you stay in the sun 6 times longer than with no protection. So you tan sure and easy. Start your tan with Shade, then go to Lotion.

FOR NORMAL SKIN COPPERTONE LOTION. Tan rich and beautiful fast. Use Lotion and you can enjoy the sun 4 times longer than with no protection. Once you get a good sun base, you can switch to Oil.

FOR DARK SKIN COPPERTONE OIL. Tan deeper and darker very fast. Use Oil and you can bask 2 times longer than with no protection. Whatever your skin type, get America's favorite. Coppertone®

Choose Your Coppertone.
Whoever you are, you'll get a beautiful tan and beautiful skin.

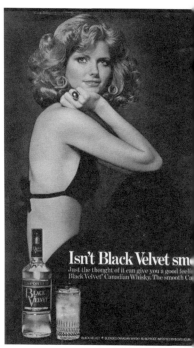

Isn't Black Velvet sm
Just the thought of it can give you a good feeli
Black Velvet® Canadian Whisky. The smooth Ca

BLACK VELVET ® BLENDED CANADIAN WHISKY 80.8° PROOF. IMPORTED BY © 1978 HEUBL.

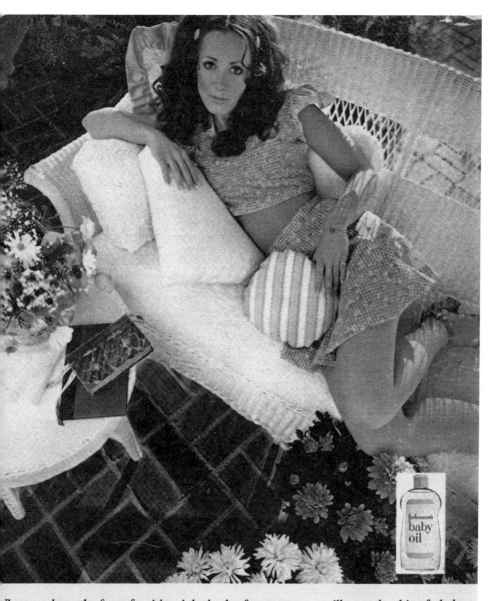

When you have the face of a girl and the body of a woman you still want the skin of a baby

While a young face usually has more than enough oil, the body that goes with it often doesn't have enough.

But Johnson's Baby Oil can help keep a body that's been exposed to sixteen or so summers and winters baby-soft all over. Even rough spots like elbows, knees, and heels. Even legs that have just been shaved. Even chapped hands. And if you add some of the pure, gentle oil that keeps babies soft to your bubbly bath, it'll leave you feeling silky and slinky from neck to toe.

Johnson's Baby Oil. If you're woman enough to want the skin of a baby.

Johnson & Johnson

Advertising - Beauty Culture

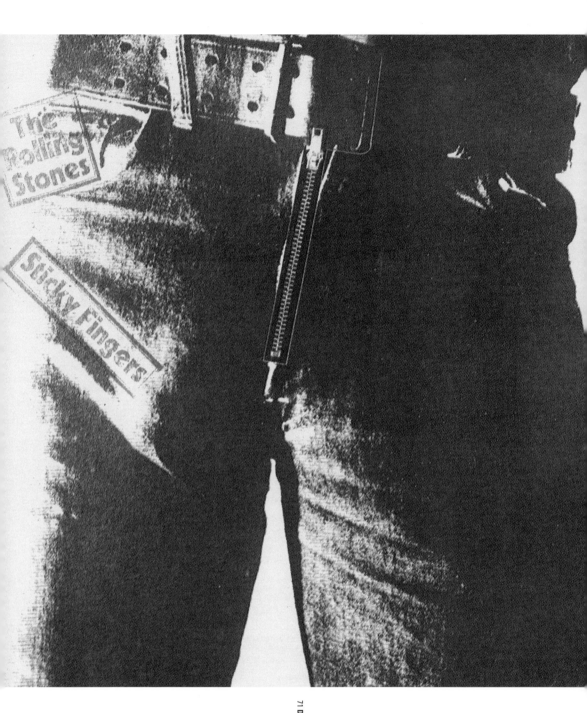

71 Designer: Andy Warhol Recording Artists: Rolling Stones

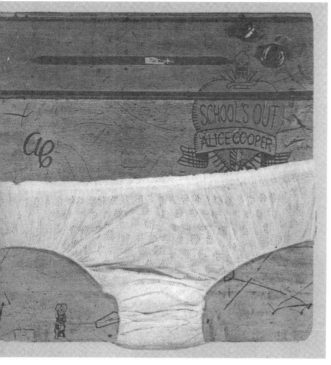

72 Photographer: Robert Otter Recording Artist: Alice Cooper

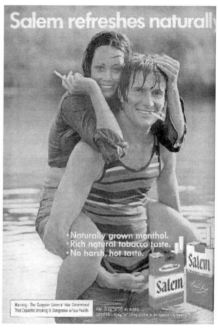

74 Advertiser: Salem

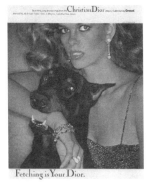

Fetching is Your Dior.

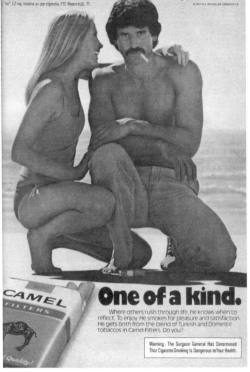

One of a kind.

Where others rush through life, he knows when to reflect. To enjoy. He smokes for pleasure and satisfaction. He gets both from the blend of Turkish and Domestic tobaccos in Camel Filters. Do you?

Warning: The Surgeon General Has Determined That Cigarette Smoking Is Dangerous to Your Health.

210

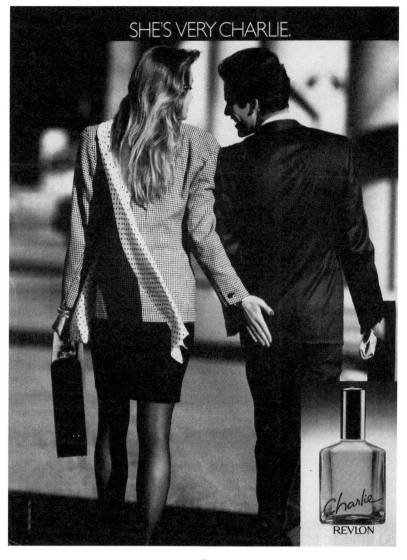

SHE'S VERY CHARLIE.

Charlie

REVLON

211

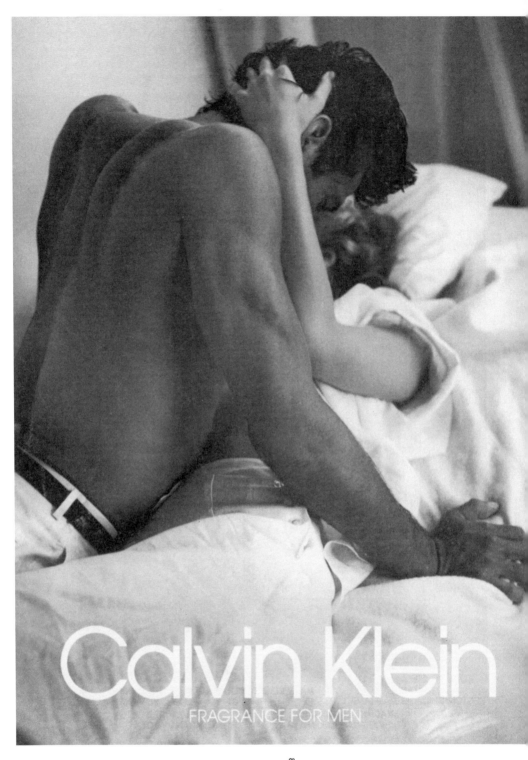

Calvin Klein

FRAGRANCE FOR MEN

212

80s **Advertiser: Round the Clock**

Campari. Reflection on art.

80 **Illustration: Steve Campbell Advertiser: Campari**

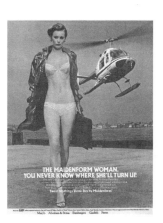

80 **Photographer: Chris Von Wangenheim Advertiser: Maidenform**

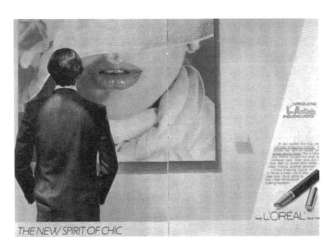

THE NEW SPIRIT OF CHIC

81 Advertiser: L'Oreal

Being in control never felt so good.

83 Advertiser: L'eggs

214

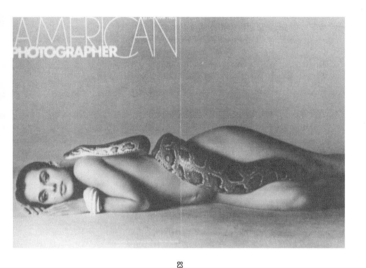

83 **Art Director: Will Hopkins Designer: Louis F. Cruz Photographer: Richard Avedon Publication:** *American Photographer*

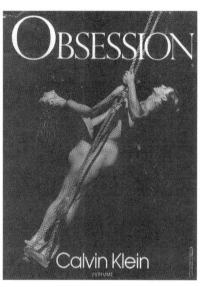

80s **Advertiser: Calvin Klein**

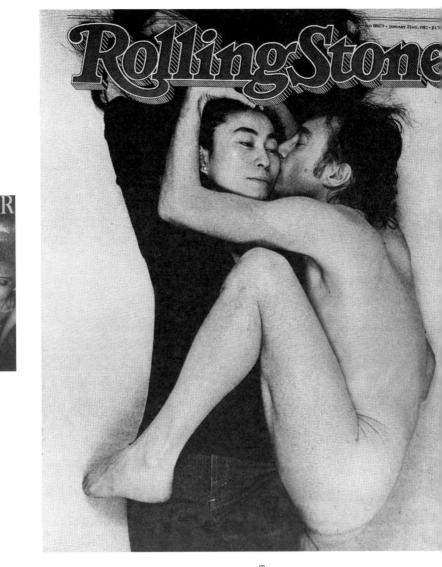

81 **Publication:** *Rolling Stone*

87 **Art Director:** Carla Barr **Publication:** *Connoisseur*

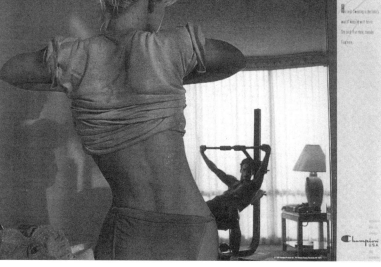

80s **Advertiser: Levis**

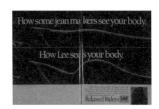

How some jean makers see your body.

How Lee sees your body.

Relaxed Riders Lee

80 **Advertiser: Lee Jeans**

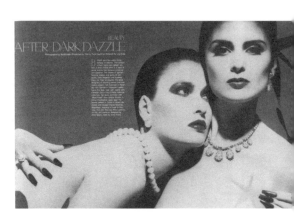

84 **Art Director: Melissa Tardiff Designer: Mary Rosen Photographer: Skrebneski Publication:** *Towne & Country*

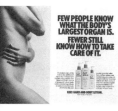

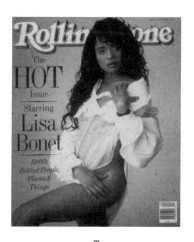

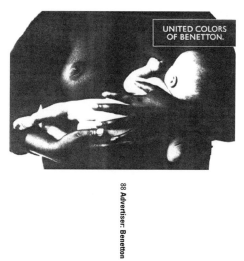

87 Art Director: Michael McLaughlin Photographer: John Mastromonaco Advertiser: Keri

88 Publication: *Rolling Stone*

88 Advertiser: Benetton

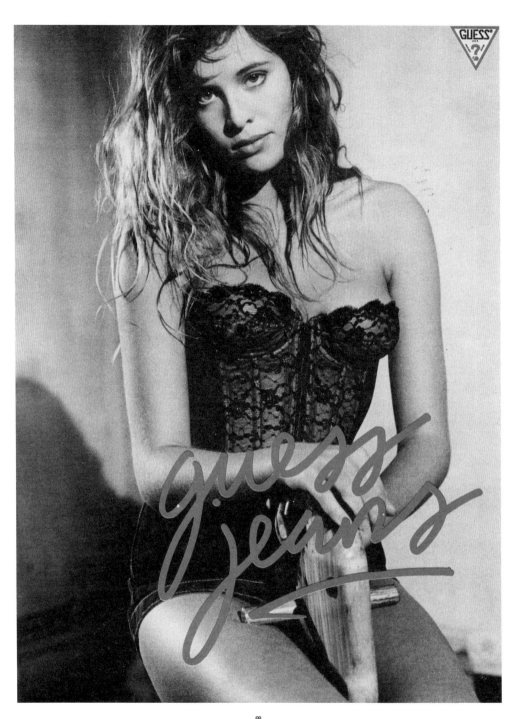

87 Advertiser: Guess Jeans

220

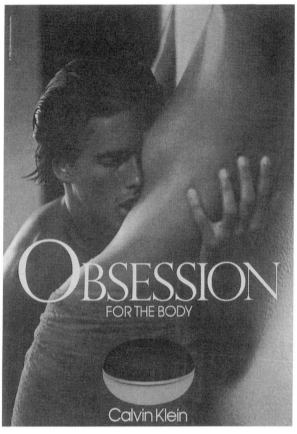

OBSESSION
FOR THE BODY

Calvin Klein

The Maidenform Woman.
Today she's sensuous.

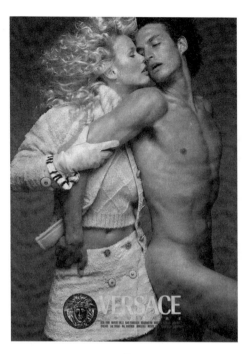

94 **Advertiser: Versace**

90s **Advertiser: Joop!**

91 Art Director: Douglas Lloyd Photographer: Bruce Weber Advertiser: Paramount Hotel

92 **Advertiser: Camel**

91 **Art Director/Designer: Terry Schneider Photographer: C.B. Harding Advertiser: Simpatico**

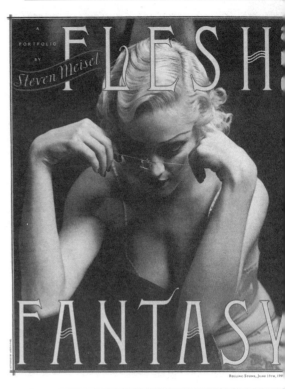

92 **Art Director:Fred Woodward Photographer: Steven Meisel Publication: Rolling Stone**

92 **Art Director:** Fred Woodward **Photographer:** Steven Meisel **Publication:** *Rolling Stone*

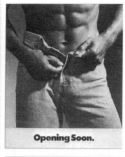

Opening Soon.

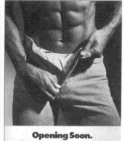

Opening Soon.

Now Open.

DOWN
UNDER

92 **Art Director:** Mike Wagner **Photographer:** Kyle Rothenberg **Advertiser:** Down Under

smooth

tender,

94 **Art Director:** Rooney Carruthers **Photographer:** Jean Loup-Sieff **Advertiser:** Haagen-Das

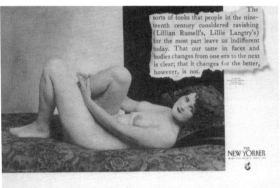

The sorts of looks that people in the nineteenth century considered ravishing (Lillian Russell's, Lillie Langtry's) for the most part leave us indifferent today. That our taste in faces and bodies changes from one era to the next is clear; that it changes for the better, however, is not.

THE NEW YORKER

94 **Art Director: Jeremy Postaer Advertiser: the** *New Yorker*

ROMEO

94 **Art Director/Designer/Illustrator: Lanny Sommese Advertiser: Penn State University**

90 **Advertiser: Benetton**

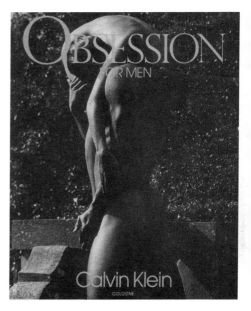

92 **Art Director: Sam Shahid Photographer: Bruce Weber Advertiser: Calvin Klein**

227

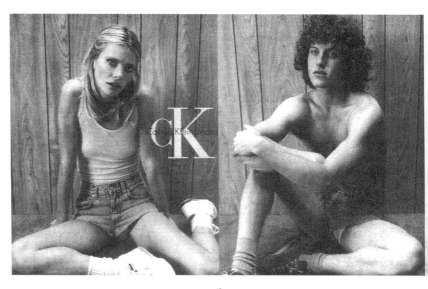

93 **Art Directors/Designers: Patricia Bradbury, Peter Comitini Photographer: Wayne Maser Publication:** *Newsweek*

95 **Advertiser: Calvin Klein**

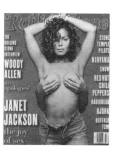

95 **Publication: Rolling Stone**

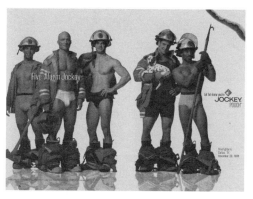

99 **Advertiser: Jockey**

99 **Advertiser: Armani**

What a Body! Paperback Covers of the 1940s and 1950s by Piet Schreuders

Turned out of her home by an over-strict mother, Lilirose sets out to solve the riddle of Life. Almost immediately she learns that she must pay a price for her ignorance of the ways of men. Bitterly disillusioned, Lilirose travels downward on a road filled with misery and disgrace . . . Will Lilirose find the life she is seeking? Paul Renin once again gives you a novel packed with fiery emotions and breathtaking suspense.

Thus reads the back cover blurb of an "Archer Book" produced by Kaywin Publishers out of Cleveland—a novel simply entitled *Sex*. Paul Renin, whoever he was, had hit the bull's-eye.

Yes, why not call a novel *Sex*? It's a much better title than *For Whom the Bell Tolls*, for instance. It is indicative of the state of American paperback publishing in the early 1950s, an era as much dominated by sex as by sexual repression. Paperback books about sex were extremely popular, with titles such as *Sexual Practices of American Women* (Christopher Gerould), *The Sexual Side of Marriage* (M.J. Exner), *Sexual Conduct of the Teenager* (Jules Archer), *Sex without Guilt* (Albert Ellis), *Sex and the Love-Life* (William J. Fielding). Paperbacks had come into their own during and after the Second World War and, by 1950, were like a giant money machine. Anything could be reprinted, from the classics to trashy novels; everything was given a "sexy" cover and was sold like a magazine on a newsstand in the widest possible distribution. If paperbacks were once considered a way to educate the masses (Good Reading for the Millions) not much evidence of it remained. Capitalism ruled.

The sex appeal of the paperback covers of the late forties and early fifties was provided primarily by their covers, which had to grab your attention among hundreds of others in bookshops or newsstands. Magazine artists like William Randall, who had worked for the *Saturday Evening Post*, and Rudolph Belarski, who had illustrated covers for pulp magazines, received quite specific instructions from the editors: "Make 'em round!"

Archer Books #50
Sex, 1951
(Artist unknown)

Avon #342
The Woman Aroused, 1951
(Artist: William Randall)

Bantam #75
Cannery Row, 1947
(Artist: Lester Kohs)

Bantam #75
Cannery Row (dustjacket), 1947
(Artist: Ben Stahl)

Dell #542
Fools Die on Friday, 1951

Dell #1542
Fools Die on Friday, 1953
(Artist: Robert Stanley
Model: Rhoda Stanley Rosenzweig)

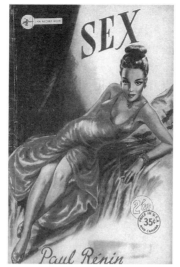
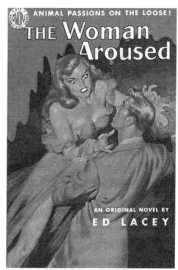

In January of 1947, John Steinbeck's novel *Cannery Row* was reprinted in the Bantam Books series with a tasteful cover illustration by Lester Kohs. In this picture, three men in the foreground are looking at a woman in the distance. A couple of years later, Bantam decided to reissue the book with a dustjacket featuring a different cover illustration—a painting by the famous magazine artist Ben Stahl. A special blurb announced: "Bantam congratulates itself on getting a great artist, Ben Stahl, to illustrate this great novel. Stahl's fine cover pulses with the very spirit and color of Steinbeck people and places." If this cover "pulsed," the effect was probably achieved by reversing the position of the woman and the men watching her, allowing us a much better view of the woman's blouse, left unbuttoned to the waist.

Showing a woman in a state of undress on a paperback cover in the 1950s was not without its risks. For the cover of A.A. Fair's 1951 mystery, Fools Die on Friday, artist Robert Stanley painted a woman with an unbuttoned blouse, zipping up her skirt. (Stanley's wife, Rhoda Rosenzweig, served as the model.) When the book was reprinted in 1953 as Dell #1542, a cleaned-up version of the same painting appeared on the cover. Rhoda is no longer zipping up her skirt but fastening her sleeve; breasts and underpants have disappeared from view. Even the original blurb, "Get your clothes on—just enough to cover yourself, and get out of here," was changed to, "You've got to get out of here! Sergeant Sellers is on his way up." These changes were reportedly made at the request of the hardcover publisher, Wm. Morrow, who approved the second version.

A generally accepted unwritten law dictated that paperback covers could show women in a state of undress as long as no breasts were fully exposed. Nipples were a no-no. An exception was Rudolph Belarski's 1948 cover painting for John Erskine's *The Private Life of Helen of Troy* (Popular Library), which has since become famous among cognoscenti as "the nipple cover."

When I interviewed Rudolph Belarski in 1981, he told me that the editors at Pines Publications (publishers of the Popular Library series) insisted on women with ample breasts ("they had to look like melons") even if no such creatures appeared in the book. "Don't worry, we'll write it in," the editors would say, according to Belarski. Incidentally, the artist was so shy with women that he preferred using men as models, allowing his imagination to fill in the more prominent parts of the female anatomy.

Mickey Spillane's "Mike Hammer" thrillers were usually issued with partially undressed women on their covers. Lu Kimmel, the artist responsible for most of this early artwork, had a fondness for partially dressed women and handgun-slinging men. Did these women decide to take off their clothes under threat, or did they try to inspire the gunman with less violent thoughts? The hugely successful series, first published in the Signet Books series in 1948, saw several reprints with many different cover styles. The 1960 incarnations were illustrated by the most famous of the Signet cover artists, James Avati.

In a 1998 interview, Mr. Avati recalled the period "when lurid and really corny sexuality was exploited." The degree of sexual attraction was mea-

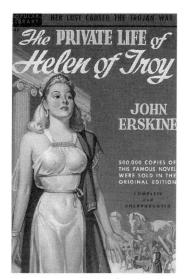

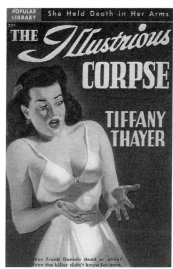

Popular Library #147
The Private Life of Helen of Troy, 1948
(Artist: Rudolph Belarski)

Popular Library #227
The Illustrious Corpse
(Artist: Rudolph Belarski)

Signet #699
I, the Jury, 1948
(Artist: Lu Kimmel)

Signet #S1758
Kiss Me, Deadly, 1960
(Artist: James Avati Model: Carole Siebeck)

Signet #S1271
Fifty Roads to Town, 1956
(Artist: James Avati)

Dell #339
She: The Story Retold, 1949
(Artist: Maurieri)

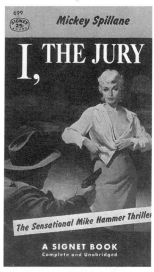

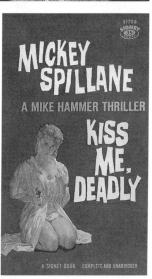

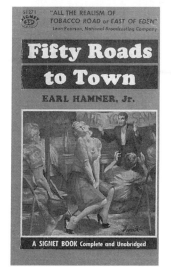

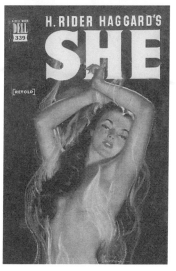

sured by "the degree of nakedness—exposure of breast, for instance, which was ridiculous, it was like, somebody's sick around here!" On the other hand, Avati acknowledges that the sexual tension between man and woman is one of the universals of mankind. "I tried to represent the stories. You're trying to sell a book. What does it have to do with that universal? And everybody's interested. And even if you're a nun you're interested, you're just trying to suppress it, you know, and probably did a very bad job."

The paperback covers James Avati is now most famous for are the ones he did for Erskine Caldwell's novels, set in the rural South. Graphic artist Daniel Clowes, interviewed in his Berkeley studio, remembers: "My grandfather was a paperback reader, and he really liked Caldwell. I vaguely thought that they were sort of pornographic adult novels, there was something so sleazy about them that I tried reading them, and I couldn't really get what was going on, but I remember really staring at some of those covers. And so I had this vague awareness of Avati."

Avati rarely placed his models in obvious sexual situations. Still, his paintings are frequently more erotic than the more explicit, literal paintings of his less talented colleagues. For a novel about a revivalist preacher, *Fifty Roads to Town*, Avati compared religious ecstasy to sexual ecstasy: "When I was directing this girl I said to her: 'Behave as though you're having an orgasm.' She said, 'I never had one!'" In 1998, Avati added: "I don't believe her, anyway . . ."

Throughout the fifties and early sixties, total frontal nudity remained taboo on paperback covers, but it was still being suggested in all sorts of titillating ways. On the cover of H. Rider Haggard's novel *She* (a "retold" version published as a Dell reprint), a nude woman dances behind a fire, the flames of which hide the more sensitive areas from view. On the cover of *Naked and Alone* (Popular Library, 1953), a topless girl draws attention to the parts she wants to hide by covering them. One of the most collectible of all paperbacks remains the Novel Library edition of Maxwell Bodenheim's *Naked on Roller Skates*, the cover painting of which is an endearing example of classic cheesecake art.

The art directors at Dell Publishing may not have been overly fond of "sexy" covers, but the back cover of Alan Green's mystery *What a Body*! was a triumph of tongue-in-cheek sexism. In a unique departure from the usual Dell "map-back," the book offered a "comparison test chart" listing several convincing reasons why it is "more interesting to spend an evening with this book than with a beautiful woman." Only in the "texture" department did a woman compare favorably to the book, which scores better in availability, number of words (60,000 as opposed to 11), laughter production, ease of placing in overcoat pocket, and cost. After all, according to the 1949 chart, an evening with a woman will set you back at least $45 for dinner, wine and cabs not included; a Dell book is still only 25¢. Fifty years later, I paid $4.95 for this book; try taking out a woman for that kind of money.

Piet Schreuders, a graphic designer based in Amsterdam, is the author of Paperbacks, U.S.A.: A Graphic History, 1939–1959 *(San Diego, 1981). He is currently working on a TV documentary about artist James Avati.*

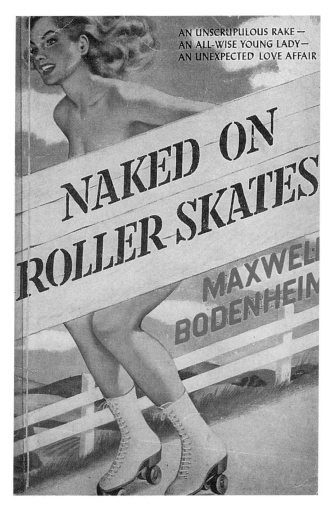

AN UNSCRUPULOUS RAKE—
AN ALL-WISE YOUNG LADY—
AN UNEXPECTED LOVE AFFAIR

NAKED ON ROLLER-SKATES

MAXWELL BODENHEIM

POPULAR LIBRARY 25¢ She Played With Fire And Got Burned

NAKED and ALONE

Michael Lawrence

Complete and unabridged

Why is it more interesting to spend an evening with this book than with a beautiful woman?

A DELL BOOK
A COMPARISON TEST CHART

	BOOK			WOMAN	
49%		TEXTURE		100%	
100%		AVAILABILITY		2-100% (depending on competition)	
60,000		NUMBER OF WORDS		11	
97%		LAUGHTER PRODUCTION		3% average	
0		MISERABILITY (capacity to make you feel terrible)		73%	
80%		INSOMNIABILITY (ability to keep you up all night, one way or another)		79%	
100%		OVERCOATABILITY (ease of placing in overcoat pocket)		11%	
25¢		COST		$45 for dinner (wine and cabs not included)	

WHAT A BODY! Alan Green

Popular Library #1488
Naked and Alone, 1953
(Artist: unknown)

Novel Library #46
Naked on Roller Skates, 1950
(Artist: unknown)

Dell #483
What a Body! 1949

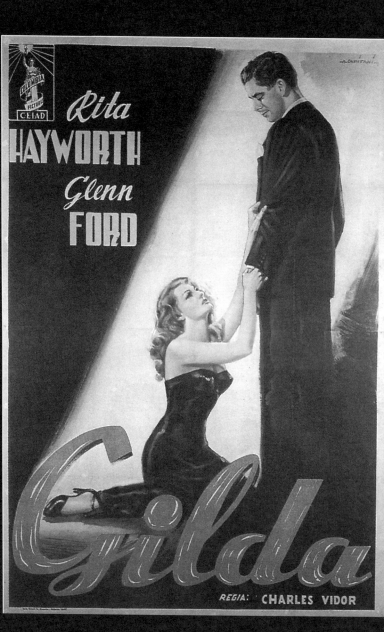

The Wanton and the Wicked: The Golden Age of Sexy Movie Posters in Hollywood by Michael Barson

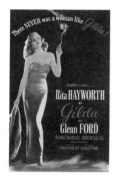

If the definition of "sexy" constitutes the promise of sex, presented in the most enticing manner imaginable, then movie posters must be granted one of the highest positions in the pantheon of Sexy, American style. For, in American popular culture, it has long been a given that sexy is, not as sexy does but rather as sexy is imagined. We now are told by the experts that it is the concept of sex that resides within our imaginations to which we respond most willingly, and which moves us most powerfully. And what medium is more powerful than film, that halfway house between reality, dreams, and myth? It is only fitting, then, that the posters advertising these marvels of the imagination often can take on a life of their own, quite apart from whatever merits (or demerits) the film itself possesses.

It's a point almost too obvious to make, but we'll make it anyway: A sexy movie poster doesn't necessarily have anything to do with the content of the movie it's advertising. In fact, devising a sexy poster for a flaccid film has long been one of the great insurance policies for the movie studios, who cynically count on the proven fact that a great poster with sexy graphics will attract ticket buyers. Thus are moviegoers often hoodwinked by the promise of erotic excitement—a promise on which the movie never quite delivers. It's the Hollywood way.

Not that it's impossible to arrange a marriage of the promise and the product. *Gilda*, a quite sexy, noirish melodrama from 1946, boasted the day's reigning pinup queen, Rita Hayworth, as its star. An impressive array of Hayworth imagery is offered on the film's well-executed poster art, ranging from a saucy, full-length portrait of the delectable Hayworth in her black satin Jean Louis evening gown to a provocative pose of her kneeling abjectly before Glenn Ford, the rather dullish object of her affections in the film. (Never mind that, in her personal life, Hayworth probably had men far more interesting than the stolid Ford kneeling abjectly before her, night and day.) *Gilda* remains one of the most erotic (not to mention kinky) examples of the postwar American cinema, and its posters

are highly prized by collectors who consider them the ne plus ultra of Hayworth art. (Not for nothing was she deemed "America's Love Goddess" in a 1947 *Life* magazine cover story.)

Another bombshell from the forties was Jane Russell, a buxom brunette discovered by Howard Hughes while she was still a teenager. In 1941, she was cast as the lead in a western called *The Outlaw*. Hughes launched a promotional campaign around the film that highlighted posed scenes of Russell lounging in a haystack, chewing a straw; her blouse was in disarray, a come-hither look smoldered in her eyes, and what can only be described as a nascent sneer was perched upon her pouty lips. It was quite an image—though one that cannot be located within the film itself. Predictably, this steamy conceit was made the focal point of the poster art. In a stroke of near-genius, Hughes hired pinup artist Zoe Mozert (one of the few female artists to work in this genre) to render Russell in all her voluptuous, half-dressed glory, six-gun in hand. When the film ran into censorship problems, Hughes withheld it from release until 1946. But some esoteric cadre of poster police must have vetoed Mozert's art, because ultimately, it never appeared on a poster in the United States— although it was reproduced in the magazine campaign for the film, and a version of it was used for the Mexican release of the film. But that idealized pinup image of Russell—"mean, moody, magnificent," as the tag line of the campaign so wonderfully summarized her—remains the iconic highlight of her rather erratic career as an American sex goddess. (For the record, pinup artists par excellence Alberto Vargas and George Petty were also commissioned in 1941 to do the art, respectively, for *Moon Over Miami* with Betty Grable, *The Flame of New Orleans* with Marlene Dietrich, and *The Ziegfeld Girl* with Hedy Lamarr.)

Also in 1946, another steamy tale, *The Postman Always Rings Twice*, made it to the screen, some twelve years after the scandalous James M. Cain novel on which it was based was published. The adulterous couple who kill to sanctify their union were played by tough-guy icon John Garfield and Lana Turner, at the time MGM's reigning glamour queen. The stars do what they can to generate heat while respecting the severe restrictions of Will Hays's Production Code, installed in 1934 to forestall what some watchdog groups perceived to be a surfeit of immoral and/or lascivious screen behavior. There was no way the depraved lust that drove the protagonists in Cain's novel was going to make it to the screen intact in 1946, so MGM relied on the power of suggestion for its poster campaign. A brooding portrait of the lovers, shrouded in shadow, is accompanied by the tag line "Their love was a flame that destroyed!" Garfield's hands are on Lana's shoulders, but she is facing away from him, a troubled look on her face. Intriguing, yes; tasteful, yes; sexy, no. (By way of contrast, the poster for the 1981 remake shows a rather sweaty Jack Nicholson and Jessica Lange; next to the stars is the kitchen table on which the picture's key coital encounter takes place.)

While Lana Turner may have considered herself too classy to be exploited as a sex object on her poster art, the next bottle-blonde to con-

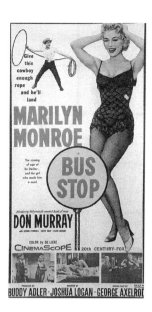

quer Hollywood had no such compunction. Marilyn Monroe had kicked around for too long in too many bit parts in forgettable films like *Love Happy*, *Love Nest*, and *Ticket to Tomahawk* to pass up her chance when she finally clicked with moviegoers in 1952. The poster art for her slate of 1953 films took full advantage of her bounteous beauty, and she became the primary focus of the advertisements for *Niagara*, *Gentlemen Prefer Blondes*, and *How to Marry a Millionaire*. Did it work? Well, a few months after those films played, Joe DiMaggio proposed to her, so draw your own conclusions. Of course, the great DiMaggio was less than pleased when he (rather belatedly!) realized that his own private pinup girl was also fueling the erotic imagination of every other American male between the ages of eight and eighty. By the time Monroe made her iconic signature piece, *The Seven-Year Itch*, in 1955 (immortalized on the poster art by the famous scene of Monroe's white skirts being blasted skyward by a vagrant blast of air from the subway grating she's standing upon—a scene actually shown in the film), DiMaggio was already separated from her. But, judge him not: Who among us mere mortals can imagine the pressure of being married to the century's most potent sex symbol?

But if the reigns were being loosened for the poster artists of the 1950s, it was only to make up ground lost earlier in the great censorship movement of the mid-thirties. Back in 1932, the usually staid MGM art department had devised a rather sexy poster for the jungle romance *Red Dust*, showing stars Jean Harlow and Clark Gable in a humid embrace, with Harlow's blouse halfway unbuttoned—not atypical attire for Harlow, the universally acknowledged sex goddess of the early thirties. Of course, these were the heady days before the Hays Code went into effect, and so the film was able to at least suggest the sort of romantic hijinks one might fantasize about on a hot night on a Malaysian rubber plantation if Jean Harlow were in the next tent. Before 1934, posters advertising a Jean Harlow movie sensibly exploited her national reputation as a wisecracking sex-

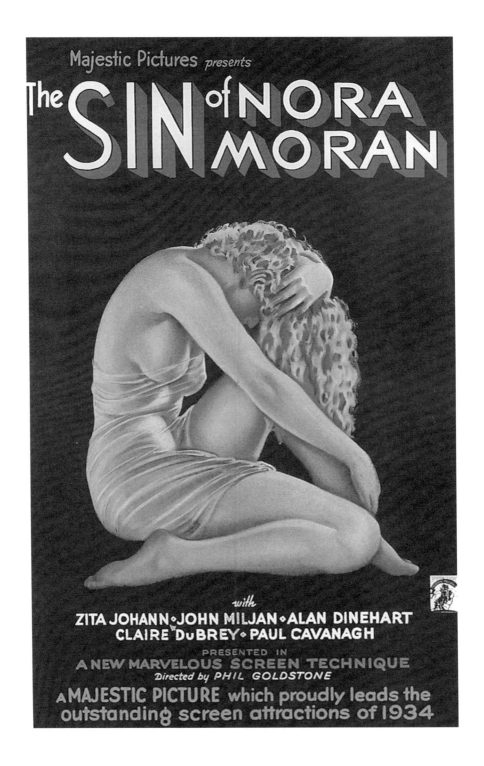

pot—she was famous, after a fashion, for never bothering to wear a bra. Thereafter, MGM concentrated on upgrading her image, emphasizing her considerable talent as a comedienne—understandable, under the circumstances, but nonetheless a loss to all fans of platinum-blonde trollops.

Star vehicles such as those described above were proscribed to some degree not only by the mores of the day, but also by the realities of how the stars in question saw their self-image. Jean Harlow made a fortune off her ability to project a brazen, if good-natured, sexuality, and probably relished the enthusiasm of the studio artists charged with the task of capturing her uniquely slutty charm on her poster art. Rita Hayworth clearly was complicit in letting her stunning figure and (carefully dyed) red tresses adorn the advertisements for her films, the better to draw in weak-kneed moviegoers. Glamorous German transplant Marlene Dietrich, on the other hand, rarely found her unique, heady sexuality given such explicit treatment in her poster art. Even Dietrich's most erotic movie, Josef von Sternberg's 1935 kinkfest *The Devil Is a Woman*, received a rather chaste (albeit attractive) design from Paramount's art department. Less reticent was the staff of Universal, who had Alberto Vargas render Dietrich in a stunning pose, reclining full length on a couch and dressed in a skintight black gown, for her 1941 film *The Flame of New Orleans*.

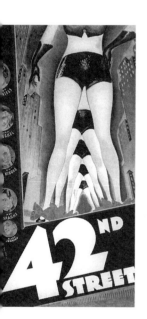

Occasionally, a studio was able to bypass the minefield of star ego by using symbolic rather than representational art. In 1933, *42nd Street* was slated to be one of Warner Bros.'s big musical releases. But while the cast contained a few recognizable names, including Warner Baxter and George Brent, most of the young cast was comprised of yet-to-be-established actors like Dick Powell, Ruby Keeler, and Ginger Rogers. Without a major star, the studio had the latitude to utilize symbolic designs for its poster art. One of the most striking designs showed an array of legs, seen from the perspective of the first row, rising upward to where the shapely legs settled into tiny, identical black shorts. The art deco rendition ends there: Just the symmetrical array of legs and crotches, posed against a stylized skyline of skyscrapers (the monochromatic faces of the cast were relegated to the left border). It's a very sexy minimalist masterpiece, and its like would not soon be seen again on a major studio's poster art.

One of the minor studios of the 1930s was Majestic Pictures, one of the "poverty row" studios, as these shoestring-budget specialists were known. Majestic didn't have the resources to buy a best-selling book property or to hire the star talent that studded the rosters of an MGM or a Warner Bros., so they had to rely on superior poster art to draw in patrons. One of the most egregiously sexy works of this ilk was the 1934 melodrama *The Sin of Nora Moran*, a potboiler that starred someone named Zita Johann. The art, set against a striking black background, shows a highly curvaceous young lady crouched over in a dramatic pose of despondency, her face obscured by flowing blonde tresses. What aren't obscured are her breasts, barely covered by the most diaphanous negligee in the history of the Western world. Whether this is supposed to represent the mysterious Ms. Johann in the film is hard to say, as no one has viewed this obscurity

for at least sixty years, but it makes a heck of a statement. Such explicit art must have hit the marketplace just moments before the advent of the Production Code. This piece commands high sums at auction these days—amounts that perhaps exceed the paltry sum the studio—Majestic, indeed!—spent making the film.

It would be another thirteen years before a poster artist would test the waters again with such an explicit rendering of the female form. This time the movie was a 1947 crime picture called *I Love Trouble*, which starred the midlevel actors Franchot Tone and Janet Blair. The one-sheet art offers an enticing image of the shapely Ms. Blair lounging in what can only be described as a see-through blouse, which clearly reveals her breasts. What Columbia Pictures was thinking of here can only be speculated upon, as the film itself—an entirely conventional murder mystery with comic overtones—presents no such erotic encounter between the stars, or anyone else for that matter, and no such content to support this enticing promise. Ah, well—when the muse settles on one's shoulders, practicality (not to mention truth in advertising) goes out the window.

Since those halcyon days, the art of the sexy poster has declined, perhaps in direct relation to the ever-increasing quotient of sex now permitted to be shown in the actual film. Why entice with imaginative artwork when the goods are there for all to see on a seventy-foot-high screen? Stanley Kubrick's 1962 version of *Lolita* had to tiptoe around the creepy sexuality explored in the book, but the poster art (young Sue Lyons licking a lollipop in loving closeup) at least conveyed a subliminal sense of what the story was about. Now, when an unabashedly lewd flick like the 1998 *Wild Things* comes along, drenched as it is in wickedly perverse erotic gamesmanship, no poster art displayable in public (for example, the walls of an eight-plex theater in a shopping mall) has the nerve to convey its humid content accurately. So why even try? In fact, why not downplay the sexual content of a film by upscaling the poster art? That's what the 1998 version of *Lolita* did. But the film was a commercial failure, and so the jury is still out on how wantonly those wicked characters of today's movies dare to be. Stay tuned.

Michael Barson has written or edited a number of books dealing with the art of the movie poster, including Lost, Lonely, and Vicious; Born to Be Bad; I Married a Monster from Outer Space; *and, with Steven Heller,* Teenage Confidential! *His next collaboration with Heller is* Wedding Bell Blues *(May 2000).*

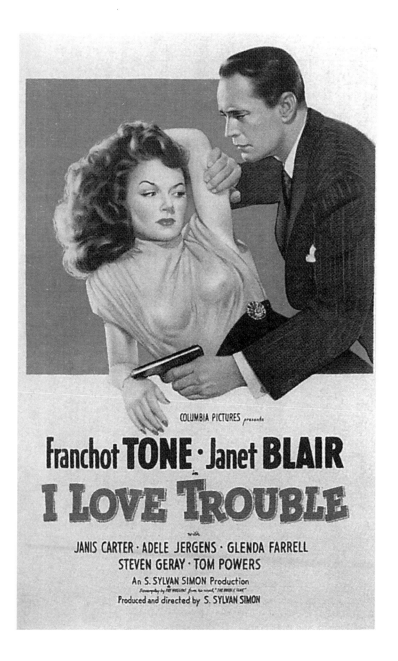

COLUMBIA PICTURES *presents*

Franchot **TONE** · Janet **BLAIR**

in

I LOVE TROUBLE

with

JANIS CARTER · ADELE JERGENS · GLENDA FARRELL
STEVEN GERAY · TOM POWERS

An S. SYLVAN SIMON Production

Screenplay by ROY HUGGINS from his novel, "THE DOUBLE TAKE"

Produced and directed by S. SYLVAN SIMON

Secti
Talki

Six

Sex

Art Paul: Designing Playboy

Interview with Steve Heller

For the generations born following the mid-twentieth century, weaned on feminism and political correctness, *Playboy* magazine, founded by Hugh Hefner, is a throwback to the Stone Age. But when the magazine premiered in 1953 it broke through ossified social and cultural values. *Playboy* enabled men to experience the sexual side of life unfettered by stultifying postwar mores and preemptive censorship that made nudity unsavory and sex taboo. The magazine's format, typography, and illustration must not be underestimated in the calculus of success: If Hefner had not enticed Art Paul to become the magazine's founding art director, *Playboy* might well have languished in a netherworld between pulp and porn. Art Paul (born 1928) studied with Moholy Nagy at the Institute of Design from 1946 to 1950. Paul agreed to do the first issue on a freelance basis, and ultimately signed on for the next thirty years. This interview looks at the way art and design contributed to the *Playboy* ethos.

Why did Hugh Hefner hire you in the first place?

Hef was trying to start a magazine. He'd worked for *Esquire* in promotion and then for a company that published a magazine called *Children's Activities*, and he was hoping to start a magazine on his own called *Stag Party*. A mutual friend, a freelance writer, had recommended me and Hef came to my studio in Chicago to ask me to illustrate a story. I don't think he knew I was also a designer until he saw my work.

What was the impetus for Hefner to start a new men's magazine?

He felt that *Esquire* was turning into a family magazine and losing its male appeal. But when he told me the magazine was called *Stag Party*, I thought he was kidding. If it was to be a sophisticated magazine, as he asserted, that name was certainly wrong. With that name it would be a loser, I thought.

What was his editorial vision?

He explained it as entertainment for men, wanted it to be a lifestyle book: work hard, play hard. But the main objective was—and I don't know whether he said it in so many words—a vehicle for expressing some sexual freedom that did not exist in mainstream magazines at that time.

Had *Stag Party* been designed when you first saw it?

Not at all. Hef brought in some sketches under his arm by a cartoonist friend of his, a cover sketch that looked like the movie magazines of that time, and a few eye-popping nude photographs with not-very-funny captions under them. He expressed dissatisfaction with what he had been able to gather so far, but said he didn't know how to get what he wanted.

Hef wanted you to do illustrations, but what stimulated his interest in your design work?

I had a lot of my art and design work on my studio walls. There were some experimental things of mine and some commercial work. He looked at these and asked if that was my work or work I liked? I said it was both and that interested him very much.

It must have been a wonderful wall.

Well, I wanted the wall display to be an advertisement of what I had already done commercially and what I wanted to do in the future. The later work was fun to look at because in it I didn't hold back in fear of frightening some clients away. I was showing off my skill and sense of humor. The hope of doing such work was why I'd stayed freelance, stayed away from working in a big studio, where I felt I'd lose my identity, my personal edge. When Hef saw my work, he locked into persuading me to be his magazine's art director.

Did you jump at the chance to design a new magazine from scratch?

I was excited about it, but I didn't know Hefner and he looked like he was spending his last cent (which he was, actually) on the first issue, and he was showing me things he planned for the magazine that seemed to be way off his mark. I had been freelancing for two years, building up an interesting and varied clientele, and my wife and I were thinking of having a baby. So I had to think of possible financial security.

From what I've read, Hefner was pretty driven at this time. And from what you say, he had invested his life into this magazine. Did his zeal ultimately convince you?

His zeal was certainly a factor in my eventually agreeing. There was the very tempting notion of designing a magazine with no previous history behind it in content or appearance. I felt that Hef had enough confidence and admiration for my work that he would give me as much freedom as he could. I freelanced the first few issues, thinking there might be only one or two at the most. Hef desperately wanted to get the magazine out by

December of 1953. But I had commitments to my other accounts. So we went back and forth about a week or more, his offering me stock, security, and such if all went well. But what most interested me was the way he was talking, and his enthusiasm for his magazine: it reminded me of the great dedicated publishers I'd read about.

Did the subject matter interest you, too?

On many levels. I was glad that Hefner was a liberal guy, and not jumping on the McCarthy bandwagon—McCarthyism was in vogue then and it made me sick. But at the same time, he stayed away from overtly political issues, except maybe censorship. Because Hef did give me, as an art direc tor, as much freedom as he could, I began to function as an editor as well—mostly because, having not worked in a magazine environment before, I didn't know any better than not to. Hef taught me a lot about editing, and listened very hard to my theories about design and illustra tion. And at that first meeting, other aspects of Hef's description of what he wanted the magazine to be also appealed to me, like its emphasis on lifestyle and especially its lighthearted humor about sex—something that 'til then had seemed limited to an occasional cartoon in the *New Yorker*. I felt the world needed to laugh more about sex. Also I felt that men were treated very narrowly when it came to magazines: Other than *Esquire* and its *GQ* fashion magazine [art directed by Paul Rand], there wasn't much but hunting and mechanics magazines.

How did the title *Playboy* then get coined?

Another magazine, titled *Stag* (a periodical for hunters), heard about *Stag Party* and felt it was too close to their name, so they sent Hef a letter sug gesting he change the title or get sued. Hef changed the title to *Playboy* after a meeting with me and Elden Sellers, a friend of Hef's who was helping him raise money for the magazine. It was Sellers who suggested the name.

Did you know that there was also a literary magazine from the 1920s called *Playboy*?

Not when the U.S. *Playboy* started. We didn't know about it until three years or so after publication. The strangest thing about the 1920s *Playboy* was one cover with a face on it, a woodcut illustration, that looked just like Hef.

Could you predict that this was going to be a controversial magazine?

Oh, absolutely. I didn't necessarily relish that, but neither was I comfort able with the puritanical attitude toward sex in the U.S.—a tolerance for violence while condemning sex. Hef's attitude toward women in the mag azine was never mean-spirited, and nudity was no problem for me. I was sketching nudes in my art-school days long before *Playboy*.

By the time you published the first issue how many of you were there?

There was Hef, myself, and Elden Sellers, who was involved with the
business side of the venture in its early years.

Was the premiere cover, with Marilyn Monroe, your idea?

Using a photo of Marilyn Monroe, clothed on the cover and nude inside,
was totally Hefner's idea. He called the nude color photo the first
"Sweetheart of the Month," and the idea grew into the playmate center
fold. As it turned out though, we'd never again have such a celebrated
woman as a centerfold. And few celebrities ever seemed as much the play
mate ideal as Marilyn. The photo for the cover, however, was of Marilyn
fully clothed. It was a black and white photo of her in a ticker-tape parade
in New York, waving her arm to cheering admirers. I was limited to two
colors on the cover, which turned out to be fortunate.

Fortunate? Why?

I had to design the cover in a way that said this magazine was new and
unique, create a cover that drew attention to itself by being unlike the cov
ers next to it on the newsstands. I remembered what I'd always heard at
the Institute of Design: Less is more. Being able to use only two colors,
black and red, helped me in this, as all the other covers were very full-
color. The cover also had to convey that there was more to the magazine
than pinups, to convey an attitude and mood of lighthearted sophistica-
tion. I did this by using the cover plugs and other cover elements as col-
lage bits suggesting the confetti surrounding Marilyn in the parade—an
open but unified design which set the magazine off from the overworked
formula designs of its counterparts, which all centered around close-ups of
faces crowded by type describing the contents from corner to corner. Even
the word "Playboy" was smaller than other titles, and not fixed along the
top edge where most magazines put them.

There was a scrapbook quality to that first issue, was there not?

I was trying to make the early issues feel lively though I was limited to
mostly reprint material Hef brought me. I didn't have a lot of time
because my other freelance accounts needed attention as well. The
arrangement was that I would freelance the first issue for a fixed price.
And Hef suggested I take some stock as part of my fee, thinking I'd be
happier having a stake if things went well. It was a gamble.

In terms of the design, here was a magazine that was trying to outdo *Esquire*, which Hefner was worried was becoming a family magazine. On the other end of the spectrum, there were nudist books out at the time and other racy or fetishy things. How were you trying to be different—indeed above the fray?

First it was a matter of getting the magazine noticed on the newsstand,
which was the only advertisement we had for the introductory issue. I felt
the cover and inside of the magazine needed to establish a design identity,
a "look" that would be recognized no matter what page or feature you
came upon. At the same time there needed to be surprise and a feeling of

youthful caring. I wanted the book to jump, to be a magazine unafraid of making mistakes, and I knew we were going to make them. I really did not want to imitate any other magazine and especially *Esquire*, which Hef seemed to want to emulate. I continually fought against looking like a second version of any other magazine—what would be the point then of starting a new one? This, I think, was the crux of the matter, that the design, the feel of a new magazine, is as important as what editorial features are in it. Hef recognized this from the start, and that was why he'd asked me to be his art director, so I held firm on this. It was especially reflected in the innovative covers of our early years. They're all idea covers.

Was *Playboy* a men's magazine as opposed to a sex magazine?

I never thought of it as just a sex magazine. Sex was always a part of the package, directly and indirectly, but the point of the magazine was to entertain men and, later, to be of some help with their problems. Of course sex determined the direction of many features and articles of *Playboy*, but it was a lifestyle magazine. There wasn't much like that for men at all then, other than *Esquire*, *GQ*, and *Coronet*, and they were pretty calm.

What were the magazines that you wanted to either emulate or transcend?

I didn't really look at too many magazines before I got involved with *Playboy*. The pinup books of my youth contained no nudity, mostly only black and white photos of clothed women with skirts raised by wind tunnels. The 1940s' design of most mass market magazines of that time didn't impress me; all I looked to them for was the occasional fine illustration. Later, when I was designing *Playboy*, I did check out *Esquire* each month because Henry Wolf was designing it with his usual flair, and kept track of what Herb Lubalin was doing in magazines, and never missed Otto Storch's redo of *McCall's* month to month. Also some foreign magazines like *Twen* had exciting design and photography. Before *Playboy's* time, there was one magazine in particular that I admired a lot: *Flair*. It caught my eye but didn't last very long because it was so expensive to produce. It was chock-full of die-cuts and delicate artwork but didn't have much editorial strength as I remember. Eventually with *Playboy* I did get to do die-cuts, slipsheets, and such. They were very effective. And Hef supported these experiments, even when the ideas I came up with were very expensive to produce or necessitated giving up advertising space for some complicated production designs. He also supported my treating illustration as art and commissioning fine artists to illustrate articles and stories. I wanted to erase false distinctions between "high" and "low" art. I expected the fine artists I hired not to alter their style and asked the commercial illustrators to be very personal in what they did for *Playboy*.

Did you articulate your philosophy to Hefner and he bought into it?

He was very positive about my theories, and encouraging. He also wanted me to talk about design a lot, explain design as I saw it. I had to be care

ful, however, never to approach design or illustration as an aesthetic entity divorced from all practicality. That wouldn't make for effective arguments. I just tried to explain how what I did worked, and why it was necessary for the magazine to be inventive in order to pleasantly surprise its readers. I became a great rationalizer. I'm not sure Hef bought the whole package, but he was very enthusiastic about my ideas for designing *Playboy*. And I talked about the orchestration of the magazine at great length, the pacing of features and text by placing them so they visually supported each other. I wanted to keep ads away from the editorial center of the magazine, so they would not interfere with the pacing of the book. So that each feature would have its own—and the most possible—impact on the reader.

How did you reconcile what you were doing artistically with the kind of sexual pictorial matter that was part of the composition?

At first it would seem a very odd mix—but in reality it defined *Playboy*. While I was lecturing at the University of Illinois in Chicago once, a good many years ago, a teacher there asked me if we had to have the playmate centerfold. He liked the magazine but not that part of it. I pointed out that the centerfold as well as all the basic editorial elements needed to be in the package. Without the combination it would be a different magazine. I remember waxing philosophical about it, considering it a matter of percentages, so to speak. It was harder at the beginning when *Playboy* didn't do its own sex pictorials, and Hef would bring me whatever photos were available for reuse—from stories on beauty contests or about strippers or whatever—that had neither the punch of porn or the intimate appeal of fine-art photography.

Did you have artistic control over the photography?

Very little control over the playmate photography, some at the formative stages, but much less later. The sex pictorials were the one visual element Hef was totally involved in, and very possessive of even when the original idea may have been mine. For the first year, not much quality control was possible in any case, as Hef was buying stock photographs which we'd run as the "Sweetheart of the Month." Then the magazine became more financially stable and we began to produce the playmate feature ourselves. I supervised the first playmate photo session (in Milwaukee). Nobody knew exactly what to do. I articulated the girl-next-door approach, but the final photograph was very much a transitional one. For the Playmate idea was new: the attitude (sex as friendly, healthy, playful) being meant to counter current attitudes toward sex as negative, and the playmate (as real girl-next-door) being meant to counter current cliches of the "pinup girl" as a removed, ideal object. Did all this work? Not too well at that first try, but good enough to start the ball rolling. Later on, my contributions to the sex pictorials came in the form of theme ideas and novel approaches to the playmate features, like asking top artists of the sixties (such as Warhol, Rosenquist, and Segal) to each create their own interpretations of the playmate (Segal's was a meditative pregnant woman).

The Sweetheart of the Month came before the Playmate of the Month?

Yes. And when that happened the feature grew in size from a full page photo to two-page spread and then a three-page gatefold. I worked on the development of the gatefold design-wise.

Were you in any way responsible for the look of the playmate, or was that entirely Hefner?

My contribution was to help make Hef's concept work. When we were doing the photography ourselves he wanted my opinion on how to present the playmate's environment. I suggested that some presence of a male object in the picture was necessary.

A male object?

Like a pipe, for example, or a man's shirt tossed on a corner of a couch. I can't give you a rational explanation for why that seemed important to me at the time. Perhaps in part I hoped it would keep the model from seeming in a vacuum, removed, and suggest more male/female mutuality. This idea didn't take. Later on, the way the painter Richard Lindner put the problem with the playmate photos was that they lacked smell.

What did he mean by that?

I knew exactly what he meant. That there was no reality to these women. They looked too plastic. Not due to any airbrushing as some think. It was the lighting, and the one-elbow-in-the-air poses. Too frequently, photographers would pose the models in a fifties' pinup style. But we should not forget that fantasy was a major part of *Playboy's* success.

Did you feel remorse about helping to create this Plastic Girl stereotype?

It is almost like Charles Dana Gibson's Gibson Girl, which was such an enslaving archetype for women in the presuffrage turn of the century. I didn't have any feelings like that about it. But I did think it could be much better and let Hef know that, but as I said, he had the last word, as well as the pulse of our readership on this. I did, however, initiate some sexy photo essays in *Playboy*, each of which focused on some particular body part, therefore avoiding "poses." For example, I did some boldly designed shots of a woman's leg with a shoeless high heel wryly supporting her nude, raised heel, and a close-up of a woman's buttocks with the panties slid gently down on one side just a bit.

What you describe is common to contemporary nude "art" photography. Were you trying to evoke a more sensual sensibility, or was it just your way of circumventing the head-on pinup shot?

It was both. I wanted strong images. I was always after that. Even when I did illustrations, I'd try for maximum impact, with simple, strong images.

Strength, as opposed to sensuality?

No, I was concerned that the work be sensual as well. I remember Lou

Dorfsman, then the chief designer at CBS, calling me to say he thought my slid-panty photo was the sexiest picture he'd ever seen—and there was no real nudity to it at all. When I was at odds with Hef about certain approaches to the photography of women in *Playboy*, it was not based on sex appeal alone, but about lack of imagination in our sex pictorials, most ly my objection was that "we're repeating ourselves." At one time I suggested a pictorial of a woman putting the clothes on instead of taking them off. It was a big hit, to everyone's surprise.

When did the bunny hop onto the scene at *Playboy*?

In the very first issue. At first, Hefner wanted a full-figure cartoon. I was afraid the magazine would be stuck with the cartoon as a logo so on my own I designed a simple silhouetted bunny-head version as well, which at first we used only as a colophon at the end of articles.

So the bunny began at the outset?

The first issue had both bunnies in it but did not have either on its cover. On the second cover Hef insisted on his full-figure cartoon version of the bunny, sandwiched between two models, which didn't work. On the third cover I incorporated the symbol I'd designed into the cover illustration (in the style of a Lautrec poster in reference to a pictorial inside the magazine on French cabaret can-can dancers). This started our reader-involving game of "find the cover bunny symbol." From then on it was on almost every cover, though at times we went back to the full-figure-bunny collage, which we tried to jazz up by doing it in a playful collage style popular then. I'd draw out the image and my wife would collage it with real fabrics including real rabbit fur for the bunny.

What was the symbolic significance of the bunny?

We were led to the bunny idea by Hef's focus on a stag as a symbol when he was thinking the magazine would be called *Stag Party*. Thinking along those lines, when the name was changed to *Playboy*, Hef reminded us that the rabbit is the "playboy" of the animal world. And because a bunny is a playful image, it suggests humor and entertainment, which is what the magazine, and corporation, are about. There's a great strength in having your logo directly illustrate what you're about, as opposed to being a lofty abstraction. I also wanted to give the now-famous symbol a chance to become a corporate logo. So I kept it simple, for impact and legibility: keeping enough detail to be engaging, but something left for the reader's imagination to fill in.

You set a standard for that kind of presentation. But there was a certain schizophrenia about *Playboy*. There was always the sophisticated literature, the beautiful artwork, the great design, and then of course the dessert was the center spread and whatever other nude features there were.

If you remember, at that time there were only a few art directors, like Henry Wolf, Otto Storch, and Herb Lubalin, who seemed to be getting their way in what they'd want to do in magazines, who were the force

behind the look of their books. In the forties and early fifties most magazine editors kept art directors at arm's length, seeing them as necessary, but a bit cuckoo. At *Playboy* Hef was the boss, but left me room to do my thing. With his support, and with being a charter staff member, I had some room to try my ideas out, to do something for artists and to raise the prestige of magazine art directors while contributing to *Playboy's* success.

Did Hef bow to you or you to him?

He ended most confrontations on design issues by saying, "Well, you're the art director," and left nearly all design and art decisions to me— though not without some lengthy memos about what I did that he hated or loved. And when he'd really insist—on images that touched on his own, personal image, such as features about the *Playboy* mansion or pictorials on certain women—he'd get exactly what he wanted, or nearly so. I was, through the years, perhaps his most stubborn employee, but when it came to these things he was intractable and everyone complied.

You used a lot of conceptual art, more than most magazines at the time. Nonetheless, the editors seemed to have traditional values, preferring Norman Rockwell-like realism.

Word people are seldom visual people, but always think they are. Hef is the exception. Most editors would ask for a literal acting-out of a story in its illustrations. And editors, like most Americans then, tended to visualize the heroine of every story manuscript as the cliché short-nosed, blue-eyed blond. But *Playboy's* editors knew of my early development of the magazine with Hef and gave me space. And when I gave manuscripts to artists to illustrate, I'd choose imaginative artists to begin with, and give them space—as if I were commissioning Michelangelo with "Here's a wall, here's a subject—go to it."

So you wanted the artist's interpretation, not mimicry?

I rejected literal illustrations of descriptive paragraphs from a story, rejected any kind of captions attached to the artwork, and asked editors to write subheads instead. And I let artists work at the same level for us as they did in their own personal work, going for the mood of a story rather than a pedestrian and literal spelling-out. For the most part, though, it had to be figurative art, though it could be and often was surrealistic.

Speaking of figurative artists, who made Leroy Nieman a fixture of Playboy?

Leroy Nieman was someone Hef knew when he was working years before at *Spiegel's* [the mail-order catalog]. He was drawing hats there for ten bucks a hat. A few months after the first issue of *Playboy* was published, Hef asked me if I wouldn't go with him to see the work of an artist friend of his to see if I couldn't use it in *Playboy*. I went to Leroy's studio, which coincidentally happened to be the basement apartment studio I had rented for a while when I was going to the Institute of Design. I was very impressed with his work: brilliant painting and quickly drawn interpretations of the life around him in Chicago. He was also teaching at

the Art Institute. He began doing fashion art and illustrations for *Playboy* and developed a great feature describing his travels through his art, which was the kind of thing he would later do on his own. My input to his work was not critical, but at times I made suggestions concerning subject matter and pacing. He became a great success story.

You did some striking covers, but the magazine's interior pages became increasingly more intricate. How did this come about?

The point of both was entertainment. The challenge was to create surpris es around familiar monthly formats and contents. We supplied surprises with graphics, in different packages. There were theme issues where the cover set the stage and the interior reflected it. For example, we had a cover with only a pair of *Playboy* cuff links on a white background. No cover plugs of any kind. To echo this spaciousness in the magazine, the illustration of the opening story was a photo of a life-size fly, placed as if it had just perched on the white page with the title of the story—"The Fly"—and a column of text a good distance away. We also sometimes used special heavier stock inserts to support die-cuts. I called these participatory graphics. Through the opening created by the die-cut the reader would glimpse the next page's image, but it would be incorporated into the image on the page he or she was already looking at. Then when the reader turned the page, that glimpse would be transformed or completed, it would be seen to be part, by seeming magic, of the next page as well [shades of *Flair* magazine!]. For example, a view through a window would open up into a whole scene. Some participatory-graphic ideas were illus trating sexually oriented features, but most were varied, from politics to environmental issues. Our readers appreciated these surprises and came to expect them.

Playboy—the magazine and the corporation—ultimately became something of an American institution, and like most institutions it became set in its ways. So tell me, were you always trying to push the envelope, even up until your last year there?

Yes, but it became harder and harder to push. As the company grew, as with many companies, it eventually had too many new people concerned only with the bottom line and advertisers. Which made a bad money situation worse because the fear of the bottom-liners overruled the creatives' energy. One wasn't allowed to make things better in the way things had got good in the first place: by pushing the creative envelope. I didn't want to be in such a situation. And after twenty-seven years, I felt wrung out from the treadmill. I wanted to leave the magazine. Hef heard about it and asked me to stay, in whatever other capacity I wanted. When he asked me what else interested me, I told him I couldn't stand *Playboy's* TV ads and would like to remake them. My new TV ads won awards, but still, I really wanted out, and to do something entirely new. Or something I'd always wanted to do, like my own personal art work and maybe some design projects far removed from office politics.

When *Playboy* began it was not the age of women's liberation, but *Playboy* was viewed as moral debauchery. Later the women's movement quarreled with the sexist nature of the magazine. How did you feel about this?

> Not very good. I didn't like the controversy much. It was a love-hate thing for me. At every speech, interview or whatever that I did, there would be someone complaining that *Playboy* was pornographic or an insult to women. Yet there would also be women in the audience who would argue against this and champion the magazine. They seemed protective of me.

In the final analysis, do you think that sex sold *Playboy*?

> Not entirely. There were many sex-only magazines, but none that worked like *Playboy*. Hef might have profited by publishing such a magazine, but it never would have reached a circulation of seven million without a broader focus.

And your major contribution to the magazine was to take it on that other track?

> I like to think I helped do that. Although that's not to minimize my feeling about the sexual side of it. I always thought sex was here to stay. And as an artist I felt it should be, like any other part of life, represented openly in strong, significant images. Sex is one part of a man's life among many and often can be a troubling part in a sexually repressive society. A little humor doesn't hurt. The *Playboy* ideal of appreciating sex very openly, straightforwardly, and truthfully and stressing its mutuality is still a great idea. So why did the end product come off as plastic and nonmutual? Perhaps because the playmate image was mainly a reaction to the negativity that went before it. And so it would naturally be as one-dimensional as what it reacted to—but in an opposite way. Perhaps the only way to get the whole, human picture is to stop being overreactive.

Mike Salisbury: Designing Sex

Interview with Steven Heller

Mike Salisbury (born 1949), the former art director of *West* and *Rolling Stone*, is the principal of Mike Salisbury Communications, which special izes in advertising and promotion for the clothing and entertainment industries. His work is a marriage of pop culture and design sophistica tion. A conceptualist (or "idea man"), he is known, in part, for stirring up controversy (he designed the Joe Camel advertising of the early 1990s) and among his most common tools: sexuality.

During your career as a magazine and advertising designer you have used sex as both a tool and subject in your work. What is the allure of sex in graphic design?

Sex is fun and gets attention. It is also part of my nature to be something of a delinquent, and you can always get into trouble with sex—look at President Clinton.

What makes you prone to delinquency?

Well, because of a great need for attention and excitement. A shrink may say it's because I harbor a lot of anger inside, but I really like making a lit tle noise once in a while. Growing up, my life was kinda somewhere between *This Boy's Life* and *Good Will Hunting*.

One of your early jobs in the early seventies as a magazine designer was with Larry Flynt's *Chic*. Flynt's purpose was to pander; what was your goal?

My goal was to make sex classy like Hefner does but more contemporary in our executions as well as ironic. I like sex and irony because it ain't that serious.

Okay, what do you mean by more contemporary? And given that *Chic* and its sister publication, *Hustler*, were inherently exploitative of women, how did you use sex ironically?

Contemporary means we used more current or avant photographers and photo styles rather than the overworked and underdesigned stuff that *Playboy* did. Our photographic situations were a lot more hardcore than *Playboy* in terms of what our girls were doing sexwise. But we also styled our photos better and hipper by using European photographers who were more into making artful erotica than the girl-next-door sex comics like *Playboy*.

And how did you achieve irony?

I used sex in an ironic way—sarcasticallly—because sex in a magazine is to me not sexy—like we say beating off to a magazine is a new position: man on top, magazine on bottom. Here's one example: *Playboy* would create a photo story with a bunch of big breasted babes close to thirty years old but dressed up as schoolgirls working in a car wash. It would be really brightly lit and overproduced. As they washed the car of course they get into a water fight and gradually—whack whack—take off all of their clothes except, of course, their sneakers. And this is all meant to be very serious. Our version was to just get on with it—the clothes are almost all the way off, but never totally, because we had better styling, and the clothes were part of the deal. Our sets and photos were all graphically designed, and we had the most erotic stuff going on that we could—like the girl sucking off the water hose and squatting on the Rolls Royce hood ornament. All meant to be a put-on in an overly dramatic way. We were saying, Come on this isn't real, but it's beautiful. And all done, as they say, in good taste—designs rather than porno comics. To me, neither is erotic, but like I said, I am not a print person when it comes to being stimulated sexually. In another spread that I designed, "A Consumer's Guide to Social Diseases," I hired [the cartoon-style illustrator] Doug Taylor to illustrate it with silhouettes in a storybook style of children and animals and dirty old men all engaged in sex and playing with sex toys and taking dirty pictures—all framed by a couple of dancing crabs. Now, that is funny. Yet another example is a picture I took of the pop singer Johnny Mathis all dressed up in white, and I asked him to suck on a pink Popsicle—that is ironic to me, and sex is funny.

I understand that you designed the famous Jerry Falwell "parody" ad that landed Flynt before the United States Supreme Court. I presume, then, that sex is not only erotic or titillating, but it serves as a foil for satire. Why is sexuality so controversial?

With a writer, I created the ad parody that got Flynt before the Supreme Court and saved the First Amendment. The ad made fun of Jerry Falwell, accusing him of sleeping with his mother in an outhouse. It just illustrates how seriously sex is taken in this country. That is why sex works so well here to get people's attention. It is still nasty.

Nasty, yes, but also kind of tasteless?

Sexuality is controversial because of our great Puritanical guilt in this

country. You can really whip people with it. Sex, in some Christian interpretations of the Bible, is bad. It is the cause of our downfall. But things are changing. Young people I meet do not feel that way. It is still mankind's goal to get laid.

Another campaign that you did was for the movie _Basic Instinct_, a fairly erotic piece of work. First, how do you view the sex in this film—as designed to excite or to further a narrative? And second, how did you go about creating a campaign that would express the movie's aims?

Sex was used to give Sharon Stone a different kind of identity, a female in total control of her sexuality. The director helped Stone be her sexiest; we just tried to find visual metaphors for that in the print ad: the eyes, the clawing on Michael Douglas's shoulder signifying dominance and badness. Douglas looking away, possibly afraid, maybe vulnerable, probably guilty.

You also designed what you've called a "sexy ad" for Gotcha, a clothing company. What was the reason for this approach, and what was the response?

The reason is obvious: to get the attention of our target, which was basically fourteen-year-old boys in conservative Orange County—oh yeah, and to piss off their moms. Gotcha went to over two million dollars in annual retail sales, proving that sex sells.

You once said that you "tried sneaking sex" into ads that you did for Levi's. Seems odd that you had to sneak sex into a jeans ad, since today most jeans are sold as sexual _accoutrements_. What were the problems related to that campaign?

San Francisco is a relatively conservative town, contrary to popular opinion. Levis is an old, conservative family business in San Francisco. The ad agency was very conservative, and they felt that Levis was bigger than sex. But, why do people buy them? For the fit. And where do they fit so well? In the ass. Ironically, no one wanted to show asses in Levis ads. So I got around that by having the model in my "Travis you're a year too late" TV ad turn to the giant house, backside to the camera, to say her line. No one noticed the beautiful ass except the consumer who wanted that sexy fit.

I remember some sexual innuendo on your last cover as art director of _Rolling Stone_. Today, _Rolling Stone_ has at least one issue a year that is fairly risqué. What was your intention when you did what you did?

Rolling Stone at that time was based in San Francisco, and even though I grew up there, I was considered a devil from Hollywood. So, just like I did with sex and the Supreme Court, I wanted to get into trouble. The feature article in that particular issue was on Steely Dan. As you know, Steely Dan is a Dildo in _Naked Lunch_. I had a forties' style pinup riding a Steel Dildo as the cover art. It got through because I personally took it to the printer and had a phony cover delivered back to the editors for proofing.

One cannot forget about Joe Camel, the infamous hawker of cigarettes, that

you helped create. In addition to all the other accusations that it fostered teenage smoking, critics also said that it was a phallic symbol. Tell me, is Joe really a penis?

I wish it was a penis—my penis! But I don't just sit naked in the mirror drawing my own dick for reference. If people see it as a penis that's their thing. I'm personally not interested. And if that causes people to smoke then Vance Packard was right!

Over the years, has sexuality in graphic design and advertising changed? Is it still something dangerous that requires circumventing social standards?

Sex is different in ads and design today. It has become more specific and more obviously targeted to women as well as men. And yes, it is still dangerous—look at Calvin Klein, another troublemaking older juvenile delinquent like me.

Ralph Ginzburg: Putting the
Erotic in Eros Interview with Steven Heller

From spring 1962 to winter 1963, Ralph Ginzburg published and edited
Eros, a hardcover quarterly magazine devoted to softcore sensuality.
Designed by Herb Lubalin, it was not only the first magazine to treat
eroticism seriously, it was one of the most exquisitely designed magazines
of its era. Here, Ginzburg talks about what made *Eros* work.

**At the time you started *Eros* the other magazines on the market were *Esquire*
(very little sex); *Playboy* (naked women and respectable fiction); and so-
called men's magazines, *Gent, Rogue, Cavalier*, and so on (naked women, fair
fiction, comics). How were you positioning *Eros* among these?**

People who "position" new magazines against competition are imitators. I
did not "position" *Eros* against anything. I had my own vision of a new
magazine on sex that was much needed. I didn't position it against any
other, not in format, not in means of distribution, not in pricing, not in
fundamental editorial concept. It was sui generis and, as a matter fact,
would still fill a gaping void in publishing if relaunched today.

**Eros by its very reference suggests "love" rather than sex. Was this your
intent to celebrate love or was it the love of sex?**

You separate the concepts of love and sex. To me they often combine.
Speaking from personal experience, the erotic in my life has always been
richest, most fulfilling, when intertwined with love, with the romantic.
This may not be true for everyone but it has been for me. The investigation
and portrayal of this summital combination is what *Eros* was all about.

**You've said that you recoined the term "erotic." What does erotic mean in the
context of *Eros*?**

I didn't say I coined the term erotic; I said I popularized it. It had been an
obscure, recondite term prior to the publication of a book I compiled in
the 1950s called An Unhurried View of Erotica [which became a best

seller, by the way]. To me, erotic refers to the pleasure-directed life instinct.

Why were the authorities so afraid of *Eros*?

They weren't afraid of *Eros*, per se. The sexual revolution had just explod
ed in American life. The Uptightniks felt that something—anything!, for
god's sake—had to be done to quash this rampant sexuality. And I was an
irresistible target. Bobby Kennedy was persuaded by certain religious
interests to attack me. Attempts to suppress magazines of Hugh Hefner,
Bob Guccione, and others had failed. Their rights were upheld in the
courts, but mine were not. As anyone experienced in law knows, justice is
an elusive term. It is not scientific and it is not definable. A court of law is
a gambling casino. Hefner and Guccione were not convicted, but I was.
Presidents Harding, FDR, and JFK all had extramarital sexual affairs
while in the White House or in the presidency. They were not scandalous.
They were not crucified. Clinton was. The analogy to myself is perfect.

What were your taboos? What are those things that you would not include in *Eros*?

The editorial contents of *Eros* reflected my personal taste. If I didn't like
an editorial feature, it didn't run. It is difficult for me to define my own
taste, but if there is one common denominator of *Eros's* editorial contents,
it is psychological maturity. Many girlie magazines dwell on immature
aspects of human development. Flynt appears never to have grown beyond
toilet training. Other magazines stop at the voyeuristic level. I think *Eros*
reflected a psychosexual attitude that transcended those.

Do you feel that sex was what made *Eros* sell?

Absolutely, it was the magazine's #1 selling point. But other aspects of
it—design, literary quality, pacing—sold it, too.

Sex-po

ogue

An Aesthetics of Sexuality: The Forgotten Eroticism of Long Hard Work (with apologies to "Learning from Las Vegas") by Elliott Earls

That's what happens when bodies start slap'n.—Tone Loc

Rule 1. Idealize or real-ize.

(You can't fake an erection.)

Brutal and heroic artistic expression relies primarily on "the original" and its privileged location within a traditional aesthetic/philosophical hierarchy for its cultural power. And yet, it is straight-up carnality pregnant with denotative meaning that is the forgotten hussy buried deep within the representational system of power. Perceptually swollen, purple-cocked, and loaded with a logical biodynamism, ripped straight from the satin sheets of Penthouse. A formal model (or equally, a "super model") caught pimping the Platonic ideal. An unorthodox reality distortion field swallowed to the hilt. Symbolically, make 'em sweat that straight-up carnality. "She," found driven by magnetism and hormonal aggression, locked in an ultra-male No Fear, Hustler gaze-field. Masturbation, the daily, systematic exploration of form. Rolling that form over and over and over and over in the mind. "(S)he" became[comes] simplicity. "(S)he" becomes a reduction in the complexity of human interpersonal dynamics. Black cherry-bomb fuse lit, blue-bruised, ripe and ready to fall from the tree like forbidden fruit. Explicit physicality charged with implicit fertility. The goal—maximum titty-lation exchanged like so much DNA. A highly ritualized semantic cock-fight. And I ain't talk'n about no chickens. That's power, the kind that any fifteen-year-old will tell you plainly, rules like the moon.

Roll'n with the girlies in my 5.0.—Vanilla Ice (Robert Van Winkle)

Rule 2. Hustle or pimp.

(The work should move your ass.)

Typological models in hues of pink, or more appropriately "salmon," brought to Deep Purple. I smell "Smoke on the (sea)Water." A fluid exchange and an organic pulse, manifest specifically and explicitly, not through language. Penetrating, that deeply stroked motivation with the extralinguistic language of desire. Testosterone and estrogen fuel denotative top nitro dragsters. Semantic NASCAR tradition is unequivocal: Winner gets to kiss the bimbo. Lubricated with the salty white hot liquidity of conjugation. This deep sexuality relies on a system of Iconographic metaphor on the most primal level. Horizontal K9. A equals B. Not commodity fetish, straight-up fetish-fetish. A paradoxical Fucking. Get'n it on, primal like two perfect holy animals without language, with no need of language. Vulgar fluid human communion returned to its source (physically, spiritually, even topographically). The topographic explorations of a caveman. A spelunking Australopithecus, now erect, becomes Homo erectus (or quite possibly Hetero erectus).

Baby got back . . .—Sir Mix'a Lot

Slap it up, flip it, rub it down.—Bel, Biv, DeVoe

Rule 3. Climax. THE universal aesthetic.

Ideological *Playboy* bunnies and pretenders to the throne all deal that kinesthetic latex linguistics. While this primal biological conjugation resides almost exclusively within a sphere of the sexually charged. Perfumed with the semaphoric logic of a purely pheromone-based language. The smell of sex—I know it when I see it (to mix a metaphor). I know it when I taste it, touch it, or listen to it. Juice, "the fifty-thousand-watt clear channel voice" of complex and unrestricted eroticism. A highly proscribed form of discourse charged with transgression and taboo. Nonrepresentational sex, becomes a system bound socially to the conjugation of the verb. Like some suburban sex-club fantasy or the mythical parallel promised land of wife swapping, implied threat is the point. The abject and the obscene locked in some self-surveyed lap dance. Subconscious consumption of some obscene pop cultural primitivism.

Rule 4. Men are from Penis, Women are from Mars.

(the Dark Continent)

"You can't improve on Nature! The secretion of hormone (sex pheromones) is detected by an organ in a woman's nose called the vomeronasal organ that has only one purpose: to relay the presence of the sex pheromones to an area of her brain that also has only one function: to trigger SEXUAL AROUSAL and EROTIC APPETITE."

My wife loves "Dark Continent," I feel like we are on our second honeymoon.—S.C., Oregon

I used your "Dark Continent" and put your free condoms to work, now I need more!
—D.C., Illinois —The Dominant Male Colognes

Rule 5. Theory of maximum titty-lation.

(It's a dog-eat-dog world)

It bears repeating, The work's got to move your ass. The tyranny of the formal language and associated systems of the contemporary cannon, lack the binary necessity and charge of human sexuality and eroticism. That is, most work sucks. It lacks the formal complexity, intellectual nuance, and cultural relevance of human interpersonal sexual relationships. On a metaphorical level the realm of the erotic (and its associated systems) provides us with a model, a schematic for the reevaluation of our operative methods, and the cultural terrain which we claim.

Elliott Earls is a performance artist and designer who recieved his M.F.A. from Cranbrook Academy of Art. He was recently awarded an "Emerging Artist" grant from the Wooster Group in New York City, and has performed at The Walker Center, The Performing Garage and at Opera Totale. Elliott's type designs are distributed world wide by Emigre inc. Elliot's posters entitled "The Conversion of Saint Paul," and "Throwing Apples at the Sun," were recently added to the permanent collection of the Cooper-Hewitt National Design Museum Smithsonian Institution.

Index

 Books from Allworth Press

The Swastika: Symbol Beyond Redemption?
by Steven Heller (hardcover, 6 x 9, 176 pages, $21.95)

Design Literacy (continued): Understanding Graphic Design
by Steven Heller (softcover, 6 3/4 x 10, 296 pages, $19.95)

Design Literacy: Understanding Graphic Design
by Steven Heller and Karen Pomeroy (softcover, 6 3/4 x 10, 288 pages, $19.95)

Looking Closer 3: Classic Writings on Graphic Design
edited by Michael Bierut, Jessica Helfand, Steven Heller, and Rick Poynor
(softcover, 6 3/4 x 10, 304 pages, $18.95)

Looking Closer 2: Critical Writings on Graphic Design
edited by Michael Bierut, William Drenttel, Steven Heller, and DK Holland
(softcover, 6 3/4 x 10, 288 pages, $18.95)

Looking Closer: Critical Writings on Graphic Design
edited by Michael Bierut, William Drenttel, Steven Heller, and DK Holland
(softcover, 6 3/4 x 10, 256 pages, $18.95)

Design Culture:
An Anthology of Writing from the AIGA Journal of Graphic Design
edited by Steven Heller and Marie Finamore (softcover, 6 3/4 x 10, 320 pages, $19.95)

Design Dialogues
by Steven Heller and Elinor Pettit (softcover, 6 3/4 x 10, 272 pages, $18.95)

Selling Graphic Design, Revised Edition
by Don Sparkman (softcover, 6 x 9, 256 pages, $19.95)

AIGA Professional Practices in Graphic Design
The American Institute of Graphic Arts, *edited by Tad Crawford*
(softcover, 6 3/4 x 10, 320 pages, $24.95)

Business and Legal Forms for Graphic Designers
by Tad Crawford and Eva Doman Bruck
(softcover, 8 1/2 x 11, 224 pages, includes CD-ROM, $24.95)

Careers by Design: A Headhunters Secrets for Success and Survival in Graphic
Design, Revised Edition *by Roz Goldfarb* (softcover, 6 3/4 x 10, 224 pages, $18.95)

Please write to request our free catalog. To order by credit card, call 1-800-491-2808 or send a check or money order to Allworth Press, 10 East 23rd Street, Suite 510, New York, NY 10010. Include $5 for shipping and handling for the first book ordered and $1 for each additional book. Ten dollars plus $1 for each additional book if ordering from Canada. New York State residents must add sales tax.

To see our complete catalog on the World Wide Web, or to order online, you can find us at *www.allworth.com*.